2020
Q/A 1169979
05/4

£6

From Gothic to Romantic:

Thomas Chatterton's Bristol

From Gothic to Romantic:

Thomas Chatterton's Bristol

Edited by

Alistair Heys

 redcliffe

First published in 2005 by Redcliffe Press Ltd.,
81g Pembroke Road, Bristol BS8 3EA
Telephone 0117 973 7207

ISBN 1 904537 20 0

British Library Cataloguing-in-Publication Data
A catalogue record for this book is available from the British Library

Design and typesetting by Stephen Morris Communications, smc@freeuk.com Bristol and Liverpool, and printed by MPG Books Ltd, Bodmin, Cornwall.

CONTENTS

In the following text, the letters CW refer to *The Complete Works of Thomas Chatterton* (ed. Donald Taylor), OUP, 1971.

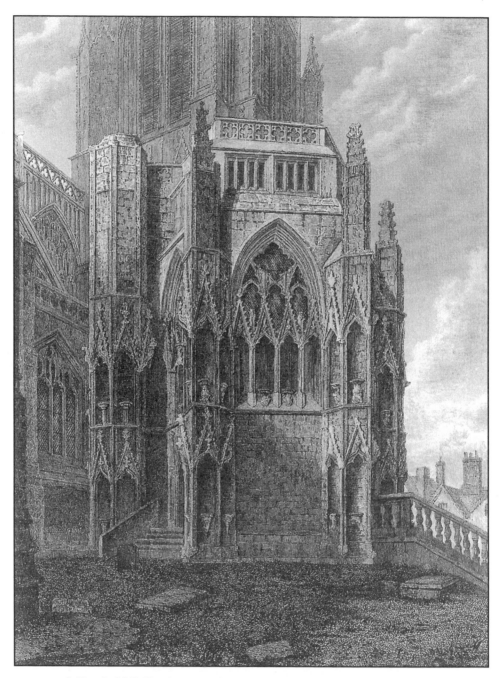

St Mary Redcliffe Church, outer north porch c.1320. Engraving from John Britton, 1813.

Before defecting to London, Chatterton put a temporal distance between himself and Bristol by imagining its antithetical predecessor, a fifteenth-century city of light called 'Bristowe'. Formerly 'Brightstowe' (CW, 93), that etymologically 'famous place' was also 'bright' in the mid-eighteenth-century sense of 'lit up with happiness, gladness, or hope'.[1] Chatterton attributed this ambience to a munificent merchant with cultivated tastes, William Canynge, whose restoration of the Gothic church of St Mary Redcliffe made it 'the Pride of Brystowe and the Westerne Lande' (CW, 99). So wrote an imaginary contemporary of Canynge's, Thomas Rowley, to whom Chatterton with the suburban chauvinism of a Redcliffe boy attributed a 'Radclifte'-centred history of Bristowe he himself had written. Chatterton also wrote and imputed to Rowley several poems 'supposed' (as their first editor, Thomas Tyrwhitt, put it in 1777) 'to have been written at Bristol' three centuries earlier. Those *faux*-antique productions would shortly fascinate Romantic poets indifferent to the controversy about their authenticity in the 1780s, when Rowleiomania flourished.

Thomas Chatterton spent all but the last four months of his life in Bristol. Does that make him a Bristol poet? Not on the evidence of either his writings or his escape at the earliest opportunity from 'Bristol's mercenary Cell'.[3] 'How superior is London,' he remarked shortly after arriving there, 'to that despicable place Bristol,' where the daily business of 'hawking [and] pedling' is conducted under the aegis of 'prudent Maxims' hypocritically at odds with 'Catamitish' goings-on (CW, 561, 516, 542, 516). Far from being the source of Chatterton's 'native, unconquerable Pride', Bristol's economic ranking as 'the second city in England' aggravated his propensity for 'raving in the Lunacy of Ink' (CW, 494, 585, 467). He habitually derided his birthplace as a 'city of commerce and avarice' run by 'little, mean, and contemptible' men (CW, 759, 586). Having no access to those social circles in which intellectual life was conducted, he regarded Bristol as a culture-free zone whose *genius loci* was 'a fish-woman' in the company of an 'Alderman', both asleep, surrounded by emblems of 'gluttony, laziness, and meanness' (CW, 577, 1092).[3] No serious writer would choose to live in Bristol, since 'hardly twenty in the Town can read', and a 'mercantile' mentality leads 'Bristoleans' to treat 'every thing which requires genius' as 'useless' (CW, 502, 572)? Bristowe was everything that Bristol was not.

In alternating praise of Bristowe with dispraise of Bristol, Chatterton reveals his virtuosity as a rhetorician who ranks his mastery of both eulogy and 'railing' (CW, 504) more highly than principled stands for or against something. 'He is a poor author,' Chatterton told his sister, 'who cannot write on both sides' in a dispute (CW, 588). The outcomes of such versatility enabled Tories and Whigs to appropriate different writings by Chatterton for their different agendas. Conservatives who wanted to believe that Bristol had a culturally rich

past delighted in the Rowleiana, whereas dissidents articulating a radical patriotism favoured Chatterton's libertine satires against political corruption.[4] That division is replicated in reassessments of Chatterton's achievements. These have coincided with attempts to decentre metropolitan culture by challenging the assumption 'that everything memorable in the book trade happens in the "golden triangle" of London, Oxford, and Cambridge', an endeavour paralleled in postcolonial studies, where descendants of the empire's former subalterns seek self-determination by provincialising Europe.[5] Bristol benefits from such revisionism. A reluctant Chatterton can now be reclaimed as the literary pride of eighteenth-century Bristol, even though his three 'African Eclogues' embarrassingly memorialise the fact that the number of African slaves it shipped to America increased during Chatterton's lifetime to over 6,000 annually.[6]

Readers persuaded by William Faulkner that fiction sublimates the actual into the apocryphal will think it pointless to go looking for Rowley's Bristowe or even Chatterton's Bristol, especially in the wake of Nick Groom's report that there is now nothing to see.[7] Visiting a place mentioned in a story by Anton Chekhov convinced Janet Malcolm that reading 'the magical pages of a work of genius' is more satisfying than pilgrimages to the inevitably disappointing 'originals' of scenes depicted there.[8] Yet literature-lovers who attend literary festivals to be in the presence of authors, and souvenir such occasions by taking home signed copies of their books, are more likely than literary critics to buy airline tickets to Romantic places, and tour the church that bears the Rowley traces. After heaving themselves up St Mary Redcliffe's steeply spiral staircase, they can relish the aura of deceased authorship in the muniments room from which Chatterton *père* removed some old legal documents that stimulated his son to invent the poetry of Thomas Rowley.

In fuelling nostalgia for the locatedness of such cultural moments, globalisation has internationalised heritage tourism. By ignoring Chatterton's questionable conviction that commerce kills culture, Bristol could capitalise on the niche market in literary tourism by doing more with the Chattertonian relics in its possession, especially the Fripp monument commemorating Chatterton as a charity-school boy. Like Stratford-upon-Avon (the location, some say, of another authorship scandal), Bristol could mark the places associated with its famous writer's life and work, and mount attractive displays of publications by major players in the Rowley controversy.

According to a popular guide to literary landscapes, Dublin, Edinburgh and London are the only British sites of eighteenth-century culture worth visiting.[9] The prime candidate for ensuring that eighteenth-century Bristol features in a revised edition is Thomas Chatterton.

Introduction Dr Alistair Heys

On January 8, 1763 *Felix Farley's Bristol Journal* published a poem by Thomas Chatterton entitled, *On the Last Epiphany; or, Christ's coming to Judgement*. He was eleven years of age, still a charity boy dressed in a blue coat and yellow stockings, who attended Colston's School. Hence, this book's celebration of the bard of Bristol begins with a schoolboy example of Bristowe bawdy:

> There was a Broder of Orderys Blacke
>
> In mynster of Brystowe Cittie
>
> Hee layd a Damoisell onne her Backe
>
> So guess yee the Taile of mie Dittie (CW, 23)

Chatterton's native sauce is the perfect spice for the sourness of Bristowe beer turned to London vinegar. In this introduction, I propose that Chatterton's relationship with Bristol is dialectical, that oscillating between love and hate, the marvellous boy wrote in proud self-admiration and lunatic fury:

> The Composition of my Soul is made
>
> Too great for Servile avaricious Trade:
>
> When raving in the Lunacy of Ink
>
> I catch the Pen and publish what I think (CW, 467)

Which is to argue that Bristol is as much part of Chatterton as Chatterton is part of Bristol; the two are inextricably linked. Chatterton is special precisely because he resurrected a Gothic Bristol, a fantasy city forged to hoodwink the credulous; one that with a strangely compelling charm, he christened Bristowe. Chatterton's most famous Gothic mouthpiece was the monk Rowley who makes his first appearance in *Bristowe Tragedie*: 'the following Transaction happen'd in Bristol the 2nd year of King Edward 4th...the Story is told in a very affecting mannr...by Thomas Rowlie Priest' (CW, 6). Even his unfinished, mock epic, *Battle of Hastynges* is indelibly associated with Bristol: 'An Ancient poem called the Battle of Hastynges written by Turgot a Saxon Monk in the *Tenth* Century and translated by Thomas Rowlie Parish Preeste St. John's in the City of Bristol in the year of our Lord 1465' (CW, 26). In actual fact Turgot is associated with Durham, and this means that another of Chatterton's aliases, Dunhelmus Bristoliensis, probably originated in Simeon of Durham's putative *Historia Dunelmensis Ecclesiæ*, which the historical Turgot perhaps wrote. The web of deceit woven by Chatterton continues to unravel when we learn that Rowley's patron was the merchant William Canynge, who built that 'Pride of Brystowe and the Westerne Lande' or St Mary Redcliffe (CW, 99). Critics have argued that Chatterton sought for the ghost of his father in the identity of this fifteenth-century Bristol figure whose ancestry is

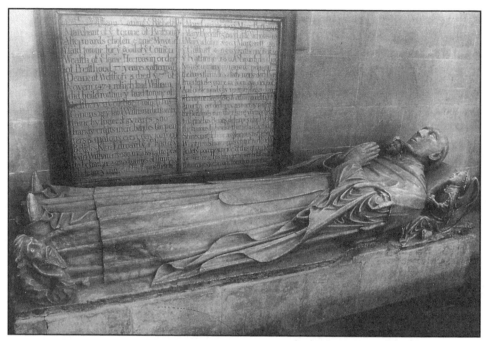

William Canynge memorial, St Mary Redcliffe Church, south transept. [photo: Damian Gillie]

outlined in this heraldic account:

> 1369 Guilliemus Canynge Founder of the Chirch of oure Ladye of the Redde Clefte in
> Bristowe, he was Sonne of Robertus Canyng Merchaunt in Bristowe, his Brother Johannes
> was Lord Maior of London and himself 5 times Maior of Bristowe (CW, 47).

It seems to be the case that the implacable antagonist of Bristolian mercantilism identified
with a medieval businessman; even to the extent of writing his own family name into the
same heraldry. His vainglorious but fictitious lineage included Johannes Sieur de
Chateautone, Randolphus de Chateautonne, Richardus Chateaton and Bourchier Hungerford
Chateaton. But William Canynge has noblesse; he displays qualities over and above pure
fiscal gain: 'Master Robert was a Manne after his Fadre's owne Harte, greedie of Gayne,
and sparynge of Almes Deedes; but Mastere William was mickle Courteous, and gave me
manie Markes in my neede' (CW, 51). Perhaps the most pathetic of Chatterton's mock
medieval poems is *An Excelente Balade of Charitie*, a poem that reworks the parable of The
Good Samaritan and outlines how a pilgrim is prepared to reward a beggar when other fig-
ures such as an Abbot would not: 'Here take this silver, it maie eathe thie care...the Seynctes
will give me mie rewarde' (CW, 648). At the time of *An Excelente Balade*'s composition,

the apparently successful Chatterton was posting presents to his mother and sister from London, behaviour that puts us in mind of the charitable Canynge. Adherents of the suicide myth would perhaps argue that this 'sadly proud and haughty'[1] spirit perished because he was too proud, and point to the fact that in London he loftily refused to accept charity in the form of a free meal cooked by a certain Mrs Angell.[2] On the other hand, there is also Mr Cross's account in which Chatterton was persuaded to accept alms, this time a barrel of oysters that the apothecary had purchased.[3] Nevertheless, the psychological subtext that accompanies this circle of giving and receiving suggests that Chatterton's ruling passion was the sin of pride: 'It is my PRIDE, my damn'd, native, unconquerable Pride, that plunges me into Distraction.'[4]

Native pride might be revealed in those writings that seem hypnotised by the pomp and circumstance of Bristol's civic heritage. Chatterton described the opening of Bristol Bridge showing great approval for the 'Ministrels, and Clarions…makyng a most goodlie Shewe; the Maior and Eldermen standyng round theie sang' (CW, 57). This represents Chatterton's earliest triumph as a forger since in September 1768 a brand new bridge over the Avon had been opened; antiquaries were interested to learn from *Felix Farley's Journal* that a certain Dunhelmus Bristoliensis had narrated a parallel bridge opening ceremony dating from the medieval period. Buoyed up by his success Chatterton could then write a pseudo-treatise on numismatics called *Of the Auntiaunt Forme of Monies* in which we learn: 'Robert Rouse earle of Gloucester erected his Mynte at Brystowe ande coined the best Moneie of anie of the Baronnes. Henrie Secundus granted to the Lord of Brystowe Castle the Ryghte of Coynynge' (CW, 65). The sublime Canynge reputedly says, 'Trade is the Soule of the Worlde but Moneie the Soule of Trade', but after refusing a royal dispensation to mint coins adds, 'you dyspende Heavenne to gette Goulde but I dyspende Goulde to gette Heaven. Thus much for Coynes' (CW, 63-65). *'Stay curyous Traveller and pass not bye'* emphasizes that Canynge displayed 'Buylders Vertues' (CW, 99) precisely because he spent the root of all evil on pious building projects that adorn Bristol even to the present day. In a parallel fashion, 'Turgotte borne of Sexonne Parentes yn Brystowe Towne' (CW, 240) must function as my metonymy for the many Bristolian artists associated with the edification of these buildings, the myckle payncters, poettes, handiecraftes, guyltyngers and carvellers. It is an undoubted facet of Chatterton's charm that he was so much in love with Bristol's beautiful architecture. In contrast, the piratical Lamyngetowne exclaims that he will, 'rob in every tyde…Theire Goodes in Brystowe Markette shall be solde…Make all the Wealthe of everie my Prize/ And Cheating Londons Pryde' (CW, 90-91). Chatterton's vision of the medieval is frequently a rather worldly affair replete with 'Chattels' and 'Goodes I downe at Brystowe Towne wyll selle' (CW, 92-3). The prophetic counterpoint to this fascination with filthy

lucre, *A Discourse on Brystowe*, outlines how: 'Sayncte Warreburgus came to Bryghtstowe and preechen to the Folkes of the Cittie…O synneful Men behould and unless ye repente your City shall be annoyed bie a Floud'. Pride goes before destruction; the benighted inhabitants of Bristol do not listen to his fire and brimstone sermon: 'Aboute Myd Nighte the See rosen and Sabrine overflowen his Banckes till wythin halfe a Fadom from Rudcleve The Men of Brightstowe fledde to the Hylls and escaped alyve but their Godes and Chattels were all destroyen' (CW, 94). Such was Chatterton's infatuation with the town of his birth that he entertained a number of possible etymological explanations for the name Bristol:

> A Gentlemanne hyght Josephus de Ascown saieth Brystowe is come from Bruytstowe or the Place of Bruyt. but Understanders of Auntiaunt thynges ne credited the Tale of Bruyt. Others saie it doeth signify Bryxton or Brystowe therebie meanynge the Place of Stones but theie have ne Awthorritie - for the Brixton of Brixtowe of certayne greete Saxonne Pensmen is bie several Leagues from Bristowe Distaunte (CW, 96)

He further speculated that, 'Caer Brito…is of Brightstowe the origynal Name' only to conclude, 'it maie not be withote foundation as witness the Peeces of Monie in my Table of Monies and those Pieces of Stone sayd by Turgot…to be dolven…in Bristowe' (CW, 100-101). Chatterton's grandiose history seems anxious that Bristol's name is given a gold standard. His artfulness was perhaps aimed at those civic-minded dupes who were all too keen to refute claims that Bristol was not an important centre for trade before the tenth century. *A Discorse on Brystowe* informs us with great parochialism how 'the Cytizens of Bryghtstowe ande nobylitye of Kente entered yntoe solemne League agaynste the Londoners who were almoste alle frenchemenne' (CW, 104). Chatterton implies that unlike the yeomen of Bristol the citizens of London were nearly all French; his bullish Francophobia reminds us that his spurious Anglo-Saxon epic was written from the perspective of the English. In another fabricated Anglo-Saxon poem, *Aella*, the eponymous central character, Chatterton's imagined 'Caesar of Bristol,' pours scorn on Londoners, 'Let cowarde Londonne see herre towne onn fyre' (CW, 202). The allegedly cowardly cockneys are not prepared to fight for freedom; their civic pusillanimity is arrestingly unlike the spirit of the pugnacious Bristolians who elect to struggle against the invaders of their isle so that, 'Brystowe, and all her joies' might not 'synke toe ayre' (CW, 203). *Three Rowley Letters* baldly states that in 1105 'Brystowe han its Maieour before London' (CW, 141). The pseudo-medieval evidence suggests that Chatterton owned a complex but emotive relationship with his native city that opposes the accumulation of wealth with charitable benevolence in the form of works of popular piety. Chatterton's forgeries praised Gothic mansions to God; their depiction bespeaks a sublimated love of Bristol and a correspondent dislike of London. But once in London, Chatterton mounted a pungent attack on Bristol's mercantilism that

seems irreconcilable with his love of the medieval. Masson explains that Chatterton's pride was partly to blame: 'In a town of 70,000 inhabitants...it must be remembered that all the public characters are marked men...it is the most natural of all things for a young man in such a town, just arrived at a tolerable conceit of himself...to be seized with a tremendous disrespect for everything locally sacred, and to delight in avowing the same.'[5] So, the received wisdom goes. But in what might be described as a praise poem to Bristol's 'urban renaissance' Masson's cocky teenager hails Clifton as a 'darling spot':

CLIFTON, sweet village! now demands the lay,
The lov'd retreat of all the rich and gay; (CW, 343)

In order to explain the evident incongruity of these couplets it will be necessary to underline the biographical pathos of Chatterton's position. Hence, I wish to adjust my argument that Chatterton grew up in poverty but knew spiritual riches by suggesting an antithetical obsession with materialism. In the same way that the swelling pride Chatterton took in his work as a forger undermines its deceitfulness, his post-Bristowe invective was fuelled by hurt pride at his impoverished status as a penniless author.

We cannot call Chatterton an Austen, although his treatment of Bristol's economic base contains striking examples of romance underpinned by financial constraints. *Journal 6th* presents a morality drama in which a merchant's son from Bristol is given three boxes to choose from. One is said to hold gold, one lead, and the other stone:

The first a Bristol Merchant's Heir
Lov'd Pelf above the charming fair
So tis not difficult to say
Which Box the Dolthead took away (CW, 367)

The poem relates a predictable moral lesson: 'The Golden Case does Ashes hold'. We are reminded of *The Merchant of Venice*, which begs the question: who was Chatterton's Portia? Chatterton wrote numerous love poems, some for his friends, most dedicated to Bristol fancies, as in *The Complaint. Addressed to Miss P***L of Bristol* or *The Advice. Addressed to Miss M***** R*****, of Bristol*. Not to mention those amorous poems Chatterton wrote in London when he supposedly hated everything about despicable Bristol, *A Song. Addressed to Miss C****am of Bristol* or even *To Miss B**sh, of Bristol*. The saucy variety of these attachments causes me to reserve judgement as to whether he left his heart in Bristol. Chatterton could write with all due cynicism while in the mode of romance; *The Unfortunate Fathers* describes how Mr Sladon, 'a merchant of Bristol, by industry and a diligent application to business, acquired a considerable fortune' (CW, 443). Sladon's character is introduced as, 'an enemy to noise and pomp...his only care centred in Maria, his

beautiful daughter'. The Sladons are offset by Mr Hinckley who upon discovery that his son is in love with Maria advises him, 'George,' said the priest of mammon, 'I commend your choice, Miss Sladon is a good economist, and will have little less than a plum to her fortune: go, and prosper.' Young Hinckley assured his father he had not the least mercenary view. 'Away,' replied the old man, 'when you have been as often upon Change as me, you'll know better.' In another of these Bristol-based prose-ballads, Chatterton assumes the identity of the put upon Astrea Brokage:

> My father, who is a plodding sort of man, and upon Bristol exchange, (or rather in the street) has the character of a rich merchant, who knows how to live in the world, designs to marry me to Bob Barter, the hopeful son of his good friend Hezekiah Barter. Bob is, in the polite language of Bristol, a devil of a Buck. You may see him in the morning, sitting under a shed on the key, registring the weight of sugars, and in the evening shining at a ball. He overturns a basket of oysters, or beats a dog with a better grace than any youthful votary of Bacchus, in that elegant city the cream of politeness. (CW, 431)

This snapshot of a Bristol buck breathes life into Chatterton's puffed-up city. Here he breaks the solemn spell of Canynge and emerges as the sarcastic poet-critic of a profane port; in these far from polite instances, Chatterton is drawn to the idea of inflation.

Chatterton denounced Bristol's golden chains; those human victims of the Merchant Venturer Society's successful petition against the slaving monopoly that the Royal African Company held until 1698. Chatterton was far from being the sole bugbear of the Merchant Venturer ethos. To mention just two examples, some forty years later 'Orator' Henry Hunt launched this assault: 'merchants and gentry...the most vulgar, the most ignorant, the most illiberal...The Corporation is the richest in the world, perhaps, except London; while the freemen...are the very poorest freemen in the world'.[6] A generation before Chatterton, Alexander Pope had refused to meet its merchants, remarking that, 'The city is very unpleasant, and no civilised company in it.'[7] During Chatterton's lifetime, Liverpool eclipsed Bristol as the most important slaving port in England; the appalling idea of human bondage inspired *Heccar and Gaira. An African Eclogue*:

> Rouze not Remembrance from her shadwy Cell
> Nor of those bloody Sons of Mischief tell
> Cawna, O Cawna: deck'd in sable Charms
> What distant region holds thee from my arms
> Cawna the Pride of Afric's sultry Vales (CW, 434)

The mind itself has become a cage as memory ensnares the speaker with the knowledge that humans sell fellow humans for gold. These lines give us an oblique feel for the profound distaste Chatterton nursed for Bristol's Common Council, which was largely self-appointed

from among an oligarchy of rich citizens. I say this because Chatterton's poem is concerned with the pity of slavery; he depicts a father's lament for the fate of his enslaved wife and children:

> The palid shadows of the Azure Waves
> Had made my Cawna and my Children slaves

Bristol's original angry young man uses the same discourse of 'Cells' and 'slaves' in *The Whore of Babylon* where his intent is that gilt-edged bonds imprison the possessor:

> But bred in Bristol's mercenary Cell
> Compell'd in Scenes of Avarice to dwell
> What generous Passion can refine my Breast
> What besides Interest has my mind possesst
> And should a galling Truth like this be told
> By me, instructed here to slave for Gold,
> My prudent Neighbours (who can read) would see
> Another Savage to be starv'd in me (CW, 453)

Chatterton hammers home the link between the suffering of slaves and the hypocrisy of Bristol's civic motto, *virtute et industria*. But it is noteworthy that he also describes himself as another poetic Savage starving in a city of mercantile parvenus literate enough to take note. Chatterton's allusion is to the poet Richard Savage who wrote the satirical *London and Bristol Compar'd*. There are other potential parallels since Johnson's *The Life of Savage* describes him as a gifted though petulant author who was arrested in Bristol in 1742 but who died soon after his transfer to a London debtors' prison.

But did Chatterton think of himself as the genius of Bristol or London? In Chatterton's last will and testament, he theatrically but tellingly coined himself as, 'Thomas Chatterton of the City of Bristol…The Soundness of my Mind the Coroner and Jury are to be judges of desiring them to take notice that the most perfect Masters of Human Nature in Bristol, distinguish me by the Title of Mad Genius' (CW, 502-503). There are significant biographical explanations for Chatterton's move to London; he had been unmasked as a forger; Lambert had dismissed him from his ignominious apprenticeship for threatening suicide; his genius had been rebuked. Immediately after his flight, the sometime son of Bristol stormed and thundered in plumed rage:

> Who but a Muse inventive, great, like thine,
> Could honour Bristol with a nervous line?
> What gen'rous honest Genius would have sold,
> To Knaves and Catamites his Praise for Gold?
> To leave alone the notions which disgrace,

> This hawking, pedling, Catamitish Place, (CW, 516)

Canynge had once functioned as the virtuous icon of an industrious but charitable Bristol but now the Ganymede-like city is rejected because it rejected. *The Exhibition*, a poem which shocked Romantic and Victorian readers, continues the attack on Bristol via its clergy: 'The awkward figure of a Bristol Dean...the many Vices which I trace/ In the black Index of his ample Face' (CW, 549). Taylor argues that his extensive literary productions and the fact that Broughton ignored Chatterton provoked this disdainful assault upon the Vicar of St Redcliffe Church.[8] Contemporary evidence suggests the venality of the clergy: 'The very parsons of Bristol,' remarked an observer in 1724, 'talk of nothing but trade and how to turn the penny.'[9] The London period is also responsible for this piece of bravado masquerading as a letter home that some might describe as whistling in the dark:

> Bristol's mercenary walls were never destined to hold me – There, I was out of my element; now, I am in it – London! Good God! how superior is London to that despicable place Bristol – here is nothing of your little meannesses, none of your mercenary securities which disgrace that miserable Hamlet. – Dress, which is in Bristol an eternal fund of scandal, is here only introduced as a subject of praise; if a man dresses well, he has taste; if careless, he has his own reasons for so doing, and is prudent...The poverty of authors is a common observation, but not always a true one. No author can be poor who understands the arts of booksellers. – Without this necessary knowledge, the greatest genius may starve; (CW, 561)

Chatterton's sourness with regard to the rejection of his genius reduces to the fact that he lacked a diffident conception of degree, which perhaps explains his wolfish appetite for satire. One also wonders at the reference to sartorial preening or the lack of it; while in Bristol, Chatterton could not hide from those proud peacocks that wore ostentatious clothing and so emphasized social rank. Note how in London it is 'prudent' to dress down, whereas in Bristol prudence is perhaps symbolic of those puritanical neighbours described in *The Whore of Babylon*. Chatterton was ashamed of his lowly station in life, one unbefitting a youth so proud: 'As to Mr. Barret, Mr. Catcott, Mr. Burgum...they rate literary lumber so low, that I believe an author, in their estimation, must be poor indeed! But here matters are otherwise; had Rowley been a Londoner, instead of a Bristowyan, I could have lived by copying his works...in Bristol's mercantile style those things may be useless...but here they are highly profitable' (CW, 572). But liars are by their very nature untrustworthy, which truism pleads that we take Chatterton's rhetoric with a pinch of salt. Despite being fooled initially, Walpole quickly saw through Chatterton's chicanery; his scepticism is quite unlike the provincial gullibility of Barrett, who made use of Chatterton's forgeries in his laughing-stock history of Bristol. Chatterton had a limited access to the upper echelons of Bristol soci-

ety, in the sense that he knew and corresponded with all of the above, a surgeon, a vicar and a pewterer. Each was of some importance in Bristol, indeed, these were his gulls.[10] Walpole's metropolitan scepticism is interpreted as scorn and consequently repaid with scorn, his ostensible 'Pride with Pride': 'Had I the Gifts of Wealth…Not poor and Mean – Walpole! thou hadst not dared/ Thus to insult' (CW, 341). When it suited Chatterton, London was no less implicated in the cash nexus than Bristol, and equally a society divided by class.

In the eighteenth century, empirical philosophers like Locke had argued that the mind is akin to a waxed tablet upon which impressions stamp their mark as ideas. Chatterton's obsession with copying seems far from passive insomuch as obedience to Bristol's mercantilism is figured as the passive reception of uncharitable codes of behaviour. When Burgum failed to lend Chatterton an undisclosed sum, the splenetic opponent of Bristolian capital responded:

> Burgum I thank thee thou hast let me see
> That Bristol has impress'd her Stamp on thee
> Thy generous Spirit emulates the My'rs. (CW, 501.)

In that gluttonous, food-fight of a poem, *The Consuliad*, Chatterton writes of 'commercial Bristol's genius…her nodding aldermen…drink, they eat, then sign the mean address' (CW, 438). Chatterton's meaning is that Viscount Clare, then M.P. for Bristol, had wined and dined the city's aldermen in order to persuade them to sign an address backing the current Ministry. It is darkly ironic that in his address *To the Freeholders of the City of Bristol*, Chatterton was to allude to pride and copying: 'The second city in England should not be ashamed to copy the first, in any laudable measure. Let not a false pride mislead you to neglect the care of your liberties…To you, then, ye Citizens of Bristol, who look above such mercenary examples. – To you, who have honour and disinterestedness, I address myself. Be it your task to take off the load of shame, which your superiors in command throw upon the city' (CW, 586). This quotation tempers our opinion regarding the vitriol Chatterton spat in literary squibs at his home town. It focuses our minds upon the fact that his invective was directed at the rich and powerful, Bristol's elite, who so exercised his mind. In *February. An Elegy* Chatterton depicts the charisma of Crœsus but also a green-eyed monster:

> Now rumbling coaches furious drive along,
> Full of majesty of city dames,
> Whose jewels sparkling in the gaudy throng,
> Raise strange emotions and invidious flames. (CW, 448)

This encapsulates Chatterton's critique of Bristol; although attracted to their swank and finery he nevertheless harbours resentment at the privileged status afforded these Bristol belles.

Chatterton's city of 'haves and have nots' was perfectly conceived in one of his most 'disinterested' couplets:

> Mounted aloft in Bristols narrow Streets,
> Where Pride and Luxury with meaness meets (CW, 635)

Wordsworth believed that Chatterton perished in his pride, but I would add the caveat that he was too proud to take responsibility for his buckram actions or to forgive the city that spurned his self-evident genius. This prompts the conclusion that whilst Chatterton might justly be described as Bristol's Punchinello; he should also be viewed as an over-proud genius of place.

When one gazes at Bristol from the top floor of the multi-storey car park near the Triangle, the panorama that meets the eye tells two different stories. The rich live on the hill while the poorer districts are situated either side of the M32. We have heard the counsel for the prosecution in all its post-Marxist primness: a dose of censure that emphasizes the distaste Chatterton felt for the dour work-a-day realities of being a scrivener's apprentice in eighteenth-century Bristol. British imperialism coupled with the slave trade brought wealth into the city, as well as social division, an exclusiveness, but also a sense of being excluded, that is still part of the city's life today. The essays in this volume reflect these divisions by placing Chatterton within a specific historical context, the cornucopia of Bristol's artistic and cultural heritage during and just after Chatterton's brief life.

In his essay, 'Chatterton, More and Bristol Cultural Life in the 1760s', Jonathan Barry questions the accepted view that mercantile Bristol was an inevitable Slough of Despond for an apprenticed author of Chatterton's rank or ability. He argues that Chatterton's aspiration out-paced his achievement; that the identity he forged for himself confined him to a limiting social circle cut off from the main streams of Bristol's culturally diverse literary scene. He presents his case by comparing Chatterton's mercurial genius with the parallel literary life of Hannah More, a Bristolian of the same generation who also moved between Bristol and London.

Timothy Mowl extends this analysis of Bristol considered as a fertile breeding ground for artists and craftsmen in his essay, 'A Rococo Poet for a Rococo City'. He suggests that the provinciality of industrial Bristol had a formative effect on Chatterton's escapist temperament whereas London killed him. Whilst London antiquarians remained sceptical of Chatterton's forgeries Bristol's upper crust nurtured an eclectic taste for myth, fakery, exoticism, anything but the correctness of French classicism. This essay explores the roguish architecture of a rococo city that was, for seventeen years, the Gothic inspiration of a rogue genius.

Michael Liversidge, in his essay, 'Romantic Redcliffe: Image and Imagination', assesses

how Chatterton influenced artistic depictions of Bristol by Girtin, Varley and Turner. He discusses Bristol's associations with the urban sublime by suggesting that representations of St Mary Redcliffe were often powerfully contrasted with images of Bristol's industrial and mercantile heritage. It is his argument that portrayals of St Mary Redcliffe in the work of these Romantic artists became influenced by the myth of Thomas Chatterton's life and death.

Katherine Turner's essay, 'Dr. Viper's Monkey: Philip Thicknesse and the Chatterton monument', augments this book's concern with the physical effect that Chatterton had upon Bristol culture by examining the notorious career of the man who erected the first Chatterton monument. She begins her discussion of 'Dr. Viper' by considering Gillray's satirical cartoon attack on Thicknesse, an etching that boasts a pictorial representation of death devouring Chatterton. Dr. Turner shows that the infamous controversialist erected a monument in celebration of Chatterton's pathos and this despite his appreciation of the dyspepsia of Chatterton's satires and the duplicity of his Gothic invention.

My own contribution to this book, 'Visionary and Counterfeit', outlines the influence Chatterton exerted over Blake. Blake was attracted to Chatterton because he saw portions of eternity in Chatterton's Gothic manuscripts and this in opposition to Wordsworth and Coleridge who tended to portray Chatterton as a tragic suicide. This essay asserts that Blake's response to Wordsworth can be connected to the figure of the builder in *Jerusalem* as much as the medieval architecture of Bristol that inspired Chatterton's muse.

In 'Within a Door or Two: Iolo Morganwg, Chatterton and Bristol', Mary-Ann Constantine argues that Chatterton's career as a copyist is best contrasted with the Welsh forger Iolo Morganwg. Iolo is a pseudonym for Edward Williams, who as a stonemason admired Bristol's architecture, but who as a bard fabricated a vision of a medieval Wales to rival Chatterton's Bristowe. Constantine explains that Iolo lived in *Y Bryste* (the then putative capital of south Wales) while searching for a Volcano near Clifton gorge; that during this period he condemned the slave trade with fiery Welsh passion. She adumbrates how the same despair-laden route carried Iolo, now haunted by Chatterton's fate, to a London garret in Brooks Market, 'within a door or two' of where the young poet ended his life.

In the final essay of this book, 'The Death of Chatterton', Nick Groom explodes the Romantic myth by a fresh unearthing of Chatterton's life in Bristol and London. He argues that Chatterton did not commit suicide by taking arsenic, although it is one of the abiding images of the Romantic era and of Pre-Raphaelite painting. His essay sifts through what biographical facts are known or can be inferred, and argues that the death of the teenager was accidental. Thus, this book closes, much as it begins, with a discussion of the Bristol-London dialectic, a binary that contrasts tragic over-reaching and Romantic myth, unlimited Gothic escapism and the mercantile reality of Bristol.

Chatterton, More and Bristol's Cultural Life in the 1760s

1 DR JONATHAN BARRY

Although Meyerstein, Taylor and others have done much to uncover Chatterton's place in Bristol culture, they have not really altered the stereotype, nurtured by Chatterton himself and by the Chatterton controversy, that Bristol in the 1760s was a business-dominated and unliterary city, incapable of recognising the talents of the young genius.[1] In this essay I present the case for a culturally rich and diverse Bristol, in which Chatterton's problem was partly his background and the circle he found himself associated with and partly that he was seeking to forge an instant career as a literary figure, whereas Bristol's cultural life was largely based on careers in the professions or on the amateur contributions of those who had other means of support. Read more carefully, Chatterton's own comments reveal his awareness (and passionate rejection) of these alternative futures within Bristol, which determined his decision to seek his future in London in 1770.

One way to focus this question is to compare Chatterton with another young Bristolian of the same generation, Hannah More. We are accustomed to see them as polar opposites: if Chatterton is the 'first romantic', then More has recently been dubbed 'the first Victorian'.[2] Yet she was in fact seven years his senior, and there were considerable similarities in their early careers and in their search for cultural patronage. Despite the resurgence of interest in More, her Bristol period is little understood, and the comparison with Chatterton throws new light on the challenges and opportunities that Bristol culture posed to both of them. More moved in the circles from which Chatterton was excluded, and in her Bristol years, at least, she accepted the restraints on the construction of a personal career, (even greater for a woman) which Chatterton rejected, before, like him, travelling to London to find a new public *persona*. Her Bristol connections, however, allowed her to enter London life as the protégé of Garrick and Johnson, to conduct that literary life on her own moral terms and to withdraw from it when, following Garrick's death, she could no longer reconcile its demands with her own self-image.

Hannah More was born in 1745; Chatterton in 1752. Both were the children of charity schoolmasters, More's father running a school at Fishponds supported by the Berkeley family, while Thomas Chatterton senior was master of the Pile Street charity school. Jacob More had been educated as a gentleman's son but forced to make a living in teaching; the elder Chatterton's background is obscure but he clearly had literary and musical interests, singing in the Cathedral choir. Hannah was initially educated by her family, like her redoubtable sisters, who by 1758 had moved, with their father, into Bristol and by 1762 opened their girls' school in Park Street, which was to become one of the leading schools in England over the

next two decades. His father having died before his birth, Chatterton apparently began his schooling at the Pile Street School under the replacement master, but perhaps not surprisingly he did not settle in. After a gap, in which one suspects he might have gone to the other charity school which met within St Mary Redcliffe church itself (in the chapel behind the chancel), he was enrolled aged eight in Colston's Hospital. Here Chatterton was formally educated in the 3 Rs for a future in commerce, without any access to classical education, although in practice the school usher, Thomas Phillips, 'great master of the boundless lyre',[3] nurtured in him and others a lively literary interest. More, by contrast, was educated not only in the 3Rs and French, but also in the classics, which many thought inappropriate for ladies: throughout her later writings she insisted on the need for women to be educated properly and not merely in fashionable or housewifely accomplishments. Chatterton left school to an apprenticeship as a clerk in the Corn Street office of the attorney Lambert (himself active in Bristol's theatre life), where he was allowed extensive leisure to pursue his antiquarian and literary interests using the books in the office. More was based at her sisters' school, but without becoming a full teacher, giving her considerable freedom, and in 1773 her independence as a single woman was assured when, following his three successive failures to honour their engagement, William Turner granted her a life annuity of £200 per annum. Chatterton threw up his apprenticeship and headed for London in 1770, where he appears to have been making a reasonable living as a periodicals contributor before his death, while More did not go there until three years later. She was soon taken up by the Garricks and their circle, and until 1779 she enjoyed considerable fame as a poet, playwright and essayist moving between London and Bristol, before a gradual withdrawal from the stage and London society in the 1780s. Her later career as a writer of moral tracts and anti-revolutionary fables, and as a leading figure in the evangelical movement, make it very hard to imagine her in the same setting as Chatterton. Johnson's notorious quip, that she should have married Chatterton and bred a line of Bristol poets, seems even more outrageous than Johnson intended it to be.

However, if we consider their literary output and interests up to 1779, then the parallels are considerable, though one might say that the two were doing no more than sharing the characteristic interests of the age. They each produced a mixture of elegiac and occasional verses, together with a number of verse plays. These plays shared the vogue for medievalism, with Chatterton's *Aella* followed by More's *Sir Eldred of the Bower*, *Percy* and *The Inflexible Captive*. Of course, More did not produce any parallel to the Rowley output of Chatterton, nor even enter with any energy into the Rowley controversy after his death, though she appears to have shared a Bristolian reluctance to give up the authenticity of Rowley. Nor, in public, did she produce an output of political and satirical poetry in the

Churchillian style such as Chatterton developed in his last year in Bristol and then transferred to London. However, it is possible that More was engaged anonymously in such writing – she was reported to have acted as Edmund Burke's literary agent in his famous 1774 campaign to become a Bristol M.P. It is hardly surprising that the seventeen-year old Chatterton had not produced any of the moral essays which More began to publish, but there is an obvious contrast between her first play, *The Search after Happiness* (apparently performed at her sisters' school in the early 1760s when she was about seventeen),[4] and Chatterton's output. Her pious critique of worldly routes to happiness and endorsement of religious virtue for young ladies is unlikely to have appealed to one who rejected religious authority for 'Nature' and her dictates, for example in his *Happiness, a Poem*, which ends 'Friend let Inclination be thy Guide, nor be by Superstition led aside' (CW, 408). Chatterton's article of belief that 'the Stage is the best School of Morality' (CW, 426) may well have been one that More shared in the 1760s, when she was central to an effort to make the Bristol stage, like the London one under Garrick, the home of a serious Shakespearean theatre which would teach morality: her disillusionment with this project from her London experience and with Garrick's death led her to renounce this youthful view in her later writings, but it was central to her earlier work. We know that Chatterton was part of a theatre-struck group of apprentices (the 'Spouting Club'), but it is not clear whether they too favoured only the elevated drama promoted in the period by the managers Holland and Powell, or if they, like most Bristolians, wanted a broader diet more centred on comedy and display. In his poems on Powell and Holland (both of whom died in 1769, the former in Hannah More's presence), Chatterton certainly praises the same 'naturalness' and emotionality which More and her friends also valued in these actors, and singles out Shakespearean roles (Romeo, Macbeth, Richard), but there is a notable lack of emphasis on moral lessons taught, Powell being loved 'for the virtues of thy heart' (CW, 158, 339-40, 344).

Whereas Chatterton admired the actor managers from afar, More was able, through the patronage of leading Bristolians, male and female, to participate fully in the city's theatrical life, attending the theatre and providing prologues and epilogues for key performances. She was closely connected with leading city clergymen such as Josiah Tucker (Dean of Gloucester but resident in Bristol as Rector of St Stephen's) and Sir James Stonehouse, an evangelical clergyman, who spent most of his time at the Hotwells and provided More with an enthusiastic introductory letter to his friend Garrick. Chatterton loathed his parish clergyman, Thomas Broughton ('Hell gave us Broughton'), attacking him for his pride of learning and mocking his theological writings, for example in his mock will 'my powers of utterance I give to the Revd Mr Broughton, hoping he will employ them to better purposes than reading lectures on the immortality of the soul' (CW, 414-17, 542, 547-9). This was despite,

or perhaps because of, Broughton's strong literary connections: he had, for example, written the libretto to one of Handel's operas and translated Cervantes.[5] He had an uneasy relationship with the vicar of Temple, Alexander Catcott, but Catcott's Hutchinsonianism made him a marginal figure in Bristol life, as were his friends and Chatterton's chief patrons, the surgeon Barrett and the pewterers Henry Burgum and George Catcott (Alexander's eccentric brother) (CW, 339, 405, 501-2). Having captured their attention through his Rowley forgeries, Chatterton might well have concluded that he had hooked the wrong fish, which had if anything made it harder to enter the circles in which More moved. Hence, perhaps, his departure for London, but also the venom of his satirical attacks on Bristol's Anglican clergy, for example in *The Exhibition* (CW, 546-55), including Tucker (as 'the hollow Dean with fairy feet', 'upright and thin' of *Journal the 6th*, who is lampooned for his aversion to marriage, his 'sermon politic' and his criticism of Burgum's generosity to 'virtue distrest') and Stonehouse ('The specious oracle, the man of noise/ The admiration of all fools and boys/ Who finds out meanings (if his talk can mean)/ In texts which Wesley dropt and left to glean', especially in the mystic writings of Jacob Behmen) (CW, 365-9, 550).[6] Against such men, Chatterton set up the freethinking distiller Michael Clayfield as his intellectual hero (CW, 393-4, 416, 504). To date, most writers have interpreted this pattern in Chatterton's life in personal, even psychological terms, but it is possible to see them more structurally, as rational outcomes of the constraints and choices Chatterton faced, given his position and the nature of Bristol literary life.[7]

In satirising Bristol as a place of uncultured businessmen, 'by writers fix'd eternal in disgrace' (CW, 462), Chatterton was following a traditional trope, often applied through a contrast between polished Bath and commercial Bristol. In 1674 Nicholas Crutwell had observed 'I fear the scandalous name of wit, here in a sober serious trading town, where nought's esteemed but wealth and a furr'd gown', and from Newgate gaol the indebted poet Richard Savage developed the theme at length in 1743 (Chatterton saw himself as 'another Savage to be starv'd').[8] The theme was explored more gently in William Combe's *Philosopher in Bristol*, which used the fashionable concept of the 'sentimental' to distinguish the outlook of the 'philosopher', whose sensibility was refined to grasp the significance of the scenes of daily life, from that of the mere trader or merchant who would judge everything in terms of money, or at least of industry and hard facts.[9] In humbler, but probably more influential ways, the contrast was brought out in the many ballads and fables with a Bristol setting which centred on the rival claims of love and money, interest and sensibility, in the matter of marriage. The painter and circulating library owner Edward Shiercliffe conceded that 'Bristol as a city of commerce, it would be ridiculous vanity to suppose could possess eminent literary characters before it was conceived practicable to unite merchandise

with learning'. But he continued, 'the expansion of the mind keeps pace with the attainments of knowledge', asserting that Bristol was then 'as polished and literary' as any city 'in the three kingdoms'.[10] He gave no date for this development, but Bristolians and visitors were wont to discover in each generation a new politeness and taste missing in previous ages. Some argued that culture and commerce were in fact interdependent, since the arts required the surplus wealth that commerce created and the road from barbarity to civilisation was based on the city and trade. The lifestyle of the merchant, in particular, with his cosmopolitan contacts and time for leisure, was just as suitable, argued Catcott's father, the headmaster of Bristol Grammar School, to the cultivation of the arts as the life of the mere gentleman. Given a decent education, either could display taste, and wealth allowed the trading elite to educate themselves and their children properly. Catcott extended his argument to craftsmen and retailers, whose work with expensive materials or in highly skilled processes also developed refined tastes and made them able to use their leisure time creatively.[11]

Many critics of the actual behaviour of Bristolians admitted that such a combination was possible. The 1742 edition of Defoe's *Tour*, like Savage's poem, contrasted petty-minded Bristolians with their London counterparts who were behaving like gentlemen (as did Chatterton)[12] while Chatterton created the Maecenas figure of William Canynge as a model of how the rich merchant could put his money to proper use. Though the industry and frugality that were believed to underlie personal success might have seemed incompatible with the Maecenas model, most Bristolians accepted that these virtues were to be balanced by sociability, generosity and the chance for rational relaxation that the arts offered. Wealth was valued because it could be embodied in social and cultural forms that others could appreciate, as the Councillor of the Sheriff's Court noted in his speech at the opening of the Exchange in 1743.[13] Indeed, Chatterton was typical of Bristolians in using the weapons of satire and panegyric to pillory the avaricious and to laud the charitable. The Muses were particularly associated with the virtues of sociability, as expressions of friendship and means to bring people together without the competitive strains of trade. Equally, however, they were distrusted for their potential to undermine urban society, precisely because their appeal to the senses was seen as a powerful one, which could easily outweigh the claims of reason. The seductive effect of the arts was particularly feared in the young, who lacked the reason and experience to establish the correct balance between industry and recreation. What was permissible in those who had established themselves in life was out of place for those without a secure position, whose devotion to pleasure could only ruin their masters or families, or prevent their own advancement. Furthermore, given the importance of credit and reputation in the commercial community, there was grave concern about the possible abuse of the literary weapons of satire and flattery. Savage's friends who told him not to bother to satirise

Bristol's merchants, because they would take no notice, proved less accurate than those who advised him that he would earn Bristol's hatred as an ingrate who had bitten the hands that had fed him.[14] Chatterton, more presciently, expected hatred not neglect when his satirical work was published, noting, 'Tis dangerous on such men to pass a joke … Men will not have the ridicule of boys', although he also questioned its effectiveness: 'useless the satire; stoically wise, Bristol can literary rules despise' (CW 377-8, 405-6, 464-6, 524). This was certainly the fate that befell his friend James Thistlethwaite, whose poem *The Consultation* not only sold in great numbers but prompted a flurry of controversy, including two verse replies, which expressed the standard disgust for the destructive malice, personal vanity and factional scheming that was assumed to underlie such abuse of the power of literature.[15]

One way of expressing this unease was to portray certain forms of the arts as a dangerous outside influence which might damage the city, while other aspects were seen as innocent, even improving. Since many artistic practices, such as the theatre, depended heavily on visiting performers, often from overseas or trading on their London and aristocratic connection, such dangers were easily personified. Chatterton himself followed this pattern, in his comments on both music and literature, when he contrasted, for example, Italianate musicianship ('ye classic Roman-loving fools') with native simplicity, or compared the virtuous literature of Nature with corrupt forms of civilisation (CW 168-70). His patriotic preference for the English past and distaste for learned snobbery reflected this attitude, as well as his own insecurity about his lack of education in these elite forms.

Yet literature, like the other arts, was also enmeshed in the daily practices of urban society, and deployed naturally by Bristolians. It was used, for example, to mark rites of passage. Death, in particular, was a major theme of Bristolian literature, from epitaphs and elegies on monuments to elegiac poems published in the newspapers or as separate publications. Although most published examples are eighteenth-century, the monumental evidence proves that this was a long-established genre.[16] Chatterton was typical in using elegies as a way to express both his ideals and his anxieties, notably in his anguished verses over the death of his role model, Phillips (CW, 383-94). Love rivalled death as a favoured theme, in forms ranging from platonic pastoral to bawdy satire, and was particularly associated with youth and courtship.[17] The apprentice circle to which Chatterton belonged were adept and competitive in such compositions, though Thomas also composed love poems for his less talented friends.[18] As noted, most of the Bristol-based songs and ballads were concerned with the trials and triumphs of young couples, often in generational conflict. A keen appetite for such literature was associated by religious converts with their years of youthful folly, while those who found the subordination of service or apprenticeship irksome, like Chatterton and his friends, cherished literary and theatrical activity as an expression of

autonomy, no doubt spiced by the disapproval of their elders. However, these same elders employed the arts in their sociability, especially in the public house or meeting place of clubs and societies: a famous piece of Bristol delftware, a large punchbowl painted by Thomas Flower, embodies this with its scene of drinking and music-making, with the song's words and music painted around the side.[19] Much of Bristol's literary output, both in print and manuscript, was produced for such settings, from Crutwell's *Bristol Drollery* to the *Odes, Elegies, Songs etc* of James Brown (Bristol, 1786) or John Bryant's *Verses*, several of which are composed for clubs meeting in public houses. Bryant's literary career began because he was wont to sing for his supper and passage when crossing to Wales to sell the tobacco pipes he made, and he was heard by a gentleman who was (fashionably) interested in his untutored versifying.[20] No doubt the *Merry Miscellany* published by James Sketchley in 1775, which has not survived, was of similar nature. Chatterton's father wrote at least one song for a club at the Pineapple tavern, although his son, ever aiming high, wrote burlettas for the London pleasure-gardens rather than songs for local innkeepers (one of whom, Lawrence, he satirised for his literary pretensions).[21] Unsurprisingly, these songs often celebrate the pleasures of drink, though *Ebriety* (a poem included in a 1751 publication by a 'gentleman' of Bristol) sought to establish the delicate distinction between drunken excess and convivial plenty.[22] Some invited those listening to cast aside their cares and disagreements and escape into their soothing charms, but others sought to express group ideals and engender solidarity: many of Brown's songs, for example, being for Freemasons. Occasional poems and songs were also produced for political and charitable societies. Another common site for literary composition and performance were the city's coffee houses. In 1721, a poet was accused of gaining his inspiration from the fumes of coffee and several poems appearing in the papers were written from the coffee houses. In Chatterton's day, the most notorious poet of this kind was a customs officer, Robert Collins, who wrote at the Assembly Coffee House.[23] Chatterton launched several attacks at this Collins, which have been mistakenly thought to refer to an earlier writer, the unorthodox clergyman Emmanuel Collins (CW, 353, 540).

The Assembly Coffee House reflected in its name the growing world of fashionable assemblies in the town, which were catering not just to Bristolians but to the clientele of the Hotwells. Spas generally became centres for literature, usually of an introspective or satirical character, and Bristol was no exception, with Hotwells residents contributing a steady flow of letters, poems and essays to both the Bristol papers and London magazines. An anonymous visitor, possibly Robert Whatley, wrote *Characters at the Hotwell* (London, 1724), 'a gentleman at the Wells' published *Bristol Wells* (Bristol, 1749) and *The Register of Folly* (London, 1773) satirised both Bath and Bristol society. William Combe published

a poem on *Clifton* (Bristol, 1775) as well as his *Philosopher in Bristol*. Bristolian contributions to this literature were largely satirical, exposing the false and ridiculous in the social pretensions both of the idle at the Wells and of the Bristolians who imitated them. They included *The Celebrated Beauties*, and its several responses, the *Badinages* of Bristol and Bath physician Dr Winter (composed in the 1720s, though they were not published until 1744) and the poems around 1770 of Chatterton, Thistlethwaite and their friends, published both locally and in the *Town and Country Magazine*.[24] In the same *genre*, though satirising the Bristol merchant and politician Henry Cruger, was the 1775 play *The Squire in his Chariot*, by Chatterton's friend Thomas Cary, in which the nouveau riche merchant Insolent and his wife are portrayed ostentatiously entertaining and travelling (in the eponymous chariot) to assemblies and concerts. Their poetry lampooned the authors who flattered the visitors in hope of patronage, such as William Whitehead in his *Hymn to the Nymph of Bristol Spring* (London, 1751) and Henry Jones in his *Clifton* (Bristol, 1767 and 1773), but later Bristolians such as John Bryant and Anne Yearsley were to seek support from the same source (CW 516, 540).[25] The link with fashion and genteel visitors underlined the image of the writer as a gentleman of leisure, exploring gentlemanly themes. Although no doubt often true, there is a certain inevitability in the claim of local poets that their works were the amusement of their leisure hours, often composed on country walks and intended only for the amusement of a circle of friends. Much of the poetry by city residents respected the traditional themes of genteel literature, and especially its elevation of the rustic and pastoral, transposing the themes of friendship, sociability and content from an urban to a rural setting, with nature as the innocent source of inspiration, in sharp contrast to the hectic and ambivalent pleasures of urban society.

One reason for this may have been the lack of an established model for urban poetry except for the city satire of Juvenal. When William Goldwin, clergyman and schoolmaster, was searching for respectable antecedents for his poetic *Description of Bristol* (London, 1712, revised by Isaac Smart as *A Description of the Ancient and Famous City of Bristol*, 1751), he could only point to the recent topographic poems in Italy by Addison (like himself, a moderate Whig) and Cooper's Hill by Denham, neither exactly urban. Goldwin did not want to be satirical, although at one point in the poem he nearly fell into the vein, before drawing back. He might have adopted the historical mode used by the anonymous author of a 1728 poem on Bristol preserved by a local annalist, James Stewart, which traces the city as a heroic character through the ages, but this approach could not easily encompass the modern glory which Goldwin wished to bring out.[26] He was therefore compelled to adopt a topographic approach, despite the uneasy transition between topics which he realised this would entail. Later writers faced the same dilemma. Most of those who sought to praise the

city followed the topographic path, but in doing so found themselves skirting the life of the city and instead portraying the countryside around. Both visitors and local poets published regularly on Abbots Leigh, Henbury, Kingsdown, the Royal Fort and, above all, Clifton, in which Bristol proper appeared as a glorious vision of commercial prosperity on the poetic horizon (CW, 341, 379).[27] Rhetorically, it was hailed as a nobler theme even than nature, but nobody was sure how to encompass it, unless satirically. Once again Chatterton can be seen facing characteristic issues, only to respond in a uniquely creative fashion. While some of his verse adopted the same rustic perspective, and in 1769 he turned to outright satire, his Rowley poetry sought to recreate the multi-faceted reality of city life, through the complex prism of earlier centuries and the voices of supposed poets (late medieval Rowley copying early medieval Turgot, for example). One advantage Rowley gave to Chatterton was that he could use the contrast (largely implicit) between medieval and modern Bristol to combine panegyric of the city with condemnation of its modern shortcomings, as summarised in his mock legacy: 'To Bristol all my spirit and disinterestedness, parcells of goods unknown on her key since the days of Canynge and Rowley' (CW, 504). Moreover, in the guise of Rowley he could speak with an authority unavailable to the individual Bristolian, let alone a poor adolescent. Many Bristolians, however, felt emboldened to comment on civic life and events and there was a general sense that putting one's comments in verse gave them greater weight, especially if expressed through a pseudonym such as Bristoliensis or Civis, which laid claim to a representative character.[28]

Famously, Chatterton first introduced Rowley to the press through a poem linked to the opening of the new Bristol Bridge. Much of Bristol's earlier literature had also celebrated such civic occasions, such as royal visits, thanksgivings, fasts, or anniversaries. For example, the coronation of 1761 was the subject of an ode printed off from a float manned by the Bristol printers during the processions to mark the day. Ordinary Bristolians used verse in public controversy, for example in 1732, when the weavers had an acrostic called Stephen Fechams' Rod printed to mark the flight from the city in disgrace of a hated employer and another poem recorded the pillorying of a sodomist called Baggs.[29] Political meetings and activities were also recorded in verse, both in ephemeral publications and in larger works, such as collections of materials surrounding various elections. Not surprisingly therefore, there were rival ideological traditions within literary circles. William Goldwin's poem of 1712 reflected his Whig sympathies and patronage by the city Corporation and followed the Addisonian model of seeking to rise above party dispute through polite culture, which meant in effect an endorsement of the establishment in church, state and city. By contrast, those who wrote in satiric mode adopted one of the range of oppositionist politics available in Bristol at this period. The chief Tory poet of the period from the 1730s to his death in 1767

was Emanuel Collins, a maverick clergyman turned innkeeper and schoolmaster, who tormented the Whig establishment with many poems in the newspapers, a hudibrastic verse rendering of a ministerialist sermon called *Unity and Loyalty Recommended* (Bristol, 1754) and his *Miscellanies in Prose and Verse* (1762), as well as various manuscript poems.[30] During the 1754 election contest the Tories produced most of the songs, fables and other fictional works, while the Whigs, co-ordinated by Josiah Tucker, concentrated on more factual arguments. But the next year the Whigs retaliated with their own verse dialogue on the Bristol Watch-Bill, written as a dialogue between two down-cast Tories, which included attacks on Collins.[31] After a 1756 by-election there was a gradual realignment of political allegiances as Wilkite radicalism and the American crisis cut across traditional Whig-Tory divisions, but most political verse remained oppositionist. In the 1774 election (the next one to be properly contested) the Tory surgeon Richard Smith (brother of Chatterton's friend William) was active composing squibs for Matthew Brickdale, together with some Tory clergymen and the Customs Officer Robert Collins whom Chatterton had attacked, while the main authors on the Cruger and Burke side were James Thistlethwaite and Richard Jenkins.[32] The Cruger supporters, in particular, inherited the patriot tradition of verse attacking corruption in the name of liberty, whose chief inspiration was Charles Churchill.[33] There was an uneasy alliance between them and Burke's supporters from the literary circle around Hannah More, which included Quakers and Anglican evangelicals, who shared a devotion to liberty and a fear of moral corruption, but lacked the alienation from the establishment which sharpened the pens of the Cruger writers. It seems unlikely that Chatterton would have been in the Burke camp, but he might have been more torn between the Tory satirical tradition, which reflected the views of his Rowleyan patrons, and the Crugerite sympathies of most of his youthful friends (he distrusted Cruger, no doubt reflecting the views of his friend Cary who was his apprentice).[34]

Closely connected with these political issues was the question of religion. Arguably, religion was the strongest single factor in Bristol's literary life. The clergy (Anglican and dissenting) formed the city's literary elite, and religious themes and *genres* shaped most of the literary output, such that much of that output was evaluated as much, if not more, for its religious meaning as for any autonomous cultural worth. It was therefore inevitable that Chatterton would spend much of his energy in critical commentary on the Bristol clergy; even his love poetry tends to digress into an attack on them (CW, 424, 508). He found himself both drawn to, and repulsed by, the religious forms and messages which this literature addressed: his freethinking outbursts may be seen as an expression of independence but one which, he well recognised, was likely to put him outside the pale of Bristol literature. His poetry regularly defends himself against the accusation that 'He's atheistical in every strain'

and acknowledges 'priests are powerful foes' (CW, 422, 466). During the 1760s, for exam-
ple, two new translations of the Bible were undertaken in Bristol, by the Quaker Anthony
Purver and the Unitarian minister Edward Harwood, while others published verse para-
phrases of parts of the Bible.[35] In addition to prayers and elegies, Bristolians committed to
verse their religious philosophies, hoping that notions shared in this form would be more
attractive and memorable than prose accounts. One such writer was Stephen Penny, a
Behmenist like Stonehouse and also satirised by Chatterton (CW, 412, 415, 422).[36] Two
clergymen, John Needham and Thomas Janes, published collections of moral and sacred
poems, including their own work, in part to provide children with suitable anthologies of
uplifting verse, and Needham's collection, *Select Lessons in Prose and Verse* (Bristol, 1755,
1765 and 1778) which first published More's *Ode to Charity*, may well have been used by
his co-pastor William Foot in his school (attended by the young Robert Southey).[37]

To take one *genre*, the writing of hymns was a major aspect of Bristol literary produc-
tion from the seventeenth century onwards. The most famous contributor was Charles
Wesley, resident in Bristol throughout Chatterton's life and an active patron of both male
and female authors in Bristol and Bath. Methodism generally invested heavily in hymns, and
many of the Wesleyan hymns were published in Bristol by the Farleys and William Pine; it
was the profit from one such publication that enabled Charles to buy his Bristol house.[38] But
other denominations were also active, such as John Beddome (father of the better-known
Benjamin), John Needham and several teachers and pupils of the Baptist Education Society
(one of whose masters taught Hannah More classics). Caleb Evans, who also taught there,
published one of the earliest hymn collections in 1769 jointly with a former pupil, John Ash.
In 1756 Robert Williamson had published another collection in Bristol under Moravian aus-
pices.[39] Many of the laity also tried their hands at hymns (or psalms), in the papers or else-
where and devout young Christians such as Mary Stokes (later Dudley) wrote hymns on
their spiritual condition.[40] The monotonous metre of traditional psalm settings or the 'bal-
lad' style of some hymns came immediately to mind when poets sought to criticize the ear
of other versifiers. Chatterton, one of whose earliest poems is a hymn on Christmas day,
attacked Methodist hymns as 'bawdy songs turned godly' (CW, 4-5, 466-7). Apart from this
rather trite criticism, Chatterton appears to have known, or cared, little about the vibrant
nonconformist culture of the city, focussing both his love and his hate on the Church of
England.

There was, however, considerable latent tension in this religious literature. In part this
was the tension between the ecumenical role which many ascribed to their work, transcend-
ing denomination and divisive theology to express common Christian values and bring the
soul to a feeling for God, and the denominational advantage which might be gained, or

feared, if literature was used to win particular audiences or sweeten the acceptance of par-
ticular doctrines. This danger seemed the more likely since many of those who used literary
forms did so almost apologetically, not only disclaiming literary merit, but drawing a dis-
tinction between the religious 'kernel' (as Penny put it) and the rhetorical shell in literature
and justifying the latter as a concession to the regrettable desire of humans to crave exter-
nal pleasure. Verse was a means to reach those who would not read plain prose and to fix
ideas in the memory. One elegy to Phillips expressed all these ideas in claiming of his work,
'Religion in this flow'ry diction veil'd,/Convinced the soul where rigid doctrine fail'd'.[41]
As the Bible lost its relative primacy to a stream of other literature, authors such as Harwood
or More attempted to restate Biblical truths in polished literary form. But again this was a
deeply ambiguous process as it was only adding to the flood of literature which many feared
was distracting the public from the traditional religious and moral truths (expressed partic-
ularly in critiques of both novels and the theatre). Authors who attempted this were also
open to accusations that they were exploiting sacred subjects with an unworthy aim or inad-
equate talent to do them justice.

 The force of this argument owed much to a general uncertainty about the propriety of
publication *per se*. Hannah More's first publication, *The Search after Happiness*, was pref-
aced by the standard claim that the work was only being published to scotch the circulation
of imperfect copies (which might be true in that case, since the work had been written some
twelve years before). The subsequent performance of this play and her next, *The Inflexible
Captive*, and her emergence as a public literary figure in Bristol, was orchestrated by a press
campaign which made her appear the passive respondent to public demand, not the active
seeker of fame.[42] The convention remained strong that an author should avoid publication,
unless urged by friends that the public good required a wider circulation, and even then
anonymous or pseudonymous authorship would demonstrate a lack of ambition for fame.
Dedicating the work to august bodies such as the Corporation or the Society of Merchant
Venturers, or to important patrons, could support the impression that the author was seeking
their glory, not his own. Above all the author had to avoid the imputation of seeking finan-
cial reward. This might be done by donating the profits to charity or even by giving away
the printed piece to friends. The literary hack who wrote for money was a figure to be
despised. It was also recognised that literary work could be advantageous without money
passing hands, and there was a similar distrust of the writer who wrote to order, flattering
his patron. For example, the accusations against Robert Collins of seeking to become
Bristol's 'poet laureate' in the 1760s were not merely for his lack of necessary talent, but for
sacrificing his literary independence to win the favour of the Corporation.[43] Chatterton toys
repeatedly with the tempting notion that 'Flattery's a cloak and I will put it on', abandoning

'stigmatizing satyre' and 'come panegyric, adulation haste, and sing this wonder of mercan-tile taste', before passionately rejecting such a betrayal of his genius (CW, 377-8, 466). Many dedications were no doubt unsolicited and they might veer close to blackmail, invit-ing the 'patron' to buy up the work to prevent its publication under his name, as James Thistlethwaite attempted to do with his scurrilous poem *The Consultation*. Henry Burgum, the dedicatee, felt obliged to draw maximum attention to the affair in an attempt to vindi-cate his honour, printing five hundred copies of a pamphlet vindicating himself at his own expense. The case illustrated the strains imposed when a system that was well suited to pub-lications by literary amateurs, wishing to establish their credentials to be heard on the pub-lic stage, was used instead by an aspiring professional writer.[44]

This requirement for independence, of financial reward and clientage, both built on and reinforced the image of the literary life as one for those whose profession or leisure time fit-ted them for such disinterested participation. The most active participants were from the pro-fessions, and clergymen (and schoolmasters, many clerical), lawyers and medical men formed an intelligentsia who were the most active subscribers to books and dabblers in verse. A number of revenue officers played an active part and the service was used occasion-ally to reward talented figures. The merchant community contained many supporters of the arts, but very few ventured to publish. The linen-draper John Peach, a friend of David Hume from his Bristol days, had a great reputation for his love and cultivation of literature and was apparently a central figure in More's literary education, but none of his own work can be identified nor that of Michael Clayfield, the distiller whom Chatterton so much appreciated. A similar silence in public applies to the numerous patronesses of the arts, such as Hannah More's chief patron, Mrs Gwatkin and her friend the Quaker newspaper owner Sarah Farley, or the circle of women around Charles Wesley.[45] To come into the public eye was, for anyone outside the liberal professions, to have one's credentials for publication subject to the most intense scrutiny. Hannah More's own failure to publish under her own name until 1773, despite a decade or more of literary prominence, reflects this, and her own writings express her struggles over the propriety of such action. She wavers uneasily between a spirited defence of the right and ability of women to engage in literary activity, and an admission that women should not expect to be scholars or artists of the first rank, but should concen-trate on developing a polished talent to appreciate and cultivate literary worth in men. She satirises men who grumble at women for leaving their needles and cooking books for culture, as well as other women who gossiped at tea about such females, accusing them of artful wiles and undue forwardness in trying to catch the men, and of using literature to conceal their plainness and want of real femininity. Yet she also rebukes not only, as one would expect, the ignorant miss and the romantic sentimentalist lost in a world of novels and plays, but

also the lover of fine literature and would-be scholar for neglecting the primary place of virtue and religion in female education.[46]

It would be wrong, however, to see gender as the only issue. The association of literature with 'gentility' meant that the social status of the author was also in question. This is very clear in the case of Henry Burgum, whose involvement with Thistlethwaite has already been noted. Burgum's passion for the arts, especially music, led him to neglect his pewtering business and he eventually went bankrupt. But even when solvent, he was liable to criticism for attempting to go beyond his station: during a dispute between two rival concert series, for example, his opponents gleefully blamed the organisational problems besetting a Cathedral oratorio on their management by a 'set of tradesmen' unaccustomed to 'transactions of that nature'.[47] Chatterton himself famously traded on Burgum's pretensions in producing the false pedigree of the 'De Burghums' for him. Yet, interestingly, on a number of other occasions he uses Burgum as a foil to his clerical targets, praising Burgum's genuine passion in contrast to their false pride and insincerity: 'I'd rather be a Burgum than a saint' (CW, 316-38, 368-9, 418, 501). Central to this trope is Burgum's lack of classical education, for which he is sneered at by his detractor 'who damns good English if not Latinized', but praised by Chatterton, who hints at a true gentility in the English honesty and generosity of Burgum: 'Burgum has parts; parts which would set aside,/ The labour'd acquisitions of your pride./ Uncultivated now his genius lies./ The owls of learning may admire the night,/ But Burgum shines with reasons glowing light' (CW 406, 418, 519-20).

Education may indeed be seen as the single most critical issue, besides leisure time, in determining the social spread of literary activity. Chatterton felt deeply ambivalent about his lack of a liberal education, especially in the classical languages, expressing throughout his poetry both despair ('O Education, ever in the wrong,/to thee the curses of mankind belong,/thou first great author of our future state,/chief source of our religion, passions, fate') and defiance: 'O learning, where are all thy fancy'd joys,/Thy empty pleasures and thy solemn toys,/Proud of thy own importance' (CW, 407, 417). Indeed, one way of interpreting his use of Rowleyan language on the one hand, and of Churchillian satire on the other, is that these were two *genres* where he could operate outside the classical framework. Had Chatterton attended the Bristol Grammar School, like Stephen Love junior (whose father had replaced Chatterton senior as Pile Street teacher and expelled the young Thomas), then he would have been subjected to an intensive study of classical literature, and been expected to compose verse and even perform publicly at the school visitations and the annual November 5 oration, which the young Love gave in 1759. Love went on to become a clergyman and Stonehouse's curate, and when he died young in 1773, Stonehouse persuaded Hannah More to write the elegy for his monument in Bristol Cathedral.[48] The two masters

from 1712 to 1743, Goldwin and Catcott senior, were both published poets themselves and encouraged their pupils: in 1737 Catcott published the visitation verses. Emanuel Collins was one of Catcott's pupils and expressed his appreciation for his master in his *Miscellanies* of 1762. Catcott had been banned by the Corporation from staging a school play in 1739, but in 1773 and 1774 such plays were performed, with More writing a poem to be recited by Lovell Gwatkin, her patroness's son, at the latter.[49] It was enthusiastically reviewed in the papers, with a comment that such performances were ideal experience for young men intended for 'the senate, the pulpit or the bar', to which one might add medicine, as most of Bristol's medical community, many of whom cultivated literary tastes, were grammar-school educated, such as Dr Francis Woodward, whose juvenile verse appeared in Catcott's 1737 volume. By contrast, Chatterton's formal curriculum at Colston's Hospital was limited to the 3Rs, in preparation for a career in trade or at sea.

However, the picture was more complex than this suggests. We know that Chatterton and his circle were in fact encouraged in poetry by the school usher. If this was unusual in a 'charity' school, there was a growing vogue for literature in the rapidly increasing number of schools for both boys and girls which offered an English education which encompassed such subjects as history, geography and elocution; *Astrea Brokage* is Chatterton's example of a girl at such a school, torn between a rich young admirer and her 'literary lover', perhaps Thomas himself (CW, 431-2). While the school run by the More sisters became the best known girls' school of its kind in Bristol, it was one of many, and there were equally eminent boys' schools. For example, in 1768 Miss Roscoe, from an acting family, was praised for her pains in teaching recitation at her girls' school, while John Jones both ran a school and offered elocution classes: one of his elocution pupils in 1773 was Thomas Cary.[50] Increasingly, these schools could boast that, in contrast to the grammar schools, they could offer their pupils an introduction not only to modern English literature, but also to the classical inheritance, which was now so easily accessible through the mass of translations and commentaries, as published by Dodsley 'whose collection of modern and antique poems are in every library' (CW, 339). The English poet could now appropriate classical mythology, as well as writing in heroic couplets and other neo-classical verse types which, while decorous and genteel, gave amateur poets the confidence that they were writing proper poetry. Significantly, the so-called 'uneducated poets', Bryant and Yearsley, who were 'discovered' by Robert Southey and the More circle as examples of 'popular verse' in the tradition of Percy's *Reliques*, were actually far from illiterate and took every opportunity to learn more about the classics and to read books, which led both of them to end up in the book trade.[51]

Throughout his poetry, Chatterton engaged in an impassioned debate, both with his patrons and himself, about what sort of a literary career he could forge for himself in Bristol.

Once he had decided that debate by departing for London, it was all too easy for him, and subsequent commentators, to adopt the simple judgment that a trading city was not a possible home for a budding poet, let alone a 'mad genius' (CW, 503). A closer reading of his writings, as well as of the literary life of Bristol in this period, reveals that he was actually very conscious of a whole series of opportunities and choices available in Bristol, but that none of these was acceptable to him. Chatterton portrayed these choices in stark terms, as requiring him to abandon his independence for a servile flattery, giving up his freedom of thought (above all on religion) and to accept that he should earn his living by other means and develop his literary career as a leisure pursuit. The advice of his patrons and his master, Lambert, that he should train as a surgeon or lawyer's clerk, was rejected so passionately precisely because it was, by Bristol standards, good advice, for anyone who wished to write poetry and participate in a rich literary scene, but impossible advice for one consumed with a desire to make a career as a writer. Unlike Stephen Love, neither his schooling nor his beliefs would allow him to train for the church, where writing was an integral part of the career, and, unlike Hannah More, he could not justify to himself a slowly developing career which accepted the patronage of others and the early avoidance of fame and controversy which could, in the longer term, allow even a woman to enter the public domain with impunity. Chatterton understood profoundly the terms of literary life in Bristol, and could deploy them to satirise others, but he was unable to resolve their contradictions as they applied to him, except by a mock suicide and a new life in London.

A Rococo Poet for a Rococo City

2 DR TIMOTHY MOWL

Bristol escaped the confining stylistic trap of the Palladian revival because it was rich, brash and had close trade links with Dublin. Thomas Chatterton escaped the classical indoctrination of a grammar school education because he was poor and attended a charity school for clerks. When they are put together, these two freedoms from the conventional cultural expectations of the country explain how and why Chatterton was able, before he was eighteen years old, to anticipate something of the mood of later Romantic poetry.

With hindsight it is possible to say that the Palladian revival, imposed upon England after 1714 by the Whig party and the royal preferences of George I, was a retrograde step, a revival of a revival. The English Baroque, handled by John Vanbrugh and Nicholas Hawksmoor, was more imaginative, less tied to rule books and would have phased, as the Baroque did in Europe, into the Rococo with all that style's delight in figurative decorative forms and an eclectic play with exotic borrowings from the Chinese, the Turkish and the Gothick. The actual term 'Rococo' would not be devised, mockingly, until the nineteenth century, but certainly from at least 1720 onwards there was a lively experimental groundswell in European art bringing in historical, geographical and botanical awareness under a gently controlling classical discipline.[1] Dublin with its Catholic, francophile craftsmen, had responded to that creative surge with superb plasterwork; London, for the most part, confined its interior decoration to conventional mouldings and designs which would not have surprised Inigo Jones and John Webb a hundred years earlier. Palladian ornament is stylized, a series of visual clichés. The vocabulary of the average eighteenth-century poet is equally predictable; but as Rococo decoration aims at accurate figurative representation, so a Rococo poet like Chatterton aims at a fresh verbal evocation of things physically explained:

> Ynn daiseyd mantels ys the mountayne dyghte;
> The nesh yonge coweslepe bendeth wyth the dewe;
> The trees enlefed, yntoe Heavenne straughte,
> Whenn gentle wyndes doe blowe, to whestlyng dynne ys brought. (CW, 186)[2]

Chatterton's medieval Bristowe decisively breaks with the classical, capturing the errant romance of paladins rather than the Palladian; such escapism is a quintessential *leitmotif* of the Rococo.

To describe Bristol as a Rococo city is a generalisation, but a justifiable one. It lacked the constraints of Court or of an aristocracy gathered about Parliament. Bristol's ruling class

was merely merchant, cheerfully corrupt, notoriously drunken, generally under-educated, absurdly proud of the bland, brick façades of Queen Square and content to muddle through architecturally with a confusion of clapped-out Baroque, as in the Redland Chapel, exquisite Rococo refinements, as in the interiors of the Royal Fort, and amateurish Gothick revival as in the trilobal Blaise Castle at Henbury.[3] Compared, however, with other English industrial cities, Bristol had, and retains even now after a century of profligate clearances, enough Rococo work to justify that Rococo title and to claim an unusual mid-eighteenth-century openness to eclectic influences.

Bristol Corporation's dalliance with the Palladian in the years 1741-3 illustrates the determination and ingenuity with which a Rococo-inclined city building establishment fought back against the alien style and that much disliked sister city nine miles up the newly canalized Avon. William Halfpenny had, for several years, been offering the Corporation various elephantine and inappropriate schemes for a new Corn Exchange with odd domes and over-ingenious cupolas.[4] But William Jefferies, an architectural sophisticate on the Corporation's Exchange Committee, had obtained a copy of the design prepared by the arch Palladian, Isaac Ware, for London's Mansion House. This he showed his fellow committee members to demonstrate what truly fashionable architecture looked like and what, therefore, a forward-looking city should be building instead of half-baked, semi-Baroque abominations from the pen of Halfpenny.

Convinced, but eager to avoid the high fees of a London architect, the Committee offered the job in 1740 to John Wood the Elder of Bath.[5] At that time Wood's Druidic-inspired King's Circus was nothing more than an ambitious notion, so the Committee members would not have known what eclectic Rococo ideas were brewing in the mind of a celebrated architect for the Palladian. A visit from the London-based architect George Dance, who actually got the contract to design London's Mansion House, was cancelled. Wood was interviewed on February 6 1741, asked to form designs and delivered them a mere seven days later. More disturbingly for Bristol builders, the most important contract for the building work, that for fine masonry, also went to Bath. William Biggs tendered to do the work for £1,967, underbidding the Bristol Paty firm, which had confidently expected the contract; Bristol was awarded the rough masonry and the carpentry. William Halfpenny got nothing, but in 1742 was asked, perhaps as a consolation, to supervise the final stages of the Redland Chapel construction for a miserly £12 a year. He rewarded an ungrateful city by devising a charming Rococo dome of individual distinction to cap the Chapel, and embellished the outside wall of the ritual east end with the heads of turbanned Moors. Whether this was intended to represent Bristol's slave trade was not made clear, but it was certainly an eclectic gesture appropriate to the mood of the city, though hardly to a Christian church.

The Royal Fort, Bristol: Rococo decoration in Eating Room. [photo: Gordon Kelsey]

Meanwhile in Corn Street war was being waged quietly at the Exchange between Palladian and Rococo building teams. The Bristol rough masons built the foundation arches, but one of these promptly collapsed, and when Captain Foy, Bristol's supervising agent, went climbing on the scaffolding, one of the Bath masons boasted in a pub: 'we will have the Captain off too 'ere long'. Warned about these threats by his men, Wood claimed that his best workers had been so abused and threatened in Bristol ale houses that they 'had rather starve here than go to Bristol again'.[6] Murder was, however, avoided, Wood was paid his 5% commission and the Exchange was opened with much pomp on September 21 1743 at a cost of £56,352. Wood's name was not even mentioned in the congratulatory speeches, so Wood published his own poem, stating the Palladian, as opposed to the Rococo, case:

See, see at length the finish'd Structure rise
A Structure that with Gresham's Labours vies!
A stately Pile by publick Spirit plann'd
Politely finish'd – regularly Grand
With striking Beauties how it charms our Eyes!

The Royal Fort, Bristol: Rococo decoration in Stair-Hall. [photo: Gordon Kelsey]

A Roman Structure gracing British Skies!

Each Beauty blended in a fine Design

Such art Palladio – and such Jones – was thine!

And such is Wood's – who rear'd this spacious Dome

A finish'd Wonder for each Age to come.[7]

Chatterton's *Parlyamente of Sprytes* emulates the spirit of Wood's praise since here Canynge's gift to posterity, St Mary Redcliffe, is depicted in pseudo-medieval diction as a Bristol wonder: 'Arches ande the Carvellynge,/ And Pyllars theyre Greene Heades to Heaven rearynge…The Glorie and the Wonder of the Lande'. (CW, 112-114)

The Patys, James and Thomas, builders with a long tradition in the city of ornate

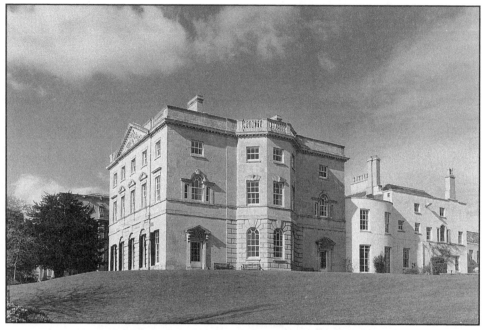

The Royal Fort exterior: an eclectic hedging of bets. [photo: Gordon Kelsey]

Baroque to Rococo design, struck back cleverly. Wood's principal façade to Corn Street is certainly a correct, if rather tame and watery, Palladian design; but Thomas Paty somehow ensured that a whole row of figurative carving, more grotesque than classical, with beast heads and monsters, challenges the strictly correct Palladian enrichments of the elevation below. Then the Patys' real Rococo master riposte was delivered in the open market square behind the show front. In each of the tympana over three of its entrance arches is a carved display representing the continents. Each one is entirely figurative and wholly un-classical: crocodiles, camels, savage Indians, bison and wild animals riot in a triumph of eclectic reference. If John Wood ever saw the Paty work his reactions were not recorded. Neither Palladio nor Jones is likely to have approved.

In the mid-1740s, therefore, the battle of styles was being waged in the West Country, with the confident rule-book Palladian of Bath on one side, the uncertain but figuratively decorative late Baroque of Bristol on the other. The perfect paradigm of this stylistic uncertainty is still poised, high up above the city: the Royal Fort, Thomas Tyndall's villa.[8] It is a house gloriously and playfully Rococo within. Squirrels scamper on its ceilings; its Eating Room has a carved doorcase with be-vined Corinthian columns and a rustic painted over-door panel that Paris would not disown; islands of Gothick and Chinoiserie rocaille float along the vine trails of its stair-hall walls, a marble shepherd and shepherdess flank its

Drawing Room chimneypiece, while Chinese ho-ho birds crane their long necks on the ceiling above. Outside its steep lawns set off three fronts, all built at the same time in a considered competitive scheme, following three distinct styles by three separate architects, an archetypal eclectic hedging of bets. The entrance front is stodgily Baroque, the south façade is pure Palladian revival, and the garden front has the canted bay of the Rococo with carved female heads of seductive French elegance on the keystones of the *piano nobile* windows.

There is clear contemporary evidence that the Fort was not designed solely by the model builder, James Bridges, but was a joint effort and an eclectic experiment that succeeded brilliantly. A contemporary poem states that the merchant owner, Thomas Tyndall,

For Aid, he, Jones – Palladio – Vanbrough viewed;

Or Wallis, Bridges, Patty's Plans pursued;

No Matter which, the Fabric soon uprose,

And all its various Beauties did disclose.[9]

Bridges merely tied all three designs into a wooden model, which survives in the Fort, and the Patys contracted to build the house.

There is a reluctance to recognise the complexity of styles in this middle of the century. Tour guides and most written accounts of Bath still insist that the King's Circus in that city is what Smollett jokingly referred to as 'Vespasian's amphitheatre turned outside in', despite its being conceived by Wood as one of the pre-historic or, as he put it, 'Druidic', stone circles at Stanton Drew, with symbolic Druidic acorns perched on its roof-line instead of the usual classical urns or pineapples. The King's Circus is an instance of Rococo eclecticism, an antiquary's awareness of past history, intruding into the very heart of 'Palladian' Bath. Wood believed that he was recreating, not a Roman but a pre-Roman, Celtic metropolis.[10] England was becoming more subtle in reference.

Chatterton revelled in exactly the same Druidic 'Gothick' nonsense with his *Elegy, written at Stanton-Drew*:

Ye dreary Altars by whose Side,

The Druid Priest, in Crimson dyed,

The solemn Dirges sung,

And drove the golden knife

Into the palpitating Seat of Life.

When rent with horrid shoutes, the distant vallies ring,

The bleeding body bends,

The glowing purple stream ascends. (CW, 379)

There is this temptation in commentators to see the eighteenth century as Lord Burlington and Alexander Pope projected it: as Augustan, Roman, masculine and severe,

when the reality was an eclectic excitement of new awareness, historical, geographical and scientific. It is imprecise to describe Chatterton as a 'Rococo Poet', but it is more accurate than to describe him as a 'proto-Romantic.' The eclectic furore of the Rococo was all around him in Bristol as he wrote, moving easily from pastoral love lyrics of casual insincerity to knightly deeds of historic improbability. High Romanticism was still thirty years ahead, though Wordsworth and Keats would have little in common to justify their being bracketed within the same literary movement. The Latin-despising Keats was Chatterton reborn, a late Rococo poet, not a Romantic. Chatterton's absorption in the monkish identity of Thomas Rowley, an eclectic fantasy, was an anticipation of Keats's negative capability: the trick of entering into other identities and imaginatively recreating their life experiences and their sensibility. But so, in a minor key, was any Rococo park owner's building of a Chinese kiosk, a Turkish tent or a Gothick chapel. In all these cases there is a sympathetic reaching out, a curiosity about other lives and alien environments. When the Quaker brass-founder, William Reeve of Arno's Vale, reared up in 1764 a sinister Black Castle of gleaming indus-trial slag as a place for the entertainment of his friends, he was only living out in three dimensions a Rococo fantasy escape into second-hand violence like that which Chatterton achieved in poetry with his *AELLA, A Tragycal Enterlude, or Discoorseynge Tragedie*, composed in the same year:

> Aella, a javelynne grypped up eyther honed,
> Flyes to the thronge, and doomes two Dacyannes deadde.
> After hys acte, the armie all yspedde;
> Fromm everich on anmyssynge javlynnes flewe;
> Theie straughte yer doughtie swerdes; the foemen bledde. (CW, 208)

Chatterton is reborn as Keats when in the 'The Minstrels Roundelay' from the same poem the 'Autumpne' scene with its 'fayre apple, rudde as even skie,/ Do bende the tree unto the fructyle grounde;/ When joice peres, and berries of black die,/ Doe daunce in ayre' (CW, 186) becomes plumped as the timeless suburban topography of *To Autumn*: 'To bend with apples…And fill all fruit with ripeness to the core; to swell the gourd.'

In those years immediately after Chatterton's grubby suicide he had become a posthu-mous iconic figure and researchers were eagerly interviewing the poet's living associates. That was how Dean Jeremiah Milles, preparing for his 1781 *Poems….by Thomas Rowley*, got from James Thistlethwaite, who had known Chatterton in 1768-9, an account of him that captures perfectly the eclectic excitement of a Bristol-reared adolescent. Here is a boy rang-ing around, mentally undisciplined, open to everything except, significantly, the convention-al classical diet of Homer, Virgil, Horace, Troy, Athens and Rome:

One day he might be found busily employed in the study of Heraldry and English Antiquities,

both of which are numbered amongst the most favourite of his pursuits; the next, discovered him deeply engaged, confounded, and perplexed, amidst the subtleties of metaphysical disquisition, or lost and bewildered in the abstruse labyrinth of mathematical researches; and these in an instant again neglected and thrown aside to make room for astronomy and music, of both of which sciences his knowledge was entirely confined to theory. Even physic was not without charm to allure his imagination.[11]

While the Royal Fort most notably exemplifies this free flow of images, the social world of Thomas and Alicia Tyndall would have been quite out of Chatterton's reach. His true environment, once he had scraped up an acquaintance with the seedy old gentlemen antiquaries who encouraged him, would have been closer to that still preserved behind the dull classical façade of 15 Orchard Street, a house belonging at that time to John Worsley. There were twenty-seven plasterers listed in Sketchley's *Directory* for 1775, but Joseph Thomas of Guinea Street in Redcliffe is most likely to have effected the magical transformation of the walls to its stair-hall into a world of bucolic fantasy.

Whoever designed and modelled it, he relied, like the Paty team which decorated the

15 Orchard Street, Bristol: transformed by its plaster-work into a world of bucolic fantasy. [photo: Gordon Kelsey]

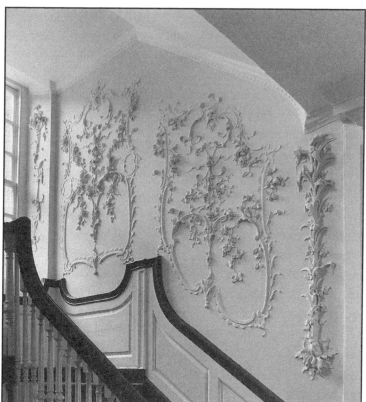

Royal Fort, on the designs of Thomas Johnson's *One Hundred and Fifty New Designs*, published in 1758, the year when the Fort was begun. But he added a creative escape from mere pattern into figurative narrative. One panel up the stairs is all fruit and flowers accurately moulded. Then, in the next panel, fork-tailed dragons peck at peaches, and further on up a wistful mandarin with a hat of leaves is entwined within the S and C scrolls characteristic of the Rococo's escape from hard Palladian geometry. Towards the top and the servants' attics the invention thins down to a few birds.

This was not high art. It was something more important. Beauty was becoming a common and accessible domestic property of the lower middle class, the solicitors and pewterers, the Burgums, Catcotts, Greens and Lamberts: Chatterton's puzzled admirers. If plasterers could borrow images and then diversify them, then so could an adolescent poet whose writings were all essentially borrowings that had been enhanced and manipulated. Joseph Thomas the plasterer manipulated the designs of Thomas Johnson and Timothy Lightoler; Thomas Chatterton manipulated the vocabularies of Speight's 1598 and 1602 editions of Chaucer. Both manipulations were part of this new Rococo freedom to borrow: an imaginative world was expanding, irreverently and cheerfully. Palladianism was classicism with a nervous concern for accuracy, a pathetic need to conform to rules; the Rococo was a confident wide-ranging naturalism with a smiling face. It was England's loss that anti-Gallicanism held the country back from any wholesale adoption of a style too clearly associated with France, the old enemy.

That Bristol's Quaker industrial entrepreneurs should have been exempt from such stylistic inhibitions made no kind of religious sense. They should have been mortally suspicious of the art forms of Catholic Europe, but possibly their familiarity with foreign markets and their dependence on them could have modified the Puritan outlook. What is so characteristically Bristolian is that these brass and copper founders, who were filling the air with noxious fumes and poisoning the earth of Warmley and Brislington with the effluents of their furnaces, were at the same time copying the Rococo gardens of neighbouring Wiltshire parks like Stourhead, Wardour and Fonthill and turning their own modest gardens and even their factory premises into little Rococo parodies of eclectic fantasy.[12] This shows how natural to Bristol thinking at this period the escape to eclecticism had become. Chatterton's retreat into the fifteenth century, Saxon England, the Druid past or Africa was only a reflection of the activities of the industrialists who had made Bristol into England's second city.

William Reeve and William Champion both brought their smelting and general metallurgical expertise to the Avon valley above Bristol in the 1740s, Reeve probably a few years before Champion, who set up his Warmley manufactory in 1749. Both men were Quakers and both went resoundingly bankrupt, but only after becoming in the late 1750s and 1760s,

Chatterton's decades, the eighteenth-century equivalents of millionaires.

Reeve's factories were at Crew's Hole, where the very earth is still stained and ominous from his activities, and he was essentially a 'hands-on' operator, supervising his huge work-force every day. He had settled on an old house, Arno's Court, in Brislington, where his first building venture was a relatively sober classical affair fronting earlier premises with the double-canted bays of standard Rococo practice following the lead of Sir Robert Taylor's villas. Mount Pleasant, as he renamed it, has a charming former Drawing Room with Bristol's Dublin-inspired plasterwork. Pheasants fly the ceiling among naturalistic rose wreaths, while ducks on the wing twist their necks to look down upon the family. At a date unknown Reeve became dissatisfied with the classical propriety of the fenestration and commissioned the Paty firm to apply a more stimulating Gothick mask to his front porch and windows, like some old dowager opting for a face-lift late in life. The stalactitic rustication and thin ogee arches were the architectural equivalents of Chatterton's tortuous 'medieval' spelling applied to the normal vocabulary of eighteenth-century verse, as in:'Lycke prymrose, droopynge wythe the heavie rayne,/ Laste nyghte I left her droopynge wythe her wiere' (CW, 223).

The rooms of the house were far too small for celebrations with the firm's employees, and Reeve was having a problem each evening, coming back home from his factory covered in soot and grime. His Black Castle, complete with dining hall, stables and, oddly, a chapel, created the required leisure centre. From the curious 'termany' figures set around the gate and the inner courtyard, the Castle was probably designed by the Halfpennys, father and

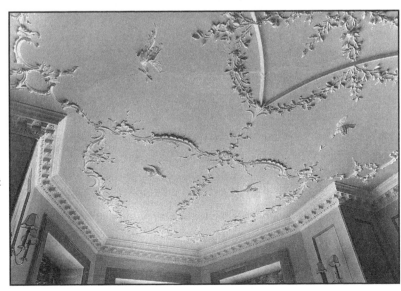

Rococo fantasy at William Reeve's Arno's Court, Brislington. [photo: Gordon Kelsey]

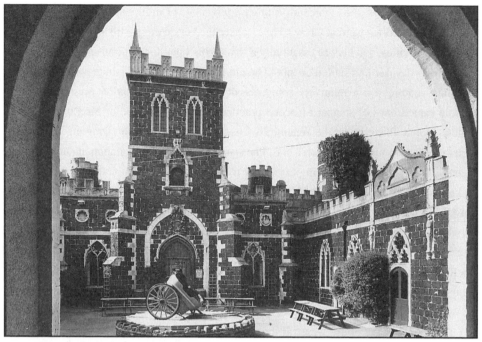

William Reeve's Black Castle, Brislington: a visual counterpoint to Chatterton's literary concoctions.
[photo: Gordon Kelsey]

son, who should be seen as performing for the city's architecture what Chatterton provided for its literary enrichment. With his thirst quenched at the factory's club room, Reeve then needed to wash before dining with his wife and family. The part-Moorish, part-Chinese, part-Gothick Bath House which the Patys built for him between the Castle and Mount Pleasant satisfied that problem. It was an enchantingly elaborate conceit which Bristol should never have lost to Clough Williams-Ellis and Portmeirion, but at least the Gothick colonnade still survives. It provided an ante-room, a changing room and a long octagonal plunge pool lit by two octagonal roof lanterns.[13] Chinese Rococo plasterwork with dolphins, shells and water gods made a fantasy event out of Reeves's daily dip. A Gothick gateway with statues, saved from the demolitons in the expanding city, created an entirely inappropriate but entertaining entry to the pleasure complex.

This fantasy Rococifying of factory premises went even further in William Champion's brass and spelter works at Warmley, further up the Avon valley. There Champion employed a workforce of 2,000 and had attracted substantial investments from Norborne Berkeley of Stoke Park House. It was almost standard practice for an eclectic garden layout like Fonthill Park to have grottoes as places where picnics with moody shadows could be held.[14] Champion went one further. His factory was running short of water supplies, even though

he had dammed the local brook to create a reservoir. What was needed was a pumping engine to return the water to its source. The engine was installed in an underground cellar beneath his house, but to give it a Gothick character he had the arch leading to the engine room turned into a monster's gaping mouth.

That was only the beginning to the gardening of the works site. On an island in the middle of the reservoir Champion had a giant, twenty-five foot statue of Neptune erected, brandishing a trident. The god has survived the reservoir and now stands even more theatrically in a big bramble bush near a mobile home park. He has the true 'rocaille' character of the Rococo period as his mantle and very brief loincloth are composed of the rough black clinker from the smelting works. It creates a sharp contrast with the chalky plaster of Neptune's bare flesh. As an additional garden feature Champion had the smaller reservoir dug to receive the recycled water; this is shaped with a curving wall of Pennant stone topped with smooth black slag blocks into an Echo Pond, a feature common in French gardens of the seventeenth century, but a rare refinement in an eighteenth-century factory complex. Unlike Reeve, William Champion was content to actually live in a plain, but handsome classical villa with no fancy dress of ogee-arched Gothick. Serving now as an attractive old people's home, it overlooks an atmospheric area of grassy mounds, causeways, broken walls starred with clusters of gleaming slag, a ruined sluice house and, of course, the Warmley Giant.

To visit Warmley is to understand Chatterton's world in one telling lesson. His Bristol was quite unlike the present genteel city. It was an industrial hell hole, Horace Walpole's 'the dirtiest great shop I ever saw.'[15] 'The best image I can give you of it,' Alexander Pope wrote to Martha Blount in 1739, 'Tis as if Wapping and Southwark were ten-times as big, or all their people run into London.'[16] But isolated in that noisy, smoke-steeped, semi-slum stood surrealist reminders of a gentler past, merchant houses in timber-carved decay, complex spires and ornate city gates. The squalor of the present made retreats into fantasy an imaginative necessity, and for citizens with an antiquarian bent those surviving relics of an historic past suggested what direction those retreats should take: Gothic and pastoral combined, as in Chatterton's verse and William Champion's garden.

It is only speculation, based upon stylistic similarities, but it seems more than probable that Thomas Wright, popular science lecturer, astronomer and garden designer, had a hand in the creation of the Warmley Giant.[17] He was a close friend of Norborne Berkeley, with his own apartment at Stoke Park, the battlements of which he had designed. Berkeley had invested heavily in Champion's enterprises and Champion's Giant has that rough ragged quality that distinguishes the grottoes and arbours of Wright's publications of this period.

Cote House, which stood until the 1920s on the far side of the Downs, was another of these fantasy escapes, a delightful complex of classical symmetry, but achieved in ogee-

Eighteenth-century Blaise Castle: fake medievalism in Henbury.
[photo: Gordon Kelsey]

arched Gothick doors and windows.[18] At Henbury, in the northern suburbs, Thomas Farr built in 1766 that trilobal Gothic tower, Blaise Castle, to house a big steam pump with which he hoped, vainly, to create a lake in the unwelcoming strata of the valley below. To give again that sense of light-hearted theatre, which so often accompanies the Rococo, he built next to it a terrace for guns, setting off, to entertain his friends, a roar of cannon to rouse the

echoes across the Avon and achieve on a grand, vulgar scale what Champion had achieved with song and flute music from his Echo Pond.[19]

There was a real poetry in the Bristol Rococo, not Chatterton's only, but in the image of that trilobal castle in its forest clearing, and in the childish gusto of those resounding cannon shots. It was too earthy and immediate to be described as Romantic, too unscholarly for its evocations to be taken seriously. Like the faked medievalism in Spenser's *Faerie Queene* – hermits, wicked witches, enchantresses sailing in small boats – Bristol's Rococo emanations were charming toys, its gestures were deliciously absurd. The ladies of the Goldney family worked from 1737 to 1764 from their Goldney House in Clifton, a staid 1722 structure of homely classicism, to create in their garden a grotto so different in spirit to the house they lived in, so unlike the image usually associated with Quakers – sober simplicity and the avoidance of graven images – that it is hard to think of it as anything less than a deliberate escape mechanism from tedium and understatement. This underground chapel to mystery and delight is a concentration of glittering rocaille work, every wall and crevice alive with rare minerals and sharp crystals of spar. A lion and lioness lurk in a dark cave with the prophet Daniel as their excuse. The pagan god Neptune presides over a miniature cascade which runs at the turn of a hidden tap, galaxies of large sea shells shine on the walls and in the basin below the cascade. Classical columns of glittering 'Bristol Diamonds' support a rocky vault. Could the pious Quaker ladies who patiently pieced and mortared it together over the reach of two generations have been worshipping and enshrining anything less than the lovely wonder of creation, that natural variety and prodigy of endowments which is behind so much Rococo art? It is all an innocent toy of praise from a religious sect robbed by their own doctrines of the usual rituals and church buildings that express devotion for other Christians. This thread of Quakerism runs very strongly through the Bristol Rococo; too strongly to be dismissed as coincidental.

To the side of this temple to Rococo expression a back passage curls out into a little hidden dell and there a slim Gothick viewing tower rears up from a terrace where the demi-god Hercules raises his club with some effort. At the other end is a fanciful Gothick gazebo with ogee-arched windows, eclectic enough in itself, but when it was first built in 1757 it was surrounded by a circlet of classical columns: a declaration of eclectic uncertainty even more perverse than those three façades to the Royal Fort.[20]

There was something of the same stylistic trickery, a playful hedging of bets, in the alterations which Norborne Berkeley and his friend Thomas Wright effected at Stoke Park in the happy years before Berkeley was ruined financially by his investments in William Champion's enterprises at Warmley.[21] The original Tudor manor house with its ridged and gabled roofline was retained, but covered over with a battlemented shell. A loggia of

Gothick columns taken from Batty Langley's 1741-2 volume of helpful hints for would-be antiquaries, *Ancient Architecture Restored and Improved*, was built as an entrance feature. Inside the house two reception rooms retain their Rococo ceilings of flowers and conventional baskets of fruit. This is one of the few instances where Thomas Stocking is documented as having done the plasterwork, though local legend credits him with virtually all Bristol's Rococo interiors.

Bankruptcy seems the appropriate fate for these wholehearted enthusiasts of the Rococo; there is something so escapist and impractical in their Gothick castles, Moorish plunge pools, engine room grottoes and half-naked giants. Reeve and Champion both fell into financial ruin, but Norborne Berkeley, being a member of the Whig establishment, had a more fortunate resolution. No one had taken him very seriously in Court circles. He was a bachelor and there was something innately ridiculous in his antiquarian scavenging through old records to find that he had the right to revive a dormant peerage and call himself the 20th Baron Botetourt. That in itself reads like an upper-class realisation of Chatterton's projection of himself as a fifteenth-century monk; while the newly created Botetourt's escapade of stowing away on a troop ship to join Pitt the Elder's disastrous expedition to St Malo was again an eighteenth-century version of one of Chatterton's knightly deeds of hopeless gallantry. His reward was to be rescued from financial distress by being appointed Governor of Virginia with a good income and a small palace to live in at Georgetown. Predictably, he took to life on an almost wild frontier like the proverbial duck to water, finding himself surrounded by all those flowering shrubs and trees which he had been planting as exotics in the grounds of Stoke Park. His death from typhoid in 1770 saved him from the problems of the American Revolution and coincided aptly with the virtual end of the Rococo in England.

It would be wrong to leave this stylistic episode on a mocking note. Chatterton could, from time to time, break through his eclectic borrowings from old chronicles and John Kersey's 1708 *Dictionarium Anglo-Britannicum* gleanings, to produce passages of sensitive verse, as in *An Excelente Balade of Charitie*, 'as wroten bie the gode priest, Thomas Rowley':

In Virgyne the sweltrie sun 'gan sheene,
And hotte upon the mees did caste his raie;
The apple rodded from its palie greene,
And the mole peare did bende the leafy spraie;
The peede chelandri sunge the livelong daie;
'Twas now the pride, the manhode of the yeare,
And eke the grounde was dighte in its mose defte aumere. (CW, 644)

In the same way, the charming, mildly ridiculous garden buildings of the Rococo broke

The Orangery, Frampton Court: playful, gracious, but quite unauthentic rehandling of medieval details.
[photo: Gordon Kelsey]

through their absurd pastiche to achieve buildings of haunting beauty. One such, the Orangery at Frampton Court, was built for a Bristol Revenue Officer, Richard Clutterbuck, another of these Rococo bachelors, probably, though not certainly, by William Halfpenny in the late 1740s. As satisfying in its modest octagonal activity, as a world renowned tourist attraction like the Taj Mahal, its stands at the head of a straight canal from which steps rise up to the exquisitely panelled ogee entrance door. The two canted bays of its front are alive with thirteen windows, all ogee-topped, hexagonally glazed and lending the façade an unbroken ripple of movement by their insistent curves. Behind them a third octagon rises, a little staircase tower with pie-crust battlements like those on the canted bays and topped again by an even smaller octagonal lantern. While proclaiming in every line that it is of eighteenth-century classical symmetry, it pretends in every one of its Batty Langley quotations to be of the Middle Ages. William Halfpenny died in 1755, when Thomas Chatterton was only three years old, but this would seem Halfpenny's foreshadowing of the *Excelente Balade of Charitie*. Rococo-Gothick architecture is working as Chatterton's Rococo-Gothick poetry works: by a playful, gracious, quite unauthentic rehandling of medieval details.

Romantic Redcliffe: Image and Imagination

3 MICHAEL LIVERSIDGE

A group of watercolours painted around 1800 by Turner, Girtin, Cotman and Varley portraying St Mary Redcliffe represent the church and its setting transfigured by powerfully imaginative and intensely poetic responses. Atmospherically charged and heightened by an exceptional sensibility towards its historic associations and picturesque, antiquarian interest, they differ from conventional topographical views in their singular evocation of a place with particular, and particularly, romantic overtones. This essay sets these images in context, and suggests that each of the artists involved responded to St. Mary Redcliffe in the way they did at least in part because they were consciously aware of its connections with Thomas Chatterton. By exploring their imaginative treatment of the church, its location and architectural presence alongside their links to patrons and others with an interest in Chatterton – among them the bookseller James Norton, the antiquary John Britton and the poet Robert Southey – the 'presence' of Chatterton within this group of pictures can be argued as an inspiring element in each artist's response to the subject. Drawing as well on contemporary influences such as Archibald Alison's theories of association, a major source informing ideas about historic sites at the turn of the century, and the development of 'poetical and historical' landscape among the artists who belonged to the Sketching Society at the time (who included Thomas Girtin, John Sell Cotman and John Varley), my essay interprets this group of pictures from a fresh perspective.

Windows feature prominently in the iconography of Thomas Chatterton's life and death as it was imagined by Victorian painters. In *The Death of Chatterton* by Henry Wallis[1] (Figure 1) the eerily pale light that illuminates the room and plays over the body of the dead poet, evoking the tragedy of the scene, comes through an open window above the deathbed which allows the viewer to glimpse the distant but immediately recognisable London skyline dominated by the silhouetted dome of St Paul's Cathedral. The topography locates the scene, and serves to remind the viewer of Chatterton's despair at his failure to attract the success and support he had sought in London's literary world. It presents a cold and distant, alienating sight which is the site of Chatterton's rejection and destruction; the topography is essential to the historical biography the picture narrates, particularising and identifying the subject of Henry Wallis's 1856 Royal Academy success. The window is symbolic in another way, too. It is open, alluding to an older iconographic tradition that the soul of the departed, no longer confined by the physical constraints of mortal existence, has been released from its earthly imprisonment – in death the poet's genius, cruelly incarcerated in life, is immortally liberated.

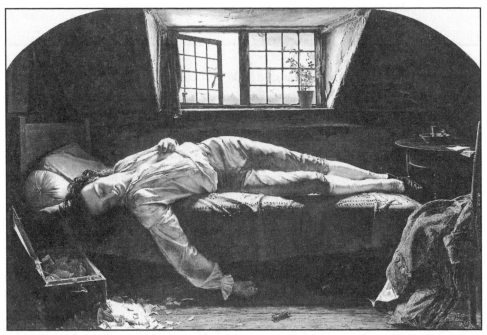

Fig.1 Henry Wallis *The Death of Chatterton*, 1855-56. Oil on canvas. [Tate Britain]

Windows, and the light that shines through them, can also serve as symbols of illumination and inspiration. Both R.J. Lewis in his 1846 *Thomas Chatterton composing the Rowleian Manuscripts*[2] (Figure 2) and Henrietta Ward in her *Thomas Chatterton in 1765*[3] (Figure 3) shown to popular acclaim at the Royal Academy in 1873, use a window and the view through it to give historical accuracy to their pictures and to suggest in the way the light is manipulated the luminous nature of inspired genius and literary invention. Both artists have carefully represented through the window the distinctive outline of St Mary Redcliffe's tower and truncated spire, thereby identifying and specifying the source of Chatterton's inspiration. In their pictures Lewis and Ward remind the viewer that St Mary Redcliffe acquired by association with Thomas Chatterton its own singular resonance as a Romantic monument. As one recent account of the church and its history puts it, 'If one tries…to identify what it is about St Mary Redcliffe that gives it such a reputation, one is forced, perhaps a little unwillingly, to admit that this reputation was greatly stimulated by the impact of Chatterton's writings on subsequent generations.'[4] Might it also be argued that it was the Chatterton association that inspired a small group of unusually powerful, romantically charged views of St Mary Redcliffe remarkable for their originality painted by Thomas Girtin, John Sell Cotman and John Varley between 1800 and 1805?

To appreciate how remarkable and exceptional these views are, it is necessary first to

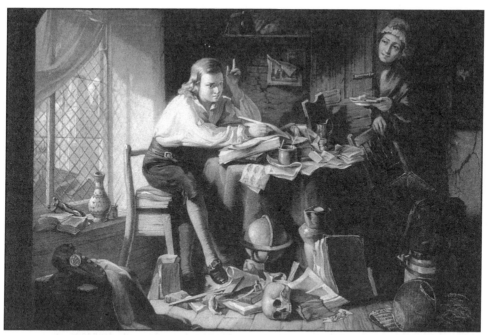

Fig.2 Engraving after Richard Jeffreys Lewis *Thomas Chatterton composing the Rowleian Manuscripts*, 1846. [Bristol Museums & Art Gallery M3015]

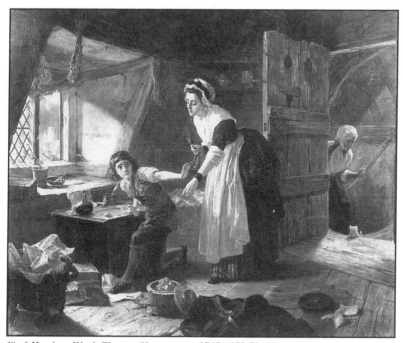

Fig.3 Henrietta Ward *Thomas Chatterton in 1765*, 1872-73. Oil on canvas. [Bristol Museums & Art Gallery K172]

consider how St Mary Redcliffe is conventionally represented in the standard kind of archi-tectural or antiquarian illustrations of the period. Two examples are typical of the general category. E.H. Locker's crisply drawn and elegantly tinted view of the church from the south-west done in 1800 gives a precise account of the architecture, neatly recording its Perpendicular Gothic details with matter-of-fact accuracy (Figure 4).[5] Likewise, in 1826, the Bristol artist T.L. Rowbotham describes the view from the north-east in outline with delicate washes of watercolour (Figure 5).[6] Drawings like these, often with the addition of picturesque incidental details to enliven the scene, are primarily concerned with enumerating the partic-ulars of St Mary Redcliffe as a medieval antiquity. While it is certainly the case that views of St Mary Redcliffe are much more numerous from the 1790s, perhaps suggesting that more people were interested in it because it had become more celebrated in the aftermath of the Chatterton controversies, there is nothing distinctive about them that differentiates them from the commonplace topographical drawings and paintings of the time.

One possible early exception to the generally unremarkable portrayal of St Mary Redcliffe might be J.M.W. Turner's picturesquely conceived, but more dramatically present-ed and individually composed, watercolour of the tower and south porch from the church-yard, taken from a viewpoint close to the corner buttress of the south transept (Figure 6).[7] This is a tour-de-force of perspective in which Turner captures the grandeur and scale of the

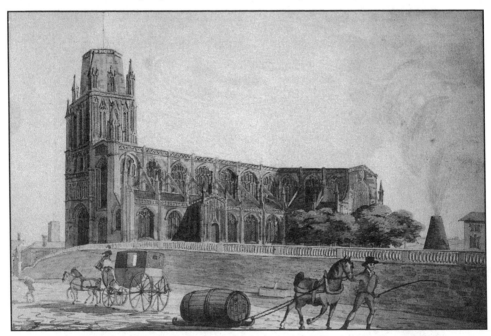

Fig.4 Edward Hawke Locker *St Mary Redcliffe from the south-west*, 1800. Pencil and watercolour. [Bristol Museums & Art Gallery]

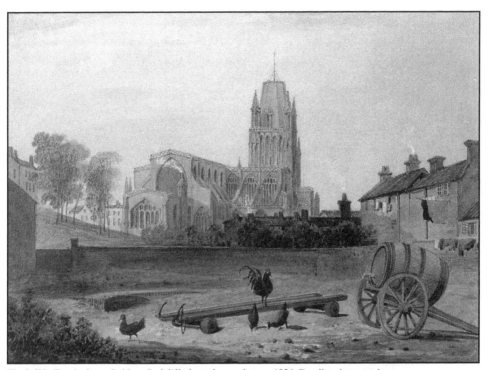

Fig.5 T.L. Rowbotham *St Mary Redcliffe from the north-east*, 1826. Pencil and watercolour.
[Bristol Museums & Art Gallery]

building so much more emphatically than anyone else before him. While these qualities are by no means unique to Turner's *St Mary Redcliffe* in his *oeuvre* at the time, it is, in fact, typical of the way he was reinvigorating the treatment of architectural subjects and topographical drawing. Is it perhaps just possible that the choice of subject had some special significance for him when he made the drawing in 1792? When he painted this picture Turner was the same age that Chatterton had been when he died. It may not be altogether fanciful to think that Turner would have been drawn to it by the coincidence. He had stayed in Bristol more than once before 1792. Hence, it is inconceivable that he would not have known Chatterton's story.[8] Indeed, there may be distant echoes of the poet's imagined life and legend present in a picture he painted some years later on the theme of despair and neglected genius, his 1809 *Garreteer's Petition* (Figure 7).[9] From very early on in his career, Turner was acutely conscious of the historical and human associations evoked in the remains of the past and the places he painted, and Redcliffe's connections with Chatterton may have prompted him to produce what is for its date a striking and ambitious composition.[10]

Turner's 1792 watercolour is conceived in the idiom of the picturesque topographical drawing of the late-eighteenth century. The views by Girtin, Cotman and Varley (Figures 8,

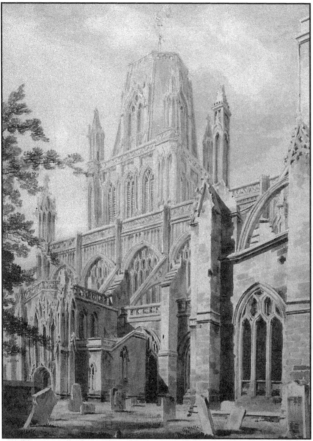

Fig.6 J.M.W. Turner
South Porch of St Mary Redcliffe,
1792.
[Bristol Museums & Art Gallery]

9, 10)[11] by contrast are more visually expressive, exploiting atmosphere and effect to conjure from the subject a different quality and register of response by evoking sensation and mood. They interpret rather than record, imparting a different kind of poetry to the view from the river Avon by means of suggestion rather than description. Of all the views of St Mary Redcliffe, they are the most imaginatively charged and romantically interpreted. In their luminous *chiaroscuro* and visual drama they reflect the impact on English landscape artists at the end of the eighteenth century of Rembrandt's *Mill* (Figure 11) which was brought to London and publicly exhibited when the Orleans Collection was sold after the French Revolution.[12] The painting had a profound effect on a whole generation of English painters who saw it, and it occupies a prominent place as one of the principal pictorial catalysts that influenced the development of Romantic landscape in England.

Thomas Girtin, John Sell Cotman and John Varley each present a distinctly 'modern' rather than antiquarian view of Redcliffe. The shipping and barges in the tidal reach of the

Fig.7 J.M.W. Turner *The Garreteer's Petition*, 1809. Oil on mahogany panel.
[Tate Britain, Clore Gallery for the Turner Collection, London]

Avon (this was before the construction of the Floating Harbour), and the smoking cones of the glass houses fired by the coal extracted from the nearby North Somerset Coalfield, show the contemporary reality of the Redcliffe area as Chatterton knew it: a busy commercial and manufacturing quarter of Bristol, an important site in the early history of the Industrial Revolution in England. Taken as a group they provide relatively early examples of the industrial sublime in English painting. These are among the first images to inaugurate what was to become a familiar iconography for representing progress by contrasting ancient monuments with their modern manufacturing neighbours and the means of trade and transport which brought the nation prosperity. As a symbol of past splendours and romantic history St Mary Redcliffe rises up amidst the commerce and industry of the modern world.

Why, though, should these three artists have chosen this particular subject as the vehicle for such powerfully evocative and expressive Bristol views? Might they have been attracted to St Mary Redcliffe by anything other than its purely pictorial potential? This question raises again the issue of whether their unusually original and romantic Redcliffe scenes may be the products, in some measure at least, of the power of association to affect their choice of this particular subject. The effects with which they invest their views and their visual sensibility are distinctively their own but, in selecting the subject, an interest in or awareness of the connections between the place, Chatterton's romantic reputation, and the vision of its

Fig.8 Thomas Girtin
St Mary Redcliffe,
1800-01.
Pencil and watercolour.
[Bristol Museums & Art
Gallery]

Fig.9 John Sell Cotman
St Mary Redcliffe, Dawn,
1801-02.
Pencil and watercolour.
[Trustees of British
Museum, London]

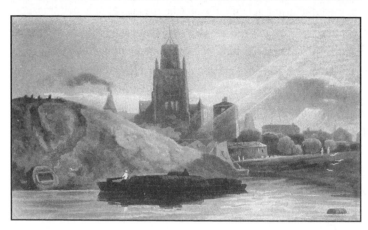

Fig.10 Frederick Christian
Lewis after John Varley
St Mary Redcliffe, 1806.
Aquatint engraving.
[M.J.H. Liversidge]

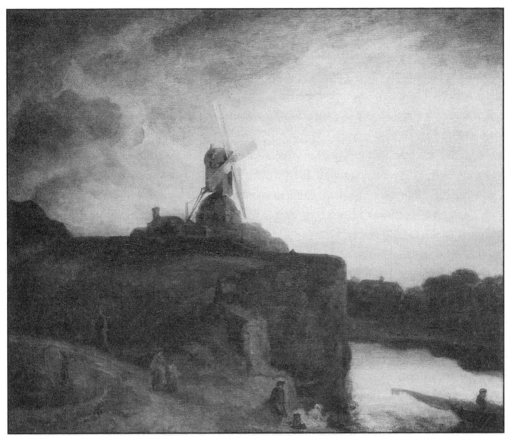

Fig.11 Dutch School, after Rembrandt *The Mill* (original c.1656). Oil on panel. An early accurate copy of the original (National Gallery of Art, Washington). [Norfolk Museum Service (Norwich Castle Museum)]

past which he fabricated may go some way towards explaining the intensity that sets these images apart.

At the end of his life, Thomas Girtin was actively exploring the links between expression, effect, poetry and landscape. In 1799 he was one of the founders of, and for its first two years (until he left England to find relief from the consumption which killed him when he was still only twenty-seven in 1802) the leading figure in, an influential informal London watercolour artists' association, the Sketching Society.[13] Its purpose was to establish 'a school of Historic landscape, the subjects being designs from poetick passages', to which end members met together to compose an imaginary landscape prompted by a text chosen by the host for the occasion. By exercising their imagination, inspired by an eclectic variety of 'poetick passages', the artists sought to enhance the expressive element in their depiction of landscapes and views, putting into practice ideas they had probably derived from

Archibald Alison's hugely influential *Essays on the Nature and Principles of Taste* first published in 1790. Especially, his ideas regarding association in which he discusses the effects produced on the imagination by invoking the cultural associations connected with particular objects or places so that they become transfigured in the viewer's mind, arousing thoughts and emotions that are evocatively suggestive.[14] The results of their experiments, applied to a real place, are apparent in Girtin's *St Mary Redcliffe* which dates from 1800 or 1801 (Figure 8).

John Sell Cotman was another early member of the Sketching Society, and in his case there are literary connections with Bristol which link him directly to circles in which Chatterton's memory was admired. Cotman spent time in Bristol in 1800 when he stayed with the bookseller James Norton. His visit is recorded by a series of portrait drawings of members of the Norton family which are mounted in a copy of William Barrett's notorious 1789 *History and Antiquities of the City of Bristol* in which, of course, Chatterton's Rowley manuscripts feature prominently as sources and for which the historian was roundly ridiculed for his credulity.[15] From this visit Cotman was certainly familiar with, or at least aware of, other Bristol literary figures, notably the poet Robert Southey whom he chose as the author on one of the occasions when he set the subject for a Sketching Society meeting.[16] His *St Mary Redcliffe* composition (Figure 9: there are three versions of essentially the same composition with minor variations in their details)[17] must have been made from a sketch taken in 1800 but is an imaginatively heightened later recollection. Opinions vary as to its date, either 1801 or 1802; the later is stylistically more convincing for the British Museum version, and prompts one to wonder whether it might not be a young painter's tribute to his model of an admired romantic genius marking fifty years since his birth. Perhaps, too, the young Cotman, afflicted throughout his life by bouts of depression, may have been drawn to Chatterton as another artist who had experienced the same acute distress that he encountered intermittently.

John Varley became a member of the Sketching Society in 1802, his first attendance recorded on the very evening that Cotman – Girtin's successor as its principal member and leading light – chose a passage from Robert Southey as the subject for the session.[18] In the summer of 1802, he visited Bristol on his way to Wales, producing from his visit an impressive view of St Mary Redcliffe from the north for the antiquary John Britton (Figure 12).[19] It was engraved in 1802, but not in fact published until 1813 when it appeared as an illustration in Britton's *Beauties of England and Wales*. Britton, because of his local Bristol origins, was a particular admirer of the city's principal medieval antiquity, and was already collecting material for the detailed account of the architecture and history of St Mary Redcliffe, including a full treatment of the Chatterton story, which he also published in 1813.[20] Varley's

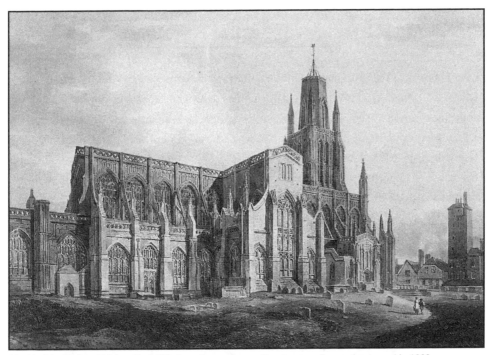

Fig.12 John Varley *St Mary Redcliffe from the north*, pencil and watercolour and engraved in 1802. [Trustees of Victoria and Albert Museum, London]

other early depiction of the church is quite different in character: bold, dramatic and expressive (Figure 10). Engraved with aquatint by F.C. Lewis in 1806, it must derive from studies made by Varley in 1802 worked up into a powerfully romantic image.[21] The aquatint was printed in rich sepia tones; Sketching Society drawings were always done either in grey washes or sepia, and here Varley seems to be deliberately contriving his view to create a 'poetick' scene and 'historical landscape'. While there is no obviously explicit reference in it to Chatterton, his association with the church and the place makes Redcliffe a suitable subject for such an interpretation. 'Romantic Redcliffe' as it is conveyed in these views by Girtin, Cotman and Varley, so different from anybody else's before them (or since), arguably owes its particular artistic expression to Chatterton's reception and reputation among the rising generation of young landscape painters at the turn of the century, an association that may have encouraged these three painters to think of the subject romantically and transfigure it imaginatively into a 'poetical' landscape suggestively uniting ancient and modern in ways that Chatterton exemplified in his life and writing.

4 Dr Viper's Monkey:
Philip Thicknesse and the 'Chatterton Monument'

DR KATHERINE TURNER

On February 15 1790, James Gillray published a satiric etching of a certain Philip Thicknesse, which Gillray's recent cataloguer has described as 'an epic portrayal', and 'one of the most sustained, complex and savage visual attacks ever sustained by a single individual' at the cartoonist's hands.[1] The cartoon was a focal point of the Gillray retrospective at Tate Britain in 2001, somewhat to the surprise of many gallery visitors for whom Philip Thicknesse had not hitherto held a prominent role in eighteenth-century culture. Gillray's composition focuses on the elderly figure of Thicknesse (who was to die in 1792) seated amongst symbolic representations of his numerous activities. These had included literary blackmail, libel, slander, and countless airings of his own dirty linen in public. He is shown being embraced by the filthy muse, Alecto: she unleashes from her head a serpent, whose tongue tips Thicknesse's pen with bile and venom. As contemporary viewers of the print would have known, Thicknesse since the mid-1760s had been publishing a stream of books and pamphlets, on an eclectic range of subjects, and always with an eye to turning a shilling. He had produced treatises on man-midwifery, remedies for gallstones, the virtues of laudanum, and the art of writing in cypher; as well as some more measured travel narratives and guidebooks. His works had also publicised some of his vitriolic personal quarrels with Gainsborough, Bute, and various more obscure individuals (including many members of his own family). In 1790, his recently published *Memoirs* (two volumes in 1788; a third in 1790) had attracted widespread critical attention, and ensured that he was once again in the public eye.

Fully to explicate the iconography of Gillray's monumental cartoon would itself demand a substantial essay (interested readers are referred to Godfrey's account in the Tate Catalogue, though should be suspicious of Godfrey's anti-Thicknesse bias). What concerns us in this context is a detail at the centre of Gillray's cartoon. Just to the right of a small monkey clad in riding garb (who had famously accompanied Thicknesse and his family on a series of continental tours), Gillray depicts an obelisk-shaped memorial on which is shown a skeleton eating an infant who holds a pen and a book. The book is Rowley's *Poems*; and the inscription on the memorial reads 'To the Memory of the Immortal Chatterton who wrote 400 years before he was born – a Stranger erects his Monument'.

By placing this detail at the very centre of his composition, Gillray not only consolidates the accusations of forgery which had always surrounded Thicknesse's own activities, but also taints Chatterton by association, firmly characterising him as another opportunistic

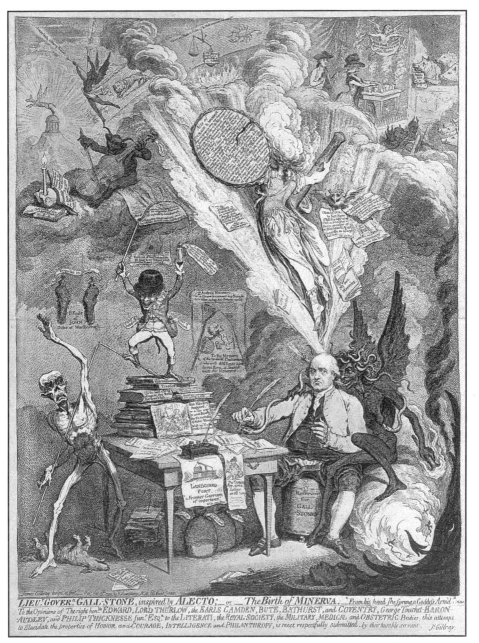

James Gillray's satirical etching of Philip Thicknesse, showing memorial to Thomas Chatterton.
[courtesy: British Museum]

forger (Godfrey suggests that the Chatterton detail may have been suggested to Gillray by George Steevens, a vehement campaigner against forgery who had also influenced the cartoonist's *Shakespeare Sacrificed*).[2]

In fact, the monument which Thicknesse had erected to Chatterton in his garden (long since disappeared) on the outskirts of Bath carefully eschewed any reference to the more controversial aspects of Chatterton's activities, and celebrated his 'genius' in a consciously sentimental fashion.[3] Although Gillray characterises Thicknesse as a vicious fraud, and Chatterton (by association) as a simple forger, the monument itself, and the various contexts in which it was publicly described and depicted, yoke Thicknesse and Chatterton together as men of feeling and 'genius'.

This tension between controversy and sentiment in the Chatterton–Thicknesse association will be explored further in this essay, which is also concerned to examine the *effect* on Chatterton's reputation of his posthumous embroilment with Thicknesse. (There is no evidence that the two ever met.) David Fairer has recently described 'how unstable the figure of Chatterton was during the two decades after his death', and it seems that this instability made Chatterton's posthumous image highly vulnerable to Gillray's suggestions.[4] As we shall see, Gillray exploits the ways in which Thicknesse's own career and misdemeanours functioned as an intriguing (and potentially damaging) mirror for the more disreputable aspects of Chatterton's work. To this extent, controversy, deceit and personal *animus* yoke the two literary celebrities together: and yet, in a very different manifestation of public display, Chatterton and Thicknesse become entangled in a poignant embodiment of late eighteenth-century pathos and sentiment, 'the Chatterton Monument', which seems to have served a significant emotional function for writers and pilgrims in search of a shrine.

Thicknesse's edifice was the first monument erected to the memory of Chatterton. The first public account of the monument was a letter (dated 1783) which Thicknesse himself wrote to *The Lady's Magazine* for February 1784, and which is illustrated with a copper plate of 'A beautiful Monument erected to the Memory of Chatterton'. Thicknesse's letter argues that 'that unfortunate youth *Chatterton* was "favoured by CELESTIAL INSPIRATION"', and explains how

> I think him worthy of a better ornament than I have erected to his memory, in a very romantic spot, near Bath; a slight sketch of which I send you inclosed, to make what use of you please. It is a rude, but substantial Gothic arch, raised between the bosom of two hills, over which is placed 'With a look that's fasten'd to the ground, A tongue chain'd up without a sound, 'the profile in relief of the unfortunate boy, and, under it, the following inscription, partly taken from a sentimental writer in the New Annual Register.[5]

Unfortunate Boy!
Short and evil are [sic] thy Days,
But the Vigour of thy Genius
Shall immortalize thee,
Unfortunate Boy!
Poorly wast Thou accommodated
During Thy short Stay among us;
Thou liv'dst unnotic'd.
But Thy Fame shall never Die.
MDCCLXXXIII

Behind the head appears part of a much broken lyre, and the young laurel planted by his side seems disposed to entangle itself amidst the broken cords, or to adorn his brow.[6]

Twentieth-century commentators have observed that, given Thicknesse's familiarity with Bristol and Bath, the engraving which he commissioned may well have been executed by somebody with a reasonable awareness of Chatterton's actual appearance. Since there are so

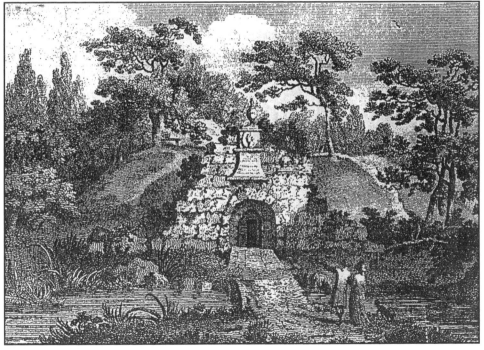

Chatterton monument, Bath, from the *Ladies Magazine*, 1784.

few reliable images of the poet, the destruction of Thicknesse's monument (we do not know when this occurred) is frustrating. John Ingram in 1910 pronounced the engraving 'most interesting', and observed that 'It seems to indicate positively the existence of a known portrait of the poet, and being almost publicly exhibited a few years after his death would doubtless come under the gaze of some who had been personally acquainted with his features.'[7]

A fuller account of Chatterton's monument in its setting can be found in Thicknesse's *Memoirs and Anecdotes*, where he reprints the contents of an earlier (now very obscure) pamphlet letter to his friend Sir John O'Carroll.[8] The tone is autumnal, and the focus of the passage, it must be confessed, is Thicknesse himself rather than Chatterton. Nevertheless, it is worth quoting at length, to give a flavour of the macabre and yet poignant context for the monument:

> You ask me, dear Sir, to send you a description of my delightful Hermitage …the situation is inferior to few spots any where, … and … most strangers are pleased with it.
> It commands a south-west prospect, and hangs on the side of Lansdown hills … a quarter of an hour's steep walk from the west end of the Royal Crescent in Bath …
>
> From my little study window, however, I look down upon Bath with that indifference, which age, and a long knowledge of its contents, or rather discontents, have furnished me, and with infinite pleasure on a mile and half of the gentle Avon gliding down the vale, and now and then, seeing the swelling bosoms of deep-laden barks freighted with merchandize; which I consider as returning messengers, whom I have sent forth to fetch me Tea from Asia, Sugar from America, Wine from France, and Fruit from Portugal.
>
> No little spot of ground can be more beautifully irregular, broken, and divided, than this dingle; and no wonder; for it is as GOD formed it, and as He willed the stately trees to grow, which shade it, and who causes the whole surface annually to be covered with the primrose, violet, and all the elder sisters of the spring…from the great quantity of broken urns which were turned up, wherever we opened the ground, on a little lawn which overhangs the dingle, I was led to suspect this to be a spot where the Romans buried their dead, when they inhabited Bath; and upon deeper enquiries, I found my conjecture established beyond a doubt. But unfortunately the Saxons, or some succeeding race, made the same use of it, so that I have never met with a perfect urn, but thousands of their fragments, and many of the convex stones which covered the tops of the urns to prevent the incumbent mould from mixing with the ashes of the dead.
>
> Three stone coffins have been dug up, two Saxon, and one Roman; the latter had the body in it, quite perfect, and some of the flesh on the skull. It had been covered with a pickle, which preserved it.
>
> Fast fixed (and never more to move) on the side of my hermit's hut, is secured the body of my old Wandering Shaise; and on an old decayed oak, which grows through the roof of

the kitchen, the following lines are engraven on the rind, as a memento to Man:

'Stranger, kneel here, to age due homage pay!

When first Eliza held Britannia's sway

My growth began: the same illustrious morn,

Joy to the hour, was gallant Sydney born.

Sydney, the darling of Arcadia's swains,

Sydney, the terror of the martial plains,

He perish'd early; I just staid behind

An hundred years, and lo! My clefted rind,

My wither'd boughs, foretell destruction nigh.

We all are mortal; Oaks and Heroes die.'

Near a rude arch, on all sides embraced with the twisted eglantine, is a perforated rockstone, from which constantly runs a small stream of the purest water imaginable, that falls into a Saxon coffin dug up hard by; from the length and narrowness of which I have disposed myself to believe the body which I found in it to be that of a beautiful Saxon virgin; so that instead of being hurt with the idea of its original use, it is become only a memento of what we must all come to. And who knows but 'some kindred spirit' may, a thousand years hence, make the same use of my departed daughter's coffin; which alas! lies hard by, and in close contact with the old Roman knight's mentioned above, which is to receive what remains of myself.

Now do not wonder! For I must inform you, that some years since I had scooped out a cave on the side of the dingle, under the spreading roots of an ash tree, and turned a rude arch in front of it; and there placed, cut in relief, the head of that wonderful genius Thomas Chatterton, with the following lines beneath it.

'Sacred to the Memory of

THOMAS CHATTERTON.

Unfortunate Boy!

Short and Evil were thy Days,

But the Vigour of thy Genius shall immortalize Thee.

Unfortunate Boy!

Poorly wast Thou accommodated,

During thy Short Sojourning among us.

Thou lived'st unnoticed,

But thy Fame shall never die.'

Since which, the long, painful, and hopeless illness of my daughter, which had worn her down to death, and her parents to such a deep sorrow, that the idea of the procession of removing her remains down the hill seemed to us but one remove less painful than that fatal remove between life and death: and therefore, as she was virtuous, dutiful, and not void of

some genius, we have deposited her body beneath the only monumental stone raised in Britain to the greatest Genius Britain, or perhaps any other nation under the sun, has produced … I cannot, however, quit this melancholy subject, without mentioning an accidental object, which, on a superstitious mind, might operate very forcibly.

The workmen, in turning this rude arch, put by the stones unhewn, in the most irregular manner; yet it so happened, that two whitish stones, something of a bastard alabaster kind, were so laid, that since my daughter's death, and the place becoming more an object of serious attention, I perceived that those stones, at a certain oblique point of view, offer a very striking figure of a winged angel, and consequently are now emblematical of the lines, which almost touch the 'silver wings' of this natural piece of sculpture.[9]

This is an extraordinary passage, and typically Thicknessian in its eclecticism. The discourses of amateur archaeology, of the picturesque, of patriotic enthusiasm (for poets, oak trees and global trading), and of sentiment, are cheerfully intermingled. Somewhere in all this is Chatterton, but he has almost vanished under the accumulation of other details, and seems in danger of terminal mingling with the fragments of Saxons and Romans (not to mention poor Miss Thicknesse). Nevertheless, Thicknesse is at pains to point out (as he had not done in the earlier *Lady's Magazine* account) the quality of Chatterton's genius. Indeed, he goes further than the suggestion made by Malone in his 1782 *Cursory Observations on the Poems attributed to Thomas Rowley* that Chatterton was 'perhaps the second poetical genius that England has produced',[10] and sides rather with Knox, who had pronounced Chatterton 'such a genius as is that of Homer and Shakespeare: such a genius as appears not above once in many centuries'.[11] It is also significant that Thicknesse pays tribute to Chatterton's genius, not Rowley's, and thus implicitly challenges the patronising view held by the pro-Rowley camp that, as George Catcott put it, the poems could not possibly have been composed by 'a boy of fifteen, bred up in a charity school, totally deprived of the advantages of Classical Learning'.[12]

The sentiment and pathos of Thicknesse's tribute to Chatterton stand in marked contrast to the image of Thicknesse as a vicious controversialist which is central to the Gillray cartoon. At this point, it seems necessary to delineate the major events of Thicknesse's career, with which Gillray assumes his viewer to be broadly familiar. A more thorough understanding of the Thicknesse phenomenon will, I hope, illuminate some of the reasons for Gillray's hostility.[13]

Philip Thicknesse was born in 1719, the seventh son of John Thicknesse, a Northamptonshire rector. The four surviving sons all achieved positions of some influence: Thomas was an eminent clergyman, Ralph an Assistant at Eton who published an edition of *Phaedrus* in 1741 (and died suddenly while playing the violin a year later), and George was

a High Master of St Paul's School. Philip's activities, in contrast, were deeply unrespectable. As a young boy, he was expelled from Westminster School before becoming apprenticed to a London apothecary and there developing addictions to various substances which led to his dismissal. He then emigrated briefly to Georgia with the Wesley brothers in 1735, and on his return irritated the authorities by giving too frank an account of settler life. He next travelled to Jamaica, where he was involved in British attempts to quell the guerrilla activities of runaway slaves in the mountains. On his return to England he rapidly got through two wives and a lot of money (gambling in Bath became a favourite hobby), and he earned some early notoriety as the lieutenant-governor of Landguard Fort in Harwich, where in 1762 he began a long feud with Colonel Vernon of the Suffolk militia, later Lord Orwell. Thicknesse purchased a printing press and produced broadsheets designed to sabotage Lord Orwell's election hopes, which were distributed in Ipswich. The final straw came when Thicknesse made Lord Orwell the mocking present of a cannon-shaped piece of flotsam. Following the infamous Affair of the Wooden Gun, Thicknesse was tried at Bury St Edmunds for libel in March 1753. Found guilty, he spent three months in the King's Bench prison, where he made many friends. Amazingly, he was allowed to resume command of Landguard Fort on his release, even though he had also, as part of his campaign against Lord Orwell, attempted to blackmail Lord Bute into supporting him, by threatening to publish some papers of Lady Mary Wortley Montagu (Bute's late mother-in-law).

He then turned his hand to the popular and lucrative genre of travel writing, spicing his narratives with bullish controversy, mainly involving Smollett. His *Observations on the Customs and Manners of the French Nation* (1766) take issue with Smollett's hostile account of France and the French in *Travels through France and Italy* (1766). Thicknesse relates suggestively that 'an English lady of fashion who resides here [Paris], to whom I lent Smollet's [*sic*] Travels, says, he certainly lodged at ale-houses, and conversed with the lowest class of mechanics that frequent such houses'.[14] In its notice of *Observations*, the *Critical Review* (formerly edited by Smollett) pronounced Thicknesse to be 'dangerous' and 'despicable'.[15] Capitalising fully on his trip, Thicknesse also published in 1768 *Useful Hints to those who make the Tour of France*, which contains more attacks on Smollett.

On their return to Britain, the Thicknesses lived briefly at Quoit in Monmouthshire, where Philip erected a monument to John Wilkes (of whom Chatterton was also a great admirer). In 1768 they moved to the livelier environment of Bath, buying a house in the fashionable Royal Crescent. Thicknesse there befriended but then antagonised the comic playwright Samuel Foote, who ridiculed him as 'Dr Viper' in his play *The Capuchin*. The name stuck and was used by Thicknesse's enemies, such as Dr James Makittrick Adair, in the years that followed. In 1774 Thicknesse sold the house in the Crescent, and based the

family at the Lansdown cottage, which he extended and landscaped in an eccentric style, naming it 'St Catherine's Hermitage' after a genuine hermitage the family visited in Montserrat, Spain during 1775.

In 1777, Thicknesse published a two-volume travelogue, *A Year's Journey through France and Part of Spain*: this was a lucrative venture, securing an advance of £580 and boasting a subscription list of 430 worthies, including the Duchess of Cumberland, Henry Pelham, David Garrick and Thomas Gainsborough. Samuel Johnson pronounced it 'entertaining'. What is notable about this travelogue is how swiftly Thicknesse has replaced the controversial tone of his earlier essays in the genre with the newly fashionable discourse of sentimental travel, describing many pathetic and emotional encounters between the Thicknesse family (including Jacko the monkey) and miscellaneous European individuals. In 1778, Thicknesse published *The New Prose Bath Guide*, containing a wealth of practical information on household management and leisure pursuits at Bath: and in 1780 *The Valetudinarian's Bath Guide; or the Means of obtaining Long Life and Health*, in which he recommends not only the Bath waters and 'Wine, and Drinking to excess', but also frequent inhalation of 'the breath of young women' as conducive to long life and good health.[16] He also championed the virtues of laudanum, especially for men over 50, whom he urged to take between 10 and 20 drops daily.

Thicknesse's *Memoirs*, published in 1788–90, attracted a great deal of attention and were widely reviewed, with general amusement. The *Memoirs* are disorganised and inconsistent, interweaving scurrility and sentiment.[17] Thicknesse is disarmingly frank about his opportunistic and often rather calculated show-downs: 'if ... it be true, that I quarrel with three out of four of my friends, I find that turns up more profitable than living well with them. ... I know not what I should have done to make both ends meet, in my old age, if it had not been for the *repeated kindnesses* of my enemies. ... I can at any time muster ten or a dozen knaves and fools, who will put an hundred pounds or two into my pocket, merely by holding them up to public scorn'.[18] In 1790, an old antagonist of Thicknesse's, Dr Adair, published *Curious Facts and Anecdotes not contained in the Memoirs of Philip Thicknesse*. This was a vituperative satire on the 'duncical' activities and deranged feuds of the 'Censor General of Great Britain', which degenerates into scatalogical accusations, with Adair alleging that Thicknesse once 'sent a letter to a person and his wife with *human excrement*, insinuating that Dr Adair was the author of the epistle and the present'.[19] Reviewing Adair's pamphlet, the *Critical Review* suggests that 'surely these *gentlemen* may throw dirt at each other, without calling in the world as spectators of the combat'.[20]

As a notorious public figure and as a private citizen, Thicknesse is an enigma. Capable of immuring his daughters in convents and quarrelling irreconcilably with his sons, he was

also adored by all three of his wives, and enjoyed intense if precarious friendships. His twentieth-century biographer observes that 'to anyone who has made a close study of Philip Thicknesse, there come occasions when he can but marvel that nobody ever shot him or bludgeoned him to death'.[21] Easily the most irascible individual within the arena of late eighteenth-century print culture, he was nevertheless celebrated by, among others, the *Gentleman's Magazine* (to which he contributed gossipy essays) as 'a man of probity and honour, whose heart and purse were always open to the unfortunate',[22] and 'a man of great sensibility'.[23] Many of his books were reviewed by the *Monthly* and the *Critical Reviews*, in the pages of which he became something of a comic celebrity. A correspondent to the *Gentleman's Magazine* in 1791 describes an encounter with Thicknesse at a hotel in Boulogne, and remarks that '(when he chose) he could shew himself the Gentleman, the Philosopher, and the Man of Letters; and for eccentricity of genius few stand superior to him: as a Traveller, he will be remembered by many in Spain as one of *monkey-driving* memory'.[24] Always adept at forging an image of himself to support his latest enterprise, Thicknesse was nevertheless vulnerable in the public arena: his significance, value, and moral standing were always up for grabs in the fast-moving print culture of the day.

Although Thicknesse's eccentric career may seem poles apart from the short and far more limited life of Chatterton, there is in fact a curious pattern of similarity and difference between Thicknesse and Chatterton, which Gillray seems to have exploited. Chatterton is the mythic embodiment of wasted youth, whereas Thicknesse attributes his longevity to the inhalations of the breath of youth. Chatterton's 'genius' – which had made him no money – contrasts strikingly with Thicknesse's conspicuous lack of this same quality, for which he had however managed to compensate through lucrative acts of literary terrorism. Chatterton's self-destructive recourse to arsenic is a tragic counterpoint to Thicknesse's life-enhancing addictions to alcohol and laudanum (and Chatterton too had paid tribute to the powers of Bacchus, in several 'Bacchanalian' snatches).

Both writers formed relationships with figures of superior social and public standing which then turned sour. Chatterton's repudiation by Horace Walpole was a matter of public scandal by 1782, although the satiric (and indeed somewhat Thicknessian) denunciation which Chatterton had drafted (though not sent) to Walpole was not published until 1803.[25] Thicknesse, in contrast, made economic if not moral capital out of his fallings-out with (amongst others) Lord Orwell, the Earl of Coventry, and the painter Gainsborough, whom he claimed to have discovered.[26]

In the opening paragraph of one of Thicknesse's more obscure pamphlets (*Pere Pascal, a Monk of Montserrat Vindicated: in a Charge brought against him by a Noble Earl of Great-Britain*, 1783), he acknowledges that he is 'a captious man, and frequently involved

in disputes'. But Thicknesse proceeds to qualify this assessment:

> I deny, that I ever engaged in any disputes, but with men, who being of a higher birth, and
> better fortune, have taken, in consequence thereof, liberties with me, which, MAN has no
> right to take with MAN.[27]

Similarly, Chatterton's verse epistle to Walpole pours scorn on his inherited 'Wealth and
Lux'ry', and warns that 'Scorn I will repay with Scorn, and Pride with Pride'.[28] Chatterton
and Thicknesse both worked opportunistically within a range of literary genres, showing
themselves alert to the fads and fashions of their reading publics (nicely satirised in
Chatterton's 'The Art of Puffing by a Bookseller's Journeyman'). Both were equally capa-
ble of sentimental tenderness and acerbic satire (though, perhaps fortunately, Thicknesse
never tried his hand at verse, let alone anything medieval). Both worked (although only
briefly in Chatterton's case) within the murky world of London's gossip magazines. Given
the extraordinary contrasts between the mythic image of Chatterton the doomed Romantic
poet, and the hideous version of Thicknesse which Gillray offers in his cartoon of 1790,
these points of intersection are intriguing.

Gillray's cartoon was marketed with exceptional effort in February 1790. Some 'anony-
mous verses' were published as part of the publicity campaign, and 'an insulting card' sent
out on the day of publication, which observed with heavy sarcasm that 'as the Engraving is
intended merely as an attempt to gibbet Meanness, Vice and Empiricism it cannot possibly
allude to so respectable a Personage as PHILIP THICKNESSE Esq'.[29] In the same year
(1790), Thicknesse's old enemy Adair refers to the cartoon in his *Curious Facts and
Anecdotes, not contained in the Memoirs of Philip Thicknesse, Esq*:

> There is lately published by a wag, an excellent caricature print of our old friend, in which
> many of his exploits are ingeniously sketched, and which we have therefore omitted here,
> trusting that every person of true taste will become a purchaser.[30]

Adair's remarks here suggest that the print was becoming well known (disingenuously, he
pilfers the head-and-shoulder detail for a frontispiece portrait). The print brings the two writ-
ers together in a manner which must have badly compromised the emergent myth of
Chatterton as genius by associating him with the mercenary literary underworld inhabited
by Thicknesse – a world in which less Romantic notions of genius could still apply, as in the
Gentleman's Magazine's enthusiasm in 1791 for Thicknesse's 'eccentricity of genius'; or the
Monthly Review's characterisation of Thicknesse in 1789 as 'ingenious', – 'we say ingenious,
notwithstanding the frequent instances of his careless writing; for *genius* and *accuracy* are
not always concomitants'.[31]

Gillray's interweaving of Thicknesse's career and reputation with that of the marvellous
boy may well have added impetus to the movement already underway by 1790, and consol-

idated by Coleridge's 'Monody' in 1794, by which supporters of Chatterton increasingly tended to foreground his poetic genius and play down his equally accomplished activities in the realms of prose and of satire. Gregory's 1789 *Life* of Chatterton had – not uncontroversially – given full weight to Chatterton's satiric works. Chatterton's partisan and satiric works (especially when compared to the career of Thicknesse) not only compromised the myth of poetic genius, they also enmeshed Chatterton in a world of latter-day Scriblerian vitriol which could do him no favours, tying him into an outdated realm of undignified personal controversy which was at odds with the medieval world of Thomas Rowley. In this context, Thomas Warton's characterisation of Chatterton as a mercenary opportunist is worth quoting, if nothing else because it functions as an even more accurate description of Philip Thicknesse: 'an adventurer, a professed hireling in the trade of literature, full of projects and inventions, artful, enterprising, unprincipled, indigent, and compelled to subsist by expedients'.[32] Even Vicesimus Knox, one of Chatterton's most fervent early admirers, concedes that his genius was not unproblematic: 'He had all the tremulous sensibility of genius, all its excentricities, all its pride, and all its spirit'.[33]

The 'Preface' to Tyrwhitt's second edition of the Rowley poems ends with the rather limp observation that 'whether the Poems be really antient, or modern; the compositions of Rowley, or the forgeries of Chatterton; they must always be considered as a most singular literary curiosity'.[34] After Gillray's cartoon, the world of the literary curiosity has become yet more dubious, and the 1794 edition of the Rowley poems (in which Coleridge's 'Monody' was first published) has shifted into a different discourse, pronouncing that 'whether the Author of them may have been Rowley, or Chatterton', the poems themselves 'fully entitle him to be ranked in the fourth place among our British Poets'. The language here is consciously literary, rising above mere curiosity. The irony is that Thicknesse himself had celebrated Chatterton precisely for those qualities of Romantic genius that most differed from his own brand of literary activity. The enthusiasm of Dr Viper for 'the greatest genius Britain has ever produced' was something of a poisoned chalice for early supporters of Chatterton, making the satiric and controversial side of his *oeuvre* a great deal more problematic than it may otherwise have been. David Fairer rightly observes that 'what we call the Romantic myth of Chatterton involved a narrowing down and weakening of a figure who had earlier offered writers so much'.[35] In 1789, for example, George Gregory's *Life of Chatterton* (originally written for the *Biographia Britannica*) praised the satiric energies of Chatterton's work, and downplayed the Rowley forgeries. Gillray's cartoon and its embroilment of Chatterton with the disreputable activities of Philip Thicknesse may have been an influence in the strategic 'narrowing down' of Chatterton's literary reputation.

The impact of Thicknesse's monument to Chatterton, however, seems to have been more

positive. There is some evidence that the affective power of the edifice struck a chord with admirers and pilgrims, who were perhaps able to disregard the more compromising aspects of Thicknesse's admiration for the poet.

The attractions of the Lansdown monument may have owed something to the absence of any other physical location at which Chatterton's early admirers could congregate. This absence in turn relates to the perceived neglect by Bristol, which was seen as having failed to protect its wayward genius son. Herbert Croft's peculiar epistolary novel, *Love and Madness* (1780), contains a large digression on the subject of Chatterton, in which the narrator castigates the city of Bristol. Croft's was the first account which supplied full details of Chatterton's none-too-salubrious activities in London, and he holds Bristol responsible for having driven the ambitious boy (like other Bristolian literary figures) to London in the first place:

> Tell me, Bristol, where is Savage, I say. Whither dist thou drive Hume. Where hast thou hid the body of murdered Chatterton? Where are his mother and his sister?
> … Miserable Hamlet! as Chatterton calls thee. Unworthy such a treasure!

He imagines 'the spirit of neglected Chatterton' haunting the city, and breaks into verse as he envisages how Chatterton,

> … in black armour, stalks around
> Embattled Bristol, once his ground …
> Perhaps for Bristol still he cares;
> Guards it from foemen and consuming fire;
> Like Avon's stream ensyrkes it round,
> Nor lets a flame enharm the ground …

Fortunately, this effusion is cut short as the narrator pulls himself together:

> But the feelings of the moment have hurried me away. Bristol is not culpable. She may be proud that she produced C. [sic] and need not, perhaps, blush for his death.
> Had he remained in the 'miserable hamlet', Rowley must inevitably have worked his way in the world.[36]

Croft is one of the first, but by no means the last, of the writers and commentators who were to dwell imaginatively on the strange placelessness of the dead Chatterton. (Coleridge, in *Monody on the Death of Chatterton*, was later to describe him as 'the heart-sick Wanderer'). Croft imagines Chatterton's spirit haunting the city of his birth, while Mary Robinson's *Monody to the Memory of Chatterton* locates the poet's ghost somewhere in the precincts of Bristol Cathedral:

> Methinks I hear his wand'ring shade complain,

While mournful Echo lingers on the strain;
Thro' the lone aisle his restless spirit calls,
His phantom glides along the minster's wall;
Where many an hour his devious footsteps trod,
Ere Fate resign'd him to his pitying God.[37]

Not only the troubling nature of Chatterton's death – by suicide – but also the curious uncertainty over the whereabouts of his remains, exercised commentators. If we return briefly to Thicknesse's letter to the *Lady's Magazine*, we find that although the picture is captioned 'Monument to the Memory of Chatterton', the article itself is entitled 'Chatterton's Mausoleum', and this confusion of terms ('monument', 'mausoleum') seems to have initiated a longstanding uncertainty as to the precise nature of the edifice. This uncertainty itself becomes entwined with the mystery of Chatterton's bodily remains, as John H. Ingram explained in 1910:

> For years it was believed that Chatterton's body was buried in a pauper's grave in 'the Pit', as it was called, of Shoe Lane Workhouse; and many pilgrims there had the supposed spot pointed out to them, until ultimately, the ground being required for other purposes, the bones of the dead were disinterred and carried away. Upwards of half a century after the poet's death [in 1829] a strange story was promulgated to the effect that his corpse had not been buried in London, but that soon after the inquest it had been enclosed in a box, taken to Bristol, and been interred in the churchyard of St Mary Redcliffe.[38]

Most probably, Ingram's account poignantly concludes, 'the poor young poet's remains were scattered, no one knows whither'.[39] There is some evidence to suggest that 'pilgrims' visited Thicknesse's memorial because it fulfilled the need for sentimental mourners to attach their grief to a particular location. In 1787, Thicknesse issued a public complaint about the number of visitors which St Catherine's Hermitage was attracting, due to its 'contiguity' to Bath.[40] In his own account of the Hermitage, Thicknesse includes a copy of some verses 'written by the ingenious Mr. TASKER' and published in the *European Magazine*. Tasker's poetry is unimpressive, but does suggest the psychological benefits which the monument provided:

– Spirit of injur'd Chatterton! Rejoice,
And hear of fame the late applauding voice!
Chill penury depress'd thy Muse of fire,
And Suicide's rude hand unstrung thy lyre. –
Tho' all the Muses smil'd upon thy birth,
And shew'd thee as a prodigy on earth;
Lo! Such the hard conditions of thy fate!

Living despis'd, lamented when too late:
Thy thread of life (by too severe a doom)
Was early cut, e'en in thy youthful bloom,
Nor was thy name yet honour'd with a tomb.
O Chatterton! If thou may'st deign to smile
On one recess of thine ungrateful isle;
Suppress a-while thy just indignant rage,
And view well-pleas'd the Wanderer's Hermitage;
There thy delighted eye at last may see
The grateful monument arise to thee:
One worthy individual thus supply'd
What all thy boasted patrons have deny'd.[41]

In the closing lines, Tasker's tribute to Chatterton is envisaged as a consolation to the poet's ghost, and, by implication, as an affecting national monument to the moral value of poetic genius. Writing before the erection of Thicknesse's monument, Vicesimus Knox had elaborated rather beautifully on Chatterton's posthumous homelessness, developing the Shakespearean notion of his works as his lasting monument: 'Thyself thou hast emblazoned; thine own monument thou hast erected', Knox exclaims, and he then extends this metaphor into a creative account of Chatterton's artful forgeries, declaring that:

> Thou hast built an artificial ruin. The stones are mossy and old, the whole fabric appears really antique to the distant and the careless spectator; even the connoisseur, who pores with spectacles on the single stones, and inspects the mossy concretions with an antiquarian eye, boldly authenticates its antiquity; but they who examine without prejudice, and by the criterion of common sense, clearly discover the cement and the workmanship of a modern mason.[42]

Mary Robinson likewise explores the immortality which Chatterton has gained through his works in a network of architectural images. Her poem and its sentiments are self-consciously indebted to Gray's *Elegy* (which also supplies an epigraph for Robinson's 'Monody'), particularly in its closing lines:

And though no lofty Vase or sculptur'd Bust
Bends o'er the sod that hides thy sacred dust;
Tho' no long line of ancestry betrays
The Pride of Relatives, or Pomp of Praise;
Tho' o'er thy name a blushing nation rears
Oblivion's wing – to hide Reflection's tears!
Still shall thy verse in dazzling lustre live,
And claim a brighter wreath than Wealth can give.

Robinson also develops the conceit whereby the 'unknown' and 'unbless'd' nature of

Chatterton's grave is compensated by the protection of 'the fond MUSE', and by the 'mournful murmurs' of 'some kindred soul', who will 'with the cypress bough the laurel twine'.

This poetic landscape is purely conventional and symbolic. In contrast, an earlier poem by Ann Yearsley, 'the Milkwoman of Clifton', strongly suggests an actual visit to Thicknesse's monument. Yearsley's *Poems on Various Subjects* of 1787 contains an *Elegy on Mr. Chatterton*, which had been published some years earlier in *The St James's Chronicle* as *Elegy on visiting the Hermitage, near Bath*.[43] In its opening lines, Yearsley's poem assumes (presumably for rhetorical effect, rather than from ignorance) that the speaker's location is Chatterton's actual tomb:

> Forgive, neglected shade! my pensive lay,
> While o'er thy tomb I hang my rural wreath;
> The modest violet to thee I'll pay,
> That bloom'd and dy'd upon yon barren heath.[44]

Like Robinson's poem, Yearsley's is swamped in the imprecise poetic diction of late eighteenth-century verse. David Fairer has referred somewhat witheringly to 'the traditional flower-passage of classical elegy' which both women poets mobilise. He is right to detect absurdity in Yearsley's extended comparison of Chatterton to a delicate harebell. However, Yearsley's depiction of the 'tomb' is vigorous, and also seems quite precisely to evoke the precipitous setting of Thicknesse's monument, as she evokes 'the mountain's brow' and 'the precipice' over which flowers 'by winds are cast'; the 'silent lyre' hanging 'high on this Willow'; and the primrose whose 'languid hue shall cank'ring Grief disclose'. We recall Thicknesse's account of the garden, whose 'whole surface' is 'annually … covered with the primrose, violet, and all the elder sisters of the spring'; and his reference to the ash tree (admittedly, alas, not a willow!) under which the 'rude arch' of the monument is cut into the rock. For Yearsley (like Chatterton, a native of Bristol), Thicknesse's edifice functions powerfully as a tangible focus for her grief-stricken posture.[45]

The desire for a more official monument to Chatterton persisted, and eventually one was erected in 1838-40, on unconsecrated ground to the north of St Mary Redcliffe. John Goodridge has outlined the troubled history of this monument (which was first mooted in 1792). It survives, but in a sorry and neglected state, after several re-locations and the vicissitudes of the Blitz: 'to Bristol's disgrace, the statue still lies in an outhouse at the back of Chatterton's birthplace'.[46] Ironically, then, with the erosion of the Bristol monument and the spectacular rehabilitation of Gillray's cartoon at the 2001 Tate Britain exhibition, the visual iconography of Chatterton – like the scholarship which has recently focused on reclaiming the satiric and controversial dimensions of the poet's work – is taking another intriguing turn.

Visionary and Counterfeit

5 DR ALISTAIR HEYS

Blake was born in 1757 and his earliest biographer, Gilchrist, adds: 'while Chatterton, a boy of five, was still sauntering about the winding streets of antique Bristol.'[1] It was on Peckham Rye that the eight-year-old Blake had his first visitation and with precocious second sight saw angels, their wings glittering like stars all perched in a tree. On another occasion, he saw angels working among haymakers; only his mother's intervention prevented his father from administering a corporal curative for these incredible and self-evident 'lies'. *A Vision of the Last Judgement* serves to link this early vision in the hay meadow with the architectural concerns of this essay: 'Multitudes are seen ascending from the Green fields of the blessed in which A Gothic Church is representative of true art Calld Gothic in all Ages'.[2] I wish to meditate upon the English Gothic by exploring the intricacies of Blake's reception of Chatterton and the forgery furore but in relation to the reciprocity of Wordsworth's figuration of nature. Hence, I want to read Blake's objections to the Wordsworthian in terms of the latter's reaction to the suicide myth as displayed in *Resolution and Independence*. Blake's response to Wordsworth, Wordsworth's poem and Coleridge's morbid fascination with the tragic circumstances of Chatterton's death are interpreted as proposing three distinct configurations of the given. I shall further suggest that Blake's critique of Wordsworth links to the building of the Temple in The Bible. The Chattertonian trope of the builder will be inducted such that Blake's interest in the Gothic can be compared with Chatterton's documentary faking of an alternative medieval Bristol. It is my intention to demonstrate that Chatterton stimulated the Romantic debate regarding the correct philosophical position from which to represent nature and the limits of belief in empirical reality. Ultimately, I shall propose that the figure of the visionary builder in Blake derived in the matrix of this poetic debate. This essay emphasizes how Chatterton's Bristowe influenced the mainstreams of British culture in the form of what is often taken as a national hymn, Blake's 'Jerusalem'.[3]

I will begin by reflecting upon the intimate connection between copying and the apprenticeships of Chatterton and Blake. Chatterton's master, John Lambert, posthumously described his erstwhile apprentice's character as that of 'a sullen, gloomy temper which showed itself in the family and among the servants by his therewith declaring his intentions to do away with himself.'[4] Excessive gloominess is consonant with our experience of the Gothic but also reinforces the romantic perception of Chatterton as an alienated poet living on the edge of society. Chatterton's family believed themselves to have been sextons in the parish of St. Mary Redcliffe from time out of mind. In fact, the Chatterton name was asso-

ciated with masons; there are references to them carrying out building and maintenance work on what has been described as the fairest of all parish churches. It is significant that Chatterton's father died before his son was born. The most tangible connection between Thomas Chatterton senior and the son seems to have been the ancient papers taken from the muniments room over the north porch in 1750. In the south transept, Chatterton junior came upon the tomb of Canynge upon which these words are inscribed: 'Mr. William Caning, ye Richest marchant of ye towne of Bristow afterwards chosen 5 time mayor…Hee was in order of Priesthood 7 years & afterwards.' Canynge's documents had been deposited in what was referred to as Canynge's Cofre until escorted to the city archives, although some inconsequential papers came into the possession of Chatterton's father. Slips of dirty illegible parchment were still jumbled about the room when the fatherless boy began to ferret through them. Chatterton's admiration was stirred, he was 'so glad nothing could be like it' even to the extent that the skills he was developing as a scrivener's apprentice began to take on a pale caste of thought divorced from mere copying. The suicide myth derives from what was in all probability a ruse dreamt up in order to escape a master who was apt, upon discovery of Chatterton's poetic writings, to snatch them from him and then rip them into shreds. Chatterton gained release from his humiliating apprenticeship by threatening to commit suicide; his master was perhaps shredding an intangible connection with his father's ghost. It is a sad irony that when Chatterton's corpse was discovered in a Holborn garret a heap of manuscript fragments were also found torn into tiny pieces and scattered around the poet's room.

Blake's marginalia response to Sir Joshua Reynolds perhaps captures the spirit of the apprentice engraver's opinion with regards the art of copying: 'How incapable of producing any thing of their own, those are, who have spent most of their time in making finished copies,' to which Blake replied: 'If he means That Copying Correctly is a hindrance he is a Liar. for that is the only School to the Language of Art'.[5] Blake learned his craft by copying Renaissance masters; for this reason his work as an apprentice is in some ways consonant with Chatterton's trade, that of copying legal documents. The Londoner could not believe that empirical description, however exacting, could in any way represent truth. Blake's method of printing combined 'the Painter and the Poet' which enabled him to argue: Copiers of Nature Incorrect while Copiers of Imagination are Correct'.[6] *The Early-most of Days* depicts Urizen, Blake's rationalistic Creator, holding a pair of calipers as He empirically measures out creation. (Figure 1). Chatterton and Blake depicted what lies beyond the bounds of what might be described as the Urizenic given; they escaped the constraints of eighteenth-century perception by a Gothic cleansing. From the perspective of the staid believer in material facts, this compulsion to invent or fabricate alternative realities might seem absurd or insane. Blake opined that the plagiarist works only from memory, is clumsy

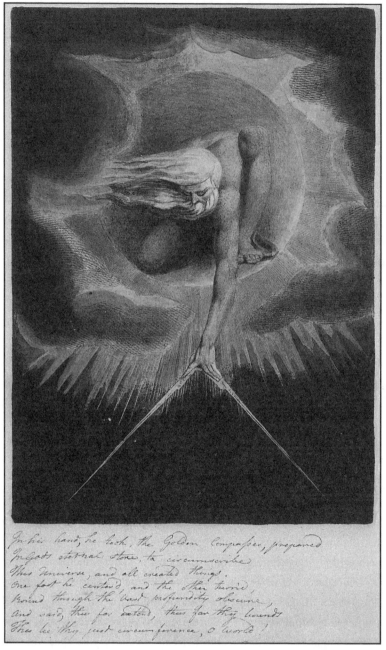

William Blake: *The Early-most of Days.* [courtesy: British Museum]

and indefinite, his progress is like that of a blind man: 'All his efforts prove this little boy to have had that greatest of all blessings, a strong imagination, a clear idea, and a determinate vision of things in his own mind'.[7] Or, as he maintained with reference to the visionary faculty in *Jerusalem*, 'all you behold, tho it appears Without it is Within/ In your Imagination of which this World of Mortality is but a Shadow' (Ch.3, P:71).[8] When Blake writes of building a second Temple this must be in his Imagination which differs from the reconstruction of St Mary Redcliffe in Chatterton's writings only in the respect that Blake believed that these were visionary creations rather than counterfeits penned to deceive Catcott and Barrett. The visionary Blake could not believe that Chatterton was a liar.

Blake's radical belief in pure invention brings us to his quarrel with the half-creations of the Wordsworthian. In his *Essay, Supplementary to the Preface*, Wordsworth attacked the spurious imagery of Ossian because he felt that nature was distinct and not 'insulated, dislocated, deadened'. Blake wrote a marginalia reply to Wordsworth: 'I believe both Macpherson & Chatterton, that what they say is Ancient Is so'. In contrast to the self-imposed empirical constraints of the Wordsworthian, Blake argued: 'Natural Objects always did & now do Weaken deaden & obliterate Imagination'.[9] His quarrel with Wordsworth is not so much that the given or external world should be represented as distinct but rather that this, 'Fit & is it not Fitting most Exquisitely too but to what not to Mind but to the Vile Body only...& its Enmities against Mind'.[10] Here is the exact passage in which the curiously wrought consummation between Wordsworth's mind and nature becomes consecrated:

How exquisitely the individual Mind
(And progressive powers no less
Of the whole species) to the external World
Is fitted – and how exquisitely too –
Theme this but little heard of among men
The external World is fitted to the Mind; (WPW, V, 3: 63-68)[11]

Blake accuses Wordsworth's faith in external nature because it seemed the equivalent of marrying Pharoah's daughter and therefore of being a natural religion: 'Solomon when he Married Pharohs daughter & became a Convert to the Heathen Mythology Talked exactly in this way of Jehovah as a Very inferior object of Mans Contemplations he also passed him by unalarmd & was permitted. Jehovah dropped a tear & followd him by his Spirit into the Abstract Void it is called the Divine Mercy'.[12] By so berating Wordsworth for including a compulsively idealist hymn to the human ego in the midst of his great spousal equivocation, Blake alludes to this passage:

All strength – all terror, single or in bands,
That ever was put forth in personal form –

Jehovah – with his thunder, and the choir

Of shouting Angels, and the empyreal thrones –

I pass them unalarmed. (31-35)

Unlike Wordsworth, Blake combines belief in Jesus as the Imagination in man with the power of the Holy Spirit in order to lift the veil from empirical reality: 'Jesus considerd Imagination to be the Real Man'.[13] Blake championed, '*the Art of Invention not of Imitation*' declaring that, '*Imagination is My World this world of Dross is beneath my Notice*'.[14] The Preface to *Milton* contains what might be described as an artisan's call to arms: 'Painters! on you I call! Sculptors! Architects!...We do not want either Greek or Roman Models if we are to be just & true to our own Imaginations, those Worlds of Eternity in which we shall live for ever'.[15] In The Prospectus to *The Excursion*, Wordsworth had written of 'the discerning intellect of Man,/ When wedded to this goodly universe' (52-53). Blake described the Wordsworthian dialectic as a conflict between accurate copies in memory figured as a married faithfulness to nature and the creative fecundity of biblical inspiration: 'I see in Wordsworth the Natural Man rising up against the Spiritual Man Continually & then he is No Poet but a Heathen Philosopher at Enmity against all true Poetry or Inspiration'.[16] To Blake's Gothic mindset true art or inspiration is distinguished from the rags of false art on the romantic/classical axis. Blake's *A Vision of the Last Judgement* attacked the classicism of the Urizenic father: 'when they Assert that Jupiter usurped the Throne of his Father Saturn & brought on an Iron Age & Begat on Mnemosyne or Memory The Greek Muses which are not Inspiration as the Bible is. Reality was Forgot & the Vanities of Time & Space only Rememberd & calld Reality'.[17] We begin to plumb the depths of Blake's scatological distaste for *The Excursion* with its invocation to the classical figure of Urania, its arrogant deprecation of the power of Jehovah, which the working-class Blake claimed acted as a purgative.[18]

Blake, Wordsworth and the dejected Coleridge fall into three philosophical categories regarding nature that may be addressed using the example of Chatterton. Perhaps the most famous allusion to Chatterton's assumed suicide occurs in *Resolution and Independence* where Wordsworth meditates upon the dejection that has overtaken Coleridge:

I thought of Chatterton, the marvellous Boy,

The sleepless Soul that perished in his pride; (WPW, II, 235: 43-44)

Wordsworth turns to the figure of Chatterton because, as Coleridge's juvenilia demonstrated, his friend nursed a fascination with the fate of a fellow aspiring West-Country poet. In the constantly revised *Monody on the Death of Chatterton*, Coleridge had written:

Ah! dash the poison'd chalice from thy hand! (CPW, 139: 82)[19]

Fairer has shown how the death of Chatterton became a standard figure for poets who wished to address the combined figure of Orpheus and a Grub Street Hack.[20] We are confronted here by two concepts of Chatterton, that of the journalistic Decimus and that of a poet capable of singing the dead back to life. It is noteworthy that Southey's posthumous edition of Chatterton called attention to the periodic madness in the Chatterton family since *Resolution and Independence* associates Chatterton with 'despondency and madness' (49). Chatterton had willed upon himself the 'Title of the Mad Genius therefore if I do a mad action it is conformable to every Action of my Life which all savored of Insanity' (CW, 503).[21] Coleridge writes in the *Monody* that the bard of *Aella* meditates upon future songs:

And, as floating high in air
Glitter the sunny visions fair,
His eyes dance rapture, and his bosom glows! (38-40)

His lines are proleptic of *Kubla Khan* where the Orphic figure with flashing eyes and floating hair would build a dome in air to rival the decreed stateliness of the God-like Kubla's pleasure-dome. Here we discover the same dialectic between the political and the Orphic, the worldly genius and the sunny spot of an opium vision. The argument of *Resolution and Independence* indicates that in his dejection Coleridge cannot redeem the given with his imaginative faculty, which the troubled poet was beginning to apprehend as contrary to a reassuringly sane belief in the primacy of God's creation. The *Monody* describes inspiration as a 'mad'ning pow'r' (100-101) and speaks ecstatically of 'Joy's wild gleams' (62). But, in *Dejection: An Ode*, Coleridge mourned the bittersweet passage of youthful joy in a humanly redeemed nature, again making use of the figure of a marriage:

Joy, Lady! is the spirit and the power,
Which wedding Nature to us gives in dower
A new Earth and new Heaven, (CPW, 697: 67-69)

When the shaping spirit of Imagination departs Coleridge is left with 'Reality's dark dream' (95) or a realist's apprehension, the hangover from his visionary addiction to opium. In *Resolution and Independence*, Wordsworth is rescued from his own viper thoughts by the providential appearance of the Leech Gatherer:

Like a sea-beast crawled forth, that on a shelf
Of rock or sand reposeth, there to sun itself; (62-63)

These lines display imaginative licence since the old man in no way resembles a creature of the tides except in terms of Wordsworth's metaphorical comparison that blends the human into an amphibious figure signifying the marriage of the visionary gleam to a sunny spot. We now have three categories before us. The dejected Coleridge perceives as a realist who

like the myth of Chatterton in the garret has passed beyond his ability to keep the poetic dream alive. The resolute Wordsworth still writes as a visionary who half-redeems the given, one able to sustain the Romantic myth in a determined fashion. Blake perceives as a visionary who almost entirely doubts the real, defiantly reading Chatterton's forgeries as examples of spiritual truth.

We can see from this that Chatterton is central to the Romantic debate. But it is possible to further implicate Chatterton in Blake's reply to Wordsworth. A good example of the idealism inherent in Blake's position is provided by a comparison that is not directly influential. In *Rowley's Printing Press*, Chatterton anachronistically relates this Gothic idea: 'I mervaile moche our *scriveynes* and *amanuenses* doe not gette lytel letters cutt in wood, or caste in yron, and thanne followynge by the eye, or with a fescue, everyche letter of the boke thei meane to copie' (CW, 60). *The Marriage of Heaven and Hell* expunges cloven fictions, 'by printing in the infernal method, by corrosives, which in Hell are salutary and medicinal, melting apparent surfaces away, and displaying the infinite which was hid'.[22] But if we are searching for an undoubted influence, then we find it when Blake writes:

> How do you know but ev'ry Bird that cuts the airy way,
> Is an immense world of delight, clos'd by your senses five?'[23]

Blake has transformed Chatterton's *Bristowe Tragedy*:

> How dydd I know that ev'ry darte
> Thatt cutte the airie waie
> Myghte notte fynde passage toe my harte
> And close myne eyes for aie? (CW, 6)

In *The Marriage of Heaven and Hell*, Blake turns rationality and the empirical on its head by offering this perspective: 'As I was walking among the fires of hell, delighted with the enjoyments of Genius; which to Angels look like torment and insanity'.[24] Blake is satirizing the classical emphasis upon an accurate faithfulness to the memory of the given: '[*If the Inspiration is Great why Call it Madness*] "For if it is a Deceit the Whole Bible is Madness". This Opinion originates in the Greeks Calling the Muses Daughters of Memory'.[25] Blake represented the figure of Jerusalem as inspiration: 'Imagination is Surrounded by the daughters of Inspiration who in the aggregate are calld Jerusalem'.[26] This creative idealism stands in opposition to Wordsworth's finely balanced marriage of subjective with objective. However, a 'marriage' was none-the-less the inspiration for Blake's concept of Jerusalem. Here are some of the most famous lines in Blake and, indeed, the English language:

> I will not cease from Mental Fight,
> Nor shall my Sword sleep in my hand:

Till we have built Jerusalem,

In England's green & pleasant Land.[27]

A well-known source for Blake's trope of the builder occurs in The Bible: 'And Solomon made affinity with Pharoah king of Egypt, and took Pharoah's daughter, and brought her into the city of David, until he had made an end of building his own house, and the house of the Lord, and the wall of Jerusalem round about' (I Kings, 3:1). Blake's allusion to the building of Solomon's Temple finds another scriptural echo in Revelations: 'And I John saw the holy city, new Jerusalem, coming down from God out of heaven, prepared as a bride adorned for her husband' (21:2). It can hardly escape comment that the trope of Jerusalem derives in the same passage that Blake also alludes to when criticizing Wordsworth's dependency upon Imagination dissociated from the divine but interfused with an empirical perception of nature. Wordsworth's imagination is married to the real while Blake's visionary faculty is married to Jerusalem.

I strongly suspect that Chatterton's Bristowe was an influence on Blake's *Jerusalem*. A consequence is that at some level the influence of Chatterton is implicated in Blake's disagreement with Wordsworth. Hence, we must now examine what features of Chatterton's pseudo-medieval poetry may have appealed to Blake. Blake's interest in British antiquity or that period historically muddied by the monkish fabrications of Geoffrey of Monmouth has come down to us as the Gould Weston Series and the Notebook list. Many of the topics for these engravings such as *Edwin & Morcar* double the nationalist subject matter of Chatterton's nationalist epic, *Battle of Hastynges*, which portrays a Saxon England defiantly resisting the Norman Conquest. Although much of Blake may be associated with his reading of Milton and Scripture, arguably his interest in the English Gothic can be better understood with reference to the influence of Chatterton. One of Blake's early pictures is entitled *Joseph of Arimathea among the Rocks of Albion* (Figure 2) to which Blake added his own gloss: 'This is One of the Gothic Artists who built the Cathedrals in what we call the Dark Ages...such were the Christians in all ages'.[28] *Jerusalem* contains this description of the building of Golgonooza or Blake's divinely inspired city of imagination:

What are those golden builders doing? where was the buying-place

Of soft Ethinthus? near Tyburns fatal Tree? is that

Mild Zions hills most ancient promontory; near mournful

Ever weeping Paddington? is that Calvary and Golgotha?

Becoming a building of pity and compassion? Lo!

The stones are pity, and the bricks, well wrought affections:

Enamld with love & kindness, & the tiles engraven gold

Labour of merciful hands: the beams & rafters are forgiveness:

William Blake: *Joseph of Arimathea among the Rocks of Albion.*
[courtesy: British Museum]

The mortar & cement of the work, tears of honesty: the nails,

And the screws & iron braces, are well wrought blandishments,

And well contrived words, firm fixing, never forgotten,

Always comforting the remembrance: the floors, humility,

The ceilings, devotion: the hearths, thanksgiving: (Ch.1, Pl:12)[29]

Paley's *The Continuing City William Blake's Jerusalem* states that Blake's city of imagination 'takes its origin from a synthesis of literary antecedents with Blake's experience of real cities' but his examples, which include Swedenborg and Boehme, exclude Chatterton who is relegated to the status of an antiquarian interest or that of the pseudo-archaic.[30] It is my contention that Blake combined the biblical with Chatterton's imaginative treatment of Bristol and then transposed this as his vision of London.

An antithetical example of Blake weaving the names of local topographic features into his poetry can be found in the instance of Albion Mill. Blake wrote that the rationalistic Urizen, or the Satan-like prince of the starry wheels, set the Sons of Albion to toil unceasingly:

O Satan my youngest born, art thou not Prince of the Starry Hosts

And of the Wheels of Heaven, to turn the Mills day & night?[31]

Blake teaches us that, unlike the craft of building in the Imagination, life and soul cannot be breathed into a milling machine. Albion Mill is of particular interest because it helps us to understand Blake's attachment to Chatterton at a formative moment during his life. The forbidding and prison-like Albion Mill was situated near Blake's home in Lambeth; the memory of this terrible steam-driven factory made a lasting impression on the engraver. This soulless edifice was erected by Matthew Boulton and contained machines invented by Watt, both of whom were members of the Lunar Society of Birmingham, a famous debating society of the time. Blake's prophetic critique of Albion's dark, satanic mills can be linked to his satire upon age-of-reason discussion groups that politely dissected the Chatterton controversy. Blake had first-hand experience of a satellite, London-based, debating club (replete with bluestockings such as Hannah More) at the Reverend Mathew's house in Rathbone Place. *An Island in the Moon* sometimes burns with the embarrassment that a working-class artisan might have felt in such well-to-do or satirically 'lunatic' company. Blake's own voice perhaps belonged to the Cynic Quid who shouts: 'Hang Italian songs! let's have English …English genius forever!'[32] Quid also challenges the great poets of past generations, but by placing Chatterton in the exalted company of Shakespeare and Milton: 'Shakespeare is too wild & Milton has no feelings they might be easily outdone Chatterton never writ those poems'.[33] Blake has the self-satisfied antiquary Etruscan Column say that Chatterton's poetry is 'wretched paltry flimsy Stuff'. The pretentious Aradabo spouts this comical Aristotelian

list: 'In the first place I think I think in the first place that Chatterton was clever at Fissic Follogy, Psitinology, Aridology, Arography, Transmography, Phizography, Hogamy, Hatomy, & hall that but in the first place he eat very little wickly that is he slept very little which he brought into consumsion, & what was that that he took Fissic or somethink & so died'.[34] Coleridge rebuffed the antiquarian Dean of Exeter's attacks on the Chatterton forgeries as, 'An owl mangling a poor dead nightingale.'[35] Malignant squibs made by the classical learned appeared foolish to the apprentice visionary because Blake would not have pored over the Rowley manuscripts with the eye of a scribe but rather looked through the eye at Chatterton's spiritual achievement. To the Gothic imagination, all ages appear the same or as Blake maintained: 'let them look at Gothic Figures & Gothic Buildings. & not talk of Dark Ages or of Any Age! Ages are All Equal. But Genius is Always Above The Age'.[36] With the phrase, 'And did those feet in ancient time' in mind we should recall that Milton notes in his *History of Britain*, 'the footsteps and reliques of something true' are contained in 'English poets and rhetoricians who, by their art, will know to use them judiciously'.[37] Blake's view on these matters is unequivocally Gothic, as a comment in the *Descriptive Catalogue* of 1809 makes clear: 'Believing with Milton the ancient British History, Mr. B. has done as all ancients did, and as all the moderns who are worthy of fame, given the historical fact in its poetic vigour so as it always happens, and not in that dull way that some historians pretend, who, being weakly organised themselves, cannot see either miracle or prodigy'.[38] Blake's interest resided not in the hard facts of the proud suicide, which so fascinated the determined egoism of Wordsworth, but in the outspoken belief that Chatterton's medieval miracle was no counterfeit.

The main section of this essay claims that the phrase 'to build' in the imagination should make us think of Chatterton. Hence, the Blakean figure of the builder partly derives in Chatterton's hyperbolic portrait of that 'prince' of church builders, William Canynge. Chatterton's abstracted genius was grounded in a particular location as his sham portrait of Canynge adumbrates: 'The Founder of that noble Gothic Pile, Saint Mary Redclift Church in this City: the Mecenas of his time: one who could happily blend The Poet, the Painter, the Priest, and the Christian – perfect in each: a Friend to all in distress, an honor to Bristol, and a Glory to the Church' (CW, 259). The figure of the builder is ubiquitous in Chatterton's early work; for instance, in *Churches of Bristol* we find a catalogue of no fewer than fifteen ecclesiastical structures 'ybuylden'. Therefore, I will concentrate only upon those instances pertaining to St Mary Redcliffe culminating in Canynge.

I want to deal with the development of the Canynge forgeries in order of composition, but it is irresistible not to subvert chronology and start with the *Lyfe of Canynge*, which was

written towards the end of Chatterton's Rowley period. The *Lyfe of Canynge* is ostensibly a series of letters exchanged between the poet Rowley and his patron Canynge; their relevance lies in the fact that here Chatterton treats of the death of the father in the context of the building of St Mary Redcliffe:

> Inne M.CCCC.XXXII was Seyncte Maryes Chyrche begonne ande Londes yboghtenne therefore from Seyncte Catharynnes Chapele to the Howse of Seyncte Johne…
> Mie Fadre ys dead: Thys Morne at the Seventhe Clocke hee dyd sende for mee. I wente; Mie Sonne, quod he, I must nowe paie mie det. bee notte doltish in dyspense botte tentiffe ande acqyre moke Gayne as I havethe done…
> The Londe ys boughte the Maconnes hyred and alle thynges ynne readynesse. nowe
> for a wondrous Pyle to astounde the Eyne. Penne anne Entyrlude to bee plaied uponne laieynge the fyrste Stone of the buyldeynge. (CW, 229-231)

These quotations outline Chatterton's Hamlet-like obsession with the father since Chatterton fulfills his ideal father-cum-patron's commandment to pen a work of praise that is itself a memorable folly. Adjunct to the pseudo-biography, *A Brief Account*, is the weak poem *Onn oure Ladies Chirch*, which contains a dialogue between Rowley and Truth; wherein Rowley is exhorted to emulate in winged words the more solid satisfaction of Canynges's piety:

> As onn a Hylle one Eve sittynge
> At oure Ladie's Chirch mouche wonderynge
> The counynge hendie worke so fine,
> Han well nighe dazeled mine Eyne
> Quod I, some counynge Fairie hand
> Yreer'd this Chapele in this Lande;
> Full well I wote so fine a Scite,
> Was ne yreer'd of mortall Wight;
> Quod Truth Thou lackest knowlachynge
> Thou forsoth ne wotteth of the thynge
> A Reverend Fadre William Canynge hight
> Yreer'd uppe this Chappelle bright;
> And eke another in the Towne
> Where glassie bubblynge Trymme doth roun
> Quod I ne doubte for all he's given
> His Sowle will certes goe to Heaven;
> Yea, quod Troth than goe thou home
> And see Thou doe as hee hath donne
> Quod I, doubte that canne be,
> I have ne gotten Markes three

Quod Troth, as thou hast got give Almes dedes soe
Canynges and Gaunts culde doe ne moe. (CW, 53-54)

Much of Chatterton's bogus historical documentation was written with the credulous Barrett
and his *History of Bristol* in mind, a book that needed this 'new' ancient material as much
as a flatterer needs vanity. Blake informs us that to the visionary apprehension such exam-
ples of flattery can be redeemed by the relativism of belief: 'What is Suspition in one Man
is Caution in Another & Truth or Discernment in Another and in Some it is Folly'.[39] Blake
believed in Chatterton as an icon of truth, whereas we might observe with sardonic Blakean
wit that Barrett played the duped devourer to Chatterton's prolific. In *Epistle to Catcott*,
Chatterton writes that Catcott is a zealous devourer of what he takes as Gospel truth: 'Might
we not Catcott infer from hence/ Your Zeal for Scripture hath devour'd your Sense' (CW,
414). The apocryphal historical dates associated with the *A Discorse on Brystowe* purport to
raise Bristol's provincial status to the power of an imaginative resource:

> The inhabiters of Rudcleve ybuilden a Churche of Woden Warke casen with a sable Stone and
> A.D. 644 did the same dedycate to Oure Ladie and Sayncte Warreburgus beynge 6 yeeres
> after the removeal of the Inhabiters of Bright-stowe.
> It stooden by the Waterre Syde. In A.D. 789 Brightrikus or Bithric, the Woden Chyrche being
> fallen ybulden a stone one goodly to behould havyng a Towre and on eche Syde fowre square
> Wyndowes verie large ande under them Six Mascil Wyndows with Vaults for buryynge as
> ye see above but nowadaies it is fallen down. (CW, 94-95)

I am proposing that Blake's interest in the vicissitudes of St Mary Redcliffe stemmed from
the curious sensation we have on reading seemingly archaic passages like these that we are
stepping into an adolescent's English Gothic dream world.

The binary model of rise and fall, or rather, build and collapse, might be added to this
catalogue of building figures. The Canynge forgeries read as constantly reverential in tone,
which is to argue that mercantile imperialism never quite vulgarizes their spirituality. *'Stay
curyous Traveller and pass not bye'* exhorts the wayfarer to view the charitable pride of
Bristol and Western lands:

> And learn the Builder's Vertues and his name
> Of this tall Spyre in every Countye telle
> And with thy Tale the lazing Rychmen shame
> Showe howe the Glorious Canynge did excelle
> How hee good Man a Friend for Kynges became
> And gloryous paved at once the Waie to Heavn and Fame. (CW, 99)

Chatterton tells us that the builder's virtues represent something greater than the scansion of
Rowley's pen. Hence, it is significant that no one voice predominates; Chatterton speaks as

Turgot, Rowley, Canynge, but, equally, St Mary Redcliffe is not the work of a single builder. *Seyncte Maries Chyrche of the Porte* sets out the dissembling historical narrative that St Mary Redcliffe was built in 1016 by a Saxon called Eldred or at least 'somme thynkethe he allein dyd ytte begynne leevynge oders to fynyshe ytte fromme a Stone yn the Suth Walle onne whyche ytte was wrotene, Eldredus posvit primum Lapydem yn nomine patris, filii et spiritus sancti..M.XVI' (CW, 120). *Three Rowley Letters* further fabricates pure elaboration masquerading as exactitude in the stern process of detailing how a roof decayed because it was built after the Roman model:

> You desirethe of mee anne Accounte of Reddclefte I sal shewe yee thereof to mie beste know-elachynge. The Chyrche whyche ys nowe yn rewyn woulde ne bee soe dydde nee the Foulke repayre to the Orratourie of Seyncte Johann of Jerusalem the Rooffe dhereof ys myckle decayde and the reasonne dhereof ys, yatte the buylderre beeynge anne Italyanne dyd ybuylde the samme yne a Romanne mannere. (CW, 137)

Blake's Jerusalem is forever built out of love but decays due to jealousy: 'to Labour in Knowledge, is to Build up Jerusalem: and to Despise Knowledge, is to Despise Jerusalem & her Builders. And remember: He who despises & mocks a Mental Gift in another...mocks Jesus the giver of every Mental Gift'.[40] Blake's business was not to reason and compare as Dr. Johnson and the so-called experts had done but rather to create as had Chaucer: 'The characters of Chaucer's Pilgrims are the characters which compose all ages and nations: as one age falls, another rises, different to mortal sight, but to immortals only the same; for we see the same characters repeated again and again'.[41] In Chatterton's medieval vision, we often notice how what is raised-up with great labour then suffers calamitous collapse:

> The Oratourie ys overre the Yate ande maketh a Syghtelie shew haveynge a Spyre
> and Towre whereyne are 6 Belles yn the Walle ys sette on a Tablette of Brasse...the
> Spyre once falleynge havethe eraste moste Tombes of yore. (CW, 137-8)

Here we find an intersection between the fallen material world and spiritual perfection conjoined with the moral that the alpha of life-in-death understood as sculpted piety is constantly subject to the omega of denudation.

I want to suggest that Blake read Chatterton for his Romantic genius, which indicates that he interpreted his imposture as self-creation. The best commentary upon this eschatology of death and rebirth, and perhaps all those Rowleyan imitations that attempt to convert the stuff of stone into the stuff of dreams, occurs in *Fragment of a Sermon*:

> Seyncte Paule sayeth Ye are the Temple of God for the Spryte of Godde dwelleth ynne you...The Spryte or divine Wylle of Godde mooved upon the Water at creatynge...He created Menne he forslagen hem, he agen raised Menne fromm the Dust and haveth saved al Mankynde from aeterne rewyne, he raysed Chryste from the Deade he made the Worlde and

hee shall destroie ytte...Itte requirethe the Power of Godde to make a Manne a newe Creatyonn, yet suche doeth the Spyrite. (CW, 151-152)

Ostensibly, this is a Pauline sermon but it actually functions as a proto-Romantic manifesto, one that reveals Chatterton's counterfeiting of a father figure as a poetic image in which the spirit of self-creation resides. There is a strong sense of divine inspiration in Chatterton who via the proxy of this priest says that man is lent creative powers, whether of physical carving or chiseling breath, by the heavenly muse. Blake could argue in a similar vein that the human face divine should be praised in all mankind: 'the Worship of God, is honouring his gifts/ In other men...each according/ To his Genius: which is the Holy Ghost in Man' (*Jerusalem*, Ch.4, Pl:91).[42] Blake's address *To The Christians* exhorts us with these words: 'Let every Christian as much as in him lies engage himself openly & publicly before all the World in some Mental pursuit for the Building up of Jerusalem'.[43] If, in his mind's eye, Chatterton saw his father as Canynge; Blake saw his deceased brother Robert: 'Thirteen years ago I lost a brother & with his spirit I converse daily & hourly in the Spirit & See him in my rememberence in the regions of my Imagination. I hear his advice & even now write from his Dictate...every Mortal loss is an Immortal Gain. The Ruins of Time builds Mansions in Eternity'.[44] The pious builders of wondrous mansions desired eternal life in spirit, which is the theme of the *Churches of Bristol*:

> Seyncte Marie of Radclifte
> THYS Wonder of Manysons was ybuyldenne bie the nowe Mastre Canynge. whilome stood aneere theretoe twayne of Houses of Godde the one ybuylden bie Syrre Symon de Burtonne and oder One bie Lanyngeton Preeste. One wholle and of oder part were taken downe and nowe Chyrche pightenne of whyche need ne oder to bee said botte see ytte and bee astonyed (CW, 247)

In his *Epitaph on Robert Canynge*, Chatterton describes the same as, 'Thys Morneynge Starre of Radcleves rysynge Raie', a true man, good of mind yet mouldering into clay until Michael's trump when, 'He'lle wynge toe heaven' (CW, 121). The Vision of the Last Judgement was an evangelical point of reference for Blake who iconoclastically argued that ultimate reality was within the ambit of imaginative cognition: 'The Last Judgement is an Overwhelming of Bad Art & Science. Mental Things are alone Real what is Calld Corporeal Nobody Knows of its dwelling Place [it] is in Fallacy & its Existence an Imposture'.[45] It is likely that Blake read one of Tyrwhitt's editions from 1777 onwards where Chatterton's first editor wrote: 'The great difficulty is to conceive that a youth, like Chatterton, should ever have formed the plan of such an imposture.' Blake's idealism is rendered all the more militant when it is considered that in an appendix to the second edition the reader is informed that Chatterton's usage of the word *blake* is etymologically incorrect. Chatterton used it to

represent bare which in Old English was signified as *nuda* whilst *blake* actually signified either black or bleak just as it is stated in Chatterton's source, Skinner's *Etymologicon Linguae Anglicanae*. Blake's protest that reality is an imposture obstinately argues that true reality is always laid bare by visionary belief as is implied by Blake's literal interpretation of Chatterton's inaccurate cribbing.

To accept Blake's reading is to agree with Walpole that 'all the house of forgery are relations', although we must interpolate the phrase in the realm of the visionary only.[46] *The Storie of Wyllyam Canynge* is framed as a dream vision:

> Strayt was I carry'd back to Tymes of yore
> Whylst Canynge swathed yet yn fleshlie Bedde
> And saw all Actyons whych han been before
> And all the Scroll of Fate unravelled. (CW, 245)

Akin to Blake's address *To The Christians*, we catch a glimpse of, 'Imagination the real & eternal World of which this Vegetable Universe is but a faint shadow & in which we shall live in our Eternal or Imaginative Bodies, when these Vegetable Mortal Bodies are no more'.[47] The poem ends with Rowley's vision meandering towards poor Chatterton's church:

> Next Radclefte Chyrche! Oh Worke of hande of Heav'n
> Whare Canynge sheweth as an Instrumente
> Was to my bismarde Eynesyghte newlie giv'n
> 'Tis past to blazonne ytt to goode Contente.
> You that would faygn the fetyve buyldynge see
> Repayre to Redclave and contented bee (317-322)

The Parlyamente of Sprytes contains the Romantic figure of the fairy Queen Mab who according to Shakespeare helps dreamers divine the truth. Chatterton does not begin with Queen Mab eating Junkets and a ghost pulling the bedsheets as in Blake's inscriptions to Milton's *Allegro*. Instead, he describes a night-time haunting when terrible or 'ugsome' spirits walk through graveyards. The prisons of the grave open when the spirits of valorous men, 'atourne theyr Etne to Nyghte,/ And Looke on Canynge his Chyrche bryghte' (CW, 107). Queen Mab acts an intermediary between the human and the spirit pageant. She concludes her introduction by arguing that in all the 'bismarde rounde' there is nothing so well pleasing, 'As ys Goode Canynge hys Chyrche of Stone'. In *There is No Natural Religion*, Blake exclaimed: 'If it were not for the Poetic or Prophetic character the Philosophic & Experimental would soon be at the ratio of all things, & stand still unable to do other than repeat the same dull round over again'.[48] Plate 3 of *Europe a Prophecy* depicts a fairy singing: 'Five windows light the cavern'd Man'. This being proceeds to state that through

the ratio of five senses man can 'see small portions of the eternal world'.[49] This oracular elf dictates *Europe a Prophecy* in which the poet alludes to 'forests of night', 'the vineyards of red France' where 'furious terrors flew around' as 'Lions lash their wrathful tails' and 'Tigers couch upon the prey & suck the ruddy tide'.[50] Blake's prophecy portends that time is cyclic; that Enlightenment inexorably leads to revolution. In her book *The Windows of the Morning*, Lowery has suggested that these lines from Chatterton's *Epistle to the Reverend Mr. Catcott*:

Else would I ask: by what immortal pow'r
All nature was dissolved as in an hour? (CW, 416)

form part of the immortal freemasonry of *The Tyger*: (Figure 3):

What immortal hand or eye,
Dare frame thy fearful symmetry?[51]

But perhaps we also hear a pre-echo of the phrase, 'And Eternity in an hour' from *Auguries of Innocence*.[52]

It is my intention to compare Blake's criticism of the imperial, and, in particular, the tower-building figure of Nimrod, with Chatterton's *The Parlyamente of Sprytes*. Blake felt that poetry gives the lie to the man that lays an entire nation in blood for the sake of glory: 'it is not Arts that follow & attend upon Empire but Empire that attends upon & follows The Arts'.[53] This sentiment is repeated by Blake when he prophesied against the classical empires of antiquity that merely copy: 'Rome and Greece swept Art into their maw & destryd it a Warlike State never can produce Art. It will Rob & Plunder & accumulate into one place, & Translate & Copy & Buy & Sell & Criticise, but not make'.[54] In the most monumental passage of the *The Parlyamente of Sprytes*, as the artist is taken in the Valley of Vision, the spirit of the mighty Huntsman Nimrod appears:

The Rampynge Lyon, felle Tygere,
The Bocke that skyppes from Place to Place;
The Olyphaunt and Rhynocere,
Before me throughe the Greene Woode I dyd Chace-
Nymrodde as Scryptures hyght mie Name, (CW, 109)

At the time of the composition of *The Parlyamente of Sprytes*, Chatterton informed his gulls that he had sprung a mine. Although, Nimrod is famous for erecting a tower that attempted to reach heaven:

For rearynge Babelle of greete Fame,
Mie Name and Renome shalle lyven for aie
But here I spie a fyner rearynge,

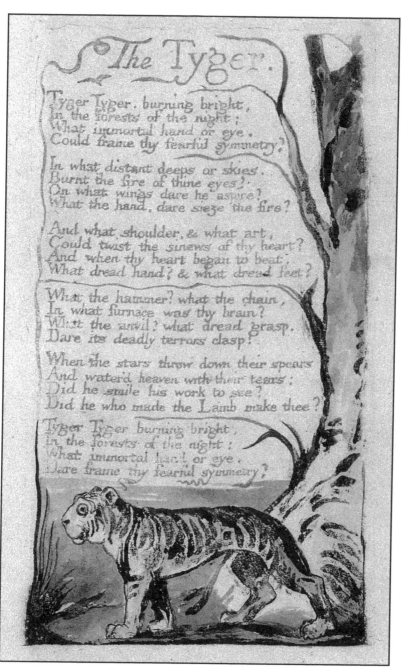

William Blake's *The Tyger.* [courtesy: British Museum]

Genst whych the Clowdes dothe not fyghte;

Onne whyche the Starres doe sytte to appearynge,

Weeke Menne thynke ytte reache the Kingdom of Lyghte (CW, 109)

Rather than spreading confusion across the face of the earth, as he does in *Jerusalem*, in Chatterton's poem Nimrod expresses a wish to change names with Canynge who has expended his worldly store so piously and, hence 'ne to goe ynto Helle'. The shade of the terrible Mesopotamian monarch has come to Bristol but unlike the sequestered riches of the orient (confiscated to build the Templer Church of Saint John of Jerusalem): 'Canynge from the Sweat of hys owne browes' 'dyd ybuylde the Temple Chyrche so fyne' (CW, 115-116). Many of the other spirits are builders of ecclesiastical structures in Bristol, including Burton who erected the second edifice on the site at Redcliffe:

Of Redclefte Chyrche the Buyldynge newe I done,

And dyd fulle manie holie Place endowe;

Of Maries House made the Foundaycon, (CW, 112)

Chatterton has Burton relate, 'Full gladde am I mie Chyrche was pyghten down' so that the present brave structure could be built in its place. (Figure 4). Merry Lamington, the penultimate builder before Canynge, modestly laments his worldly faults, that he, 'dyd not immeddle for to buylde' this curiously devised and glorious church. Elle's is the last ghostly voice to be heard; his valediction takes us from genesis to revelation:

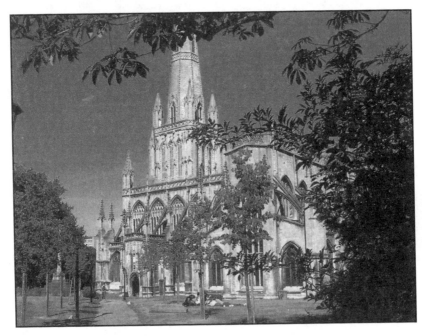

St Mary
Redcliffe
Church from
the south.

When Mychaels Trompe shall sounde to ynmoste Lande-

Affryghte the wycked and awken alle

Then Canynge ryses to eternal Reste

And fyndes hee choose on Erthe a Lyfe the beste- (CW, 116)

Destruction and regeneration form a familiar pattern in the history of St Mary Redcliffe, which is similar to the eschatology of Blake's poem. Jerusalem is based upon Ezekiel and Revelation such that Jerusalem falls to foreign invaders but is then restored when the New Jerusalem descends from heaven. Blake borrowed from Chatterton the idea of using local-ized topography against which a biblical framework is cross-referenced: (Figure 5):

Highgates heights & Hampsteads, to Poplar Hackney & Bow:

To Islington & Paddington & the Brook of Albions River

We builded Jerusalem as a City & a Temple; from Lambeth

We began our Foundations; (Ch.4, Pl:84)[55]

Blake then reveals that 'Jerusalem lies in ruins', that his spiritual Jerusalem must be built in love in order to counter the continual decay of jealousy. (Figure 6). In an unexpected coun-terpoint to Chatterton's praise, Burton prophesies that, just as his structure was pulled down, due to the envy of time, the modern St Mary Redcliffe may meet with the same dilapidated fate:

But if percase Tyme of hys dyre Envie,

Shall beate ytte to rude Walles and Throckes of Stone;

The Parlyamente of Sprytes makes us wonder with Johnson that a boy of sixteen had stored in his mind such a train of images and ideas with their comparative ease of versification and elegance of language.[56] Blake might instead have argued that in Chatterton's case exuber-ance is beauty. There seems ample evidence to propose that Chatterton's depiction of Canynge as the builder of churches in an imaginary Bristowe influenced Blake's visionary building of London as the New Jerusalem.

As a coda to my main argument, I would like to point out the discrepancy between Chatterton's journalistic portrayal of London and his self-evident love of Bristol's medieval architecture. I also wish to underline the greater love Blake demonstrates for London's Gothic architecture. The Gothic in Blake will always be associated with Westminster Abbey. (Figure 7). It was here that he saw a strange vision as the 'aisles and galleries of the old building (or sanctuary) suddenly filled with a great procession of monks and priests, choris-ters and censer-bearers, and his entranced ear heard the chant of plain-song and chorale, while the vaulted roof trembled to the sound of organ music.'[57] Chatterton pre-echoes Blake's championing of the English medieval: 'The Motive that actuates me to do this, is to

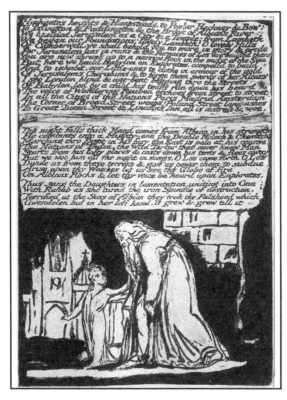

From William Blake's
Jerusalem.
[courtesy:
British Museum]

convince the World that the Monks (of whom some have so despicable an Opinion) were not such Blockheads, as generally thought and that good Poetry might be wrote, in the dark days of Superstition as well as in these more inlightened Ages' (CW, 172). The Society of Antiquaries had ordered a number of engravings of Gothic art from Basire, who sent his apprentice to Westminster Abbey in order to sketch interesting features from the interior of the edifice. These antiquaries constituted the same unusual audience for whom Chatterton concocted his Bristowe 'antiquities'.[58] As a London-based journalist, Chatterton wrote in quite a pedestrian if fashionably sublime fashion regarding Westminster Abbey: 'The tombs in Westminster abbey fill the mind with that awful reverence' (CW, 744). Blake would have whole-heartedly agreed with Chatterton in everything except tone: 'Our Churches & Abbeys are treasures of [*Spiritual riches*]' and extends this verdict to 'the Great Public Monuments in Westminster St Pauls & other Cathedrals'.[59] Chatterton could make this distinction regarding the English Gothic: 'The artillery is no unpleasing sight; if we bar reflection; and do not consider how much mischief it may do. Greenwich Hospital, and St. Paul's Cathedral, are the only structures which could reconcile me to any thing out of the gothic'

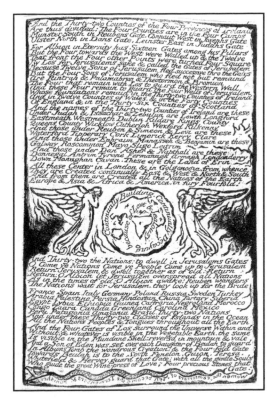

From William Blake's
Jerusalem.
[courtesy:
British Museum]

(CW, 588). In Chatterton's thoughts on London-as-journalism, as opposed to Blake's London-as-Jerusalem, we confront the question of whether Chatterton preferred Bristol or London? It seems clear that Chatterton was more in love with a Gothicized vision of Bristol-as-Bristowe.

In this essay, I have tried to outline Chatterton's role in the development of the English Romantic debate regarding the visionary imagination. While the suicide myth exercised a strong compulsion over Wordsworth and Coleridge, who was haunted by Chatterton's death, Blake was more deeply influenced by the genius of Chatterton's Gothic creations. Although Coleridge adopted an archaic diction in the first published version of *The Rime of the Ancyent Marinere*, Blake's poetry and prose more frequently echoes the mental architecture of Chatterton. In the examples considered, Wordsworth and Coleridge appropriate the Chatterton myth in order to represent the continuation or otherwise of their visionary vocations. For Blake Chatterton's figure of the builder was synonymous with vision, to the extent that his reply to Wordsworth begins to look like a defiant championing of Chatterton as a poet of visionary scope rather than as a Romantic suicide. St Mary Redcliffe stimulated the

Westminster Abbey: epitome of Blake's love of London's Gothic architecture.

Gothic imagination in Chatterton, much as Westminster Abbey had a corresponding effect upon Blake. Both were influenced by the spiritual grandeur of medieval Christianity and form a flying buttress of what is more commonly referred to as the Gothic revival. Ackroyd has argued that both their works are impregnated with these relics of the dead, venturing the idealistic statement: 'it is as if they recognized part of their own selves when they encountered the evidence of past ages'.[60] Within these Anglican edifices both writers happened

upon many different images and inscriptions from discrete historical epochs, or, as Flaxman argued: 'specimens of the magnificence of such works of the age…which forcibly direct the attention and turn the thoughts not only to other ages, but to other states of existence'.[61] To a rational mind, this might seem anachronistic, an insult to linear progression, but to Blake's Gothicized imagination it revealed the true nature of visionary reality: 'Greek Philosophy…teaches that Man is Righteous in his Vegetated Spectre: an Opinion of fatal & accursed consequence to Man, as the Ancients saw plainly by Revelation to the intire abrogation of Experimental Theory, and many believed what they saw, and Prophecied of Jesus'.[62] Blake's critique of classical philosophy is directed against empirical reason, those who would mathematically measure out dimensions as if they were the two halves of a walnut shell. According to his disciple, Samuel Palmer, Blake was passionate with regard to Gothic building: 'Everything connected with Gothic art and Churches, and their builders, was a passion with him.'[63] Palmer also reconfirms the importance of Blake's first impressions of Gothic London: 'In Westminster Abbey were his earliest and most sacred recollections. I asked him how he would like to paint on glass, for the great west window, his 'Sons of God shouting for Joy,' from his designs in the *Job*. He said, after a pause, "I could do it!" kindling at the thought.'[64] Palmer is adept in his recollection of the imaginary worlds of fiery invention that burned in the symmetry of Blake's mind. His sister noted that it was a unique characteristic of Chatterton's eyes that they 'flashed fire'. It is a moot point whether the forger did not lapse into vision:

> There was one spot in particular, full in the sight of the church, in which he seemed always to take a particular delight. He would frequently lay himself down, fix his eyes upon the church, and seem as if he were in a kind of ecstasy or trance. Then on a sudden and abruptly he would tell me, 'that steeple was burnt down by lightning; that was the place where they formerly acted plays'.[65]

From Blake's perspective, Rowley speaks through Chatterton and not Chatterton through Rowley. Hence, in 'mye Phantasie' (CW, 243) the bard of St Mary Redcliffe wrote: 'airie vysyons swarme around mie ente' (CW, 234). Which leads me to the conclusion that, proud as Lucifer, Chatterton's eyes sparkling blazed when thinking on his earliest and most sacred recollections of what must be regarded as an equivalent Westminster Abbey.

'Within a Door or Two': Iolo Morganwg, Chatterton and Bristol

6

DR MARY-ANN CONSTANTINE

Thomas Chatterton's medieval Bristol is a remarkable fusion of antiquarianism, history, poetry and invention: it is, as Donald Taylor puts it, 'an imaginary construct from books, local monuments, and local topography'.[1] Those attempting to describe the nature of this creation have reached for parallels in other literary *genres*, such as fantasy (Tolkien) or the historical romance (Scott, even Hardy). Others have claimed that Chatterton's creation is unique. Few people have noticed that the best parallel can be found much closer to home, a short boat trip across the water, in Glamorgan.[2]

The poet and stonemason Edward Williams, better known by his bardic name as Iolo Morganwg ('Ned of Glamorgan'), was born in 1747, five years before Chatterton. But when Chatterton died in 1770, Iolo, at twenty-three, was just beginning a long literary life, much of it devoted to summoning up a vision of medieval Glamorgan as intricate and passionate as Chatterton's Bristol; it was described by his biographer in 1956 as 'one of the great creations of the Romantic period in Wales'.[3] The parallels in the lives and works of the two men are striking: poets, collectors and coiners of medieval words, both were shrewd manipulators of historical sources and of historically-minded contemporaries seeking to throw light on dark ages. Like Chatterton, but over decades rather than months, Iolo constructed elaborate genealogies, rewrote the histories of local families, wove connections between them, and gave life and poetic *oeuvres* to dozens of characters who were bare names in the sources. And though Iolo's Bardic Order was envisaged as (and indeed became) a national institution for all of Wales, its centre of gravity was always Glamorgan: what Claude Rawson says about Chatterton's 'local pride' giving his work a 'mythologizing radiance' is also exactly right for Iolo.[4]

There are differences, too, in language and culture first and foremost, but this is not the place for a detailed comparison of Iolo and Chatterton as forgers of the past. I shall focus here rather on moments of proximity, where the two lives intersect and it is possible to feel the presence of Chatterton in Iolo's work. In spite of their similarities, that presence is intriguingly faint: in thousands of manuscript pages of writings in Welsh and English on every topic under the sun, Iolo rarely mentions Chatterton at length.[5] But he was well aware of the Rowley controversy and he had certainly read at least some of the poems: at one particularly difficult period in his life (like so many poverty-stricken authors before and after him) he was dangerously haunted by the thought of Chatterton's death. The most obvious connection of all, though, is that of place. Over Iolo's lifetime the fate of south Wales, and

indeed much of Iolo's own ideological positioning, was intimately (and often ambiguously) bound up with the economic and cultural dominance of Bristol.[6] Iolo came to know Bristol as a stonemason, a tradesman, a radical abolitionist, a Unitarian and an aspiring poet. He walked the city's streets from the late 1760s, when Chatterton walked them too, until the second decade of the nineteenth century, when illness and old age kept him closer to home. In that time both 'old Iolo' and the 'marvellous Boy' had become numinous literary characters in their own right: another strand that binds them to each other and to Bristol is their appearance as inspirational figures in the work of the most Bristolian of the Romantics, Coleridge and Southey.

St Mary Redcliffe is the place to start. There is no hard proof that Iolo ever visited the church, but there are compelling reasons to take him there, especially once Chatterton's death had magnetized it with literary significance. Even before then, there are tempting possibilities for an evocative near-miss. In one autobiographical draft Iolo claims that he first visited Bristol in 1765: he would have been 18, working as a mason for his father.[7] At any point between then and Chatterton's departure for London in 1770 they could have passed each other in an aisle, absorbed in their different worlds. There is perhaps a greater likelihood, however, that Iolo visited the church when he left Wales in 1773 to work as a mason in London and then Kent. In another draft he says:

> Soon after my mother died I went to Bristol, London and other places in England. My chief study during these rambles was Architecture. I have particularly studied the Gothic and am surprized to find that hardly a man living knows any thing of its true principles.[8]

To any one even mildly interested in Gothic architecture, St Mary Redcliffe is an important site; to a stonemason with a passion for the medieval, it would have been a revelation. Iolo's manuscripts contain numerous sketches and designs, usually connected with his work: urns and drapery, flourishes for headstones and chimney pieces. These, work for patrons, tend to be in the best Classical style, but a genuine interest in the Gothic appears in word-lists of Gothic terms, in sketches of arches and windows, and in more extravagant fantasy-designs (notably a 'Gothic summerhouse [...] for a Gentleman in Canada 40 miles higher up than Quebec on the River St Lawrence').[9] There are no dates to any of these (and it may be wrong to suppose that Iolo would have been much aware of Chatterton before the Tyrwhitt edition of Rowley sparked the debate in 1777), but it is not inherently unlikely that one of his many trips through Bristol could have taken him to Rowley's church.

The first datable mention of Chatterton, though, is in 1782, a peak year in the controversy. Iolo was by now in his mid-thirties, back in Glamorgan, married and trying to make a living at various trades. The letter containing his thoughts has apparently not survived, but his

correspondent is gratifyingly informative: he is Daniel Walters, son of the lexicographer John Walters, a likeable young man somewhat intoxicated by the older 'Bard Williams'. In the first letter, proposing 'a little literary correspondence between Yourself, my Brother, and me' which 'might be productive of mutual gratification, if not improvement' he asks:

> Have You ever read Rowley's (or Chatterton's) Poems? If You have not, I will send my Father and You some extracts. Be sure to say something about this in your Letter that I may not tell You what You already know.[10]

Iolo's reply (which has not survived) is conveniently summarized in the next letter:

> Your Remarks upon the <u>Chattertonian Controversy</u> are shrewd and ingenious; but yet, I confess, my sentiments do not perfectly coincide with yours on that subject. I cannot admit your idea of a <u>Third Person</u>. I argue thus: What could have induced any Third Person to usher those Poems into the world through the hands of Chatterton? For, if he supposed they would pass for the real Production of the ancient Poet to whom they were ascribed, why not put them off himself? But You will say, perhaps, that he fixed upon Chatterton, as a more proper person, from the Access which he had to the recesses of Redcliffe-church. In opposition to which I will ask You whether You think it probable that the well-known pride of Chatterton, and the Jealousy which must have arisen in a breast like his on such an occasion, would have [su]b[m]itted to act so low a part in this grand Imposture? – If, on the other hand, this <u>third person</u>, whoever he might be, thought that the world would suspect the originality of these Poems, he might be assured that all the credit of them would be given to Chatterton – in which the Mind that could produce such exquisite pieces would hardly acquiesce. – And where is this ingenious Person? What has he written besides? Has so great a Genius laid dormant ever since? – In short, I see no reason for supposing a third person to have had any concern in the matter. – I have been a Rowleyist, but am now rather inclined to Chatterton's side of the Question. Dr. Milles, Dean of Exeter, has lately published a very splendid Edition of these Poems in Quarto, with a multiplicity of Notes, the purport of which, together with a long Introductory Essay, and an Appendix, is to endeavour to prove that Rowley was the Author of them. – As You say You have transcribed only a few lines, I shall send you a passage or two, with this letter, and more another time, if you desire it.[11]

The passages included were the Chorus from *Goddwyn A Tragedie*, and stanzas from *An Excelente Balade of Charitie*: interesting and appropriate choices since both could have been read as critiques of social inequality, a topic close to Iolo's heart (the Goddwyn chorus was apparently anthologized as 'Ode to Freedom').[12] However, since according to this letter Iolo has 'transcribed only a few lines", he clearly did not own a copy of the poems: one may perhaps deduce that in 1782 he was not especially in thrall to either Chatterton or

Rowley. We do learn though that he advocated the idea of a 'Third Person', a position that seems to have been held (at least temporarily) by Dr Johnson at almost the same period.[13] As Nick Groom and others have shown, the authenticity debate rapidly succumbed to the lure of biography, with speculation built on the analysis of the slender (and often specious) psychological data:[14] Daniel Walters's reply here shows one version of the Chatterton myth fully in action, with the poet's 'well-known pride' and 'jealousy' forming a key part of his refutation. By a typical irony, his earnest argument that the poet who could turn out such pieces would hardly let someone else bask in their glory was later used by Iolo himself when arguing for the authenticity of one of his own forged medieval works:

> A beautiful piece of this kind or on any similar subject would never, we may fairly infer, have been given by any Poet to another, he would not have had the useless self-denial to deprive himself of the just fame to which his genius would be entitled. We can not perceive an adequate motive for such a conduct, but I leave to every man his opinion, mine is that the poem under consideration of Bardd Glas is authentic for of such Poetry it does not appear that we have any spurious pieces in our Language.[15]

When Chatterton's name appears elsewhere in Iolo's work it is usually in the context of his own discussions of authenticity, a topic on which he has a good deal to say, much of it alarmingly perceptive. Here (probably in the early 1800s), he is defending the honour of the Welsh manuscript tradition:

> If a great number of copies of any old MS exist it is a sufficient proof that the work has long been extant for nothing but a considerable length of time can give existence to such a number of copies, more especially if these are obviously of different ages, evinced to be so by the writing, and other appearances of colour, decay etc which art can never give, at least has not been hitherto successful in attempting to do so. Witness *Chatterton* and *Ireland*.[16]

Chatterton and the equally youthful William Ireland are dismissed as *failed* forgers. Iolo's own forgeries rely on the assumption that they are faithful copies of lost originals: he was never tempted by the messier side, the physical re-creation of the past. Elsewhere, linked dismissively with James Macpherson or John Pinkerton, the Bristol poet becomes a mere shorthand for imposture:

> it is no difficult thing to manufacture very fine Poems, and impose them on the Public for works of great Antiquity. Macpherson & Chatterton, and others of very inferior Abilities, as Pinkerton, have done this.[17]

In all Iolo's writings and letters there is to my knowledge no more detailed consideration of the Chatterton controversy; nor is there any further sign of close engagement with the poetry. That absence, in itself, is somewhat unnerving.

It does not end there. As in so many other cases, the *story* of Chatterton, of his miraculous childhood and iconic death, did affect Iolo, sometimes consciously, sometimes not. It can be detected, for example, in the way he framed his own life for public consumption. In the brief autobiographical sketch which prefaced his collection of *Poems, Lyric and Pastoral* in 1794, he describes himself in his early years as introverted and misunderstood:

> I had worked at my father's trade since I was nine years of age; but I never, from a child, associated with those of my age, never learned their diversions. I returned every night to my mother's fire-side, where I talked or read with her; if ever I walked out, it was by myself in unfrequented places, woods, the sea-shore, &c. for I was very pensive, melancholy, and very stupid, as all but my mother thought.[18]

('What was supposed to be dullness in Chatterton was genius', as John Davis would put it succinctly in 1806).[19] And like Chatterton, famously reluctant to read until he learned the alphabet 'from an old Folio music book', Iolo claimed that *he* learned to read:

> In a volume of Songs, intituled The Vocal Miscellany; for, I could not be prevailed upon to be taught from any other book. My mother sang agreeably, and I understood that she learned her songs from this book, which made me so very desirous of learning it. This I did in a short time, and hence, I doubt not, my original turn for poetry.[20]

The many surviving drafts of this piece show how hard Iolo struggled to create a self-portrait which would appeal to a broad range of subscribers, but because these constituted such an extraordinarily broad range, the portrait is, like the volume, fraught with conflict. If the Hannah Mores and Elizabeth Montagus (and indeed, the dedicatee himself, the Prince of Wales) were intended to see and approve of the hard-working, plain-living, self-taught journeyman stonemason, and if the Romantically-inclined were intended to see a Welsh Burns, a lyrical child of Nature and a Genius in the Chattertonian mould, there was still enough of the angry and resentful Jacobin (who, with 'an Ancient Briton's warm pride' rejected patronage in all its forms) for fellow radicals to take the book as a token of solidarity with anti-Establishment causes.[21]

The violent dualities of this volume are a pertinent example of what Bridget Keegan has described as the 'double-voiced' nature of the self-taught tradition, which strains to combine a demotic 'authenticity' with the acceptable language of high literature. The virtual impossibility of achieving this in practice meant that the lives and works of writers like John Clare or Ann Yearsley (the 'Bristol Milkmaid') were riven with anxieties about identity and ownership of their poetic voices, and Iolo's work at this period is no exception.[22] The numerous drafts of the preface and other unpublished writings (such as draft letters to potential subscribers which tail off in spluttering rage)[23] give some indication of the strain he came under

over the two or three years he spent getting the work through the press. The initial process of collecting subscriptions for his book involved assiduous cultivation of the gentry in Bath and Bristol, and at this period he came into contact with writers and notables such as Hannah More, Harriet Bowdler, Hester Lynch Piozzi and Christopher Anstey. He may or may not have met Ann Yearsley, who sent her name for the list in the summer of 1791, but he certainly claimed later to have discussed her 'frequently' with Hannah More (since Yearsley had by then publicly and acrimoniously split from her erstwhile patroness, one would give much to know how those conversations went).[24] Success with the *beau monde* was alternately exhilarating and intolerable. The same summer of 1791 saw him jeopardize the future of his work with an impulsive display of principle in the form of an open letter to several Bristol printers, withdrawing the subscription lists he had left in their shops lest they be contaminated by names from a blood-tainted city:

> for it is my fixed resolution not to disgrace my list with the names of any villainous abettors of the slave trade, who so exultingly rejoiced lately in your City, on the failure of the humane Mr Wilberforces Bill for the abolition of that inhuman traffic, for which Bristol is and always has been, so remarkably infamous.[25]

The results of this gesture do not seem to have harmed his prospects too badly, and the final list weighed in at over six hundred and fifty names ('Humanity's Wilberforce' proudly capitalized amongst them).[26]

Most importantly, Iolo's decision to publish his poems and try to make a career as a writer took him, as it had taken Chatterton two decades earlier, from Bristol to London – the difference being that Iolo was now well into his forties, with a wife and four children at home in the cottage in Flemingstone. His literary contacts with the London Welsh had often brought him to the capital, but between 1792 and 1795 he was effectively based there. This period, as Geraint Phillips has convincingly shown, was when Chatterton really came to haunt him. Early in 1792 Iolo was living with the lexicographer William Owen (later William Owen Pughe) and his family in Pentonville. But by the summer he had moved out to cheap accommodation in – of all places – 'Beachamp Street, Brook's Market, Holborn', hardly a stone's throw from the room where Chatterton had died twenty years earlier. Not surprisingly, this proved to be a bad move. In July he wrote to his wife Peggy:

> Let me know immediately the first line of your letter whether my dear little children are all or any of them living, It has been for many months so fixed in my imagination that some if not all of them are dead that I have not been able to do any thing, but what trifles could be done in a very few days that I have been able to get the better of such thoughts, I have this three weeks had a sheet to correct, but am not able to look at it I rise in the Morning early, for I never sleep, and walk about I know not where, often to the fields where I lie down under

a hedge, I then come home, and pass the night in a manner so distressing that it will soon bring me to the grave.[27]

A month later he was still in turmoil, the obsession with his children's health still paramount. There are darker hints, too, in the invocation of Chatterton's name:

tell me sincerely whether the little ones are alive. I cannot possibly put it for two minutes together out of my thoughts but that they are dead [...] I should not have been in this world now but from the hopes of still being of some help to them. It was from this street, and within a door or two, that poor *Chatterton* was obliged to force his way out of this good-for-nothing world. [28]

In October he is still wretched and Chatterton is still on his mind. He complains of his cold and uncomfortable lodgings, of lack of sleep and 'a perpetual pain' in his head:

laudanum gives me no relief but rather increases the internal heat in my head, you can not imagine how effectually this disables me from doing any thing [..] I have but one hope left now, which is that I shall soon die, for it is impossible for me to be relieved any other way. send me one letter more, and let me see in it the names of my dear little ones, I shall never see their faces again. Poor Chatterton who lived and died almost the next door to where I am, found means, like myself, to keep his distresses unknown. There are some in this street that knew him well, he could not complain, and I can not, if I could, I have some reasons to think that things would have been otherwise than they are with me now. One letter more to inform me how you are, and how the little ones [...] [29]

Iolo invariably exaggerates his miseries when writing to Peggy, but this cannot be entirely dismissed as a defence-mechanism against guilt. It is certainly, as Geraint Phillips has shown, testimony to the effect of laudanum on his naturally lively paranoia; a justified fear of harassment by government spies cannot have helped him either. But the influence of Chatterton himself is equally potent: self-identification is evident at every turn, in the description of the lodging, the poverty and mental anguish and, highly untypically, the hints at suicide.[30] Chatterton here is much more than a figure of speech – Iolo had even talked to the neighbours regarding him. This is a real haunting, akin to the 'Ghosts of Otway & Chatterton, & the phantasms of a Wife broken-hearted, & a hunger-bitten Baby!' that pursued the hysterical and newly-wed Coleridge in 1796.[31] Iolo seems to have spent the second half of 1792 in a state of nervous collapse, painfully incapable of marking proof sheets, drafting the preface, or answering letters for long periods at a time. A rumour started that he had in fact absconded to America with the subscription money, and it was perhaps this (and a timely gift of eight guineas from Harriet Bowdler) which roused him to furious action: the preface as finally published begins with a vitriolic refutation of this story. The American connection was plausible enough, since, like many other radicals (his acquaintance Joseph

Priestley most notably among them), Iolo was seriously considering emigration, and had plans for an egalitarian commune on the banks of the Mississippi. The same is also true of Coleridge and Southey who had sketched out plans for a utopian society named Pantisocracy, which was to be founded near the head of the Susquehanna in Pennsylvania. Amongst the London Welsh, all such transatlantic schemes now had the added dimension of Madoc fever' – the recently-revived hunt for a lost tribe of Welsh-speaking American Indians, supposed descendants of a group of exiles who had left Wales in the twelfth century with Madoc, Prince of Gwynedd. Iolo Morganwg and William Owen Pughe played pivotal parts in the collection and dissemination (and, in Iolo's case, invention) of information relevant to the search for these 'Madogwys'. Indeed, in 1791 and early into 1792 Iolo fully intended making the expedition himself, preparing for the rigours of the wilderness by sleeping rough and eating nuts and berries. His breakdown over the summer put a stop to that.[32]

It is not yet clear exactly when Iolo met Robert Southey, but the Madoc story is their obvious point of contact: they certainly knew each other by 1797, and several things point to a period fairly soon after the publication of Iolo's own poems. Southey was in Bristol and working on an early version of his epic poem *Madoc* (copies were even circulating in manuscript) in 1795, at exactly the time that Iolo, now a published poet (though still an impoverished one) and with a declared interest in the legend, returned to the south west. He seems, in fact, to have come back to Glamorgan via Bristol at a particularly interesting moment. Judging from the dates of letters to his wife, he could well have encountered Coleridge on this return journey, stopping off to hear his 'Lecture on the Slave-Trade' at the Assembly Rooms down by the quay before catching the boat home.[33] It is hard to think of a more appropriate venue for their meeting than this focal point of arrivals and departures, the crossing for Glamorgan and America, a harbour of tainted commerce and of idealistic settings-out.

Whatever the circumstances of their first encounter (and it may, more prosaically, have taken place later in the drawing room of any of several mutual friends in radical and Unitarian circles, such as George Dyer or John Prior Estlin) Iolo did become a 'character' on the English Romantic scene. Recent work by Damian Walford Davies has uncovered a curiously disconcerting picture of the 'Welsh Bard' through English eyes. Coleridge, for example, alludes to an incident involving William Godwin, from which Iolo emerges as a highly sensitive and 'very meek' man, with an almost religious devotion to the memory of his mother; Southey's account of him, written just after Iolo's death, is not dissimilar:

> Poor fellow! with a wild heart and a warm head, he had the simplicity of a child and the tenderness of a woman, and more knowledge of the traditions and antiquities of his own country than it is to be feared will ever be possessed by anyone after him.[34]

Though not unlike the benign old man evoked in the memoirs of Elijah Waring, this is not how Iolo Morganwg was seen by his Welsh contemporaries.[35] Indeed, it is as hard to reconcile the 'child-like' Iolo with the often bitter character who emerges from the letters and writings, as it was for Meyerstein to square eighteenth- and nineteenth-century judgements of Chatterton:

> This unfortunate person, though certainly a most extraordinary genius, seems yet to have been a most ungracious composition. He was violent and impetuous to a strange degree [...] he appears to have had a portion of ill-humour and spleen more than enough for a youth of 17.[36]

That 1784 description could be Iolo, seen through the eyes of many friends and contemporaries whom he let down, insulted or unfairly accused. 'Poor Williams – a very meek man', on the other hand, is not so far from the lyricism of the 'poor unshelter'd Head' of Coleridge's 1794 version of *A Monody on the Death of Chatterton*.[37] Unlike Chatterton, of course, Iolo actively colluded in the process of his own sentimentalization; once again, the split voices of *Poems, Lyric and Pastoral* point to a complex negotiation of identities at political, personal and cultural levels. Southey's 'feminizing' of the Welsh bard ('the tenderness of a woman') can also be seen as a correlative of the colonial tensions at the uneasy heart of *Madoc*.

Of all the English poets, Southey, with his explicitly Welsh project, was Iolo's keenest admirer. Quite apart from his use of the legend itself, he worked a great deal of Iolo's bardic esoterica (much of it obtained through William Owen Pughe) into his epic, and gave 'old Iolo' himself a cameo role as healer to the wounded Aztec leader (Book 8, lines 3-7). In 1802 he was tempted enough by south Wales to consider renting a house in the Vale of Neath, but not long after this, as his politics changed, he fell out of favour with his Welsh acquaintances. In 1805 William Owen Pughe noted disparagingly, 'Mr. Southey's Madoc I understand will be published in a few days in a splendid 4to. volume which none but the rich can get', and in 1813, unimpressed by his acceptance of the Laureateship, Iolo remarked to his son that Southey was 'gone to the Devil' (as Caroline Franklin notes wryly, he was 'not speaking metaphorically').[38] But it is Southey, aptly enough, who provides the final datable link between Iolo and Chatterton.

In a letter written in 1803, David Davis tells Iolo: 'I brought with me from Bristol, a set of Chatterton's works, which Mr. Southey begged me to give you, with his best respects'.[39] This was Southey's and Joseph Cottle's long-projected three-volume edition of *The Works of Thomas Chatterton,* intended as a source of income for the poet's surviving family. In the short Preface, amongst other acknowledgements, appears the following:

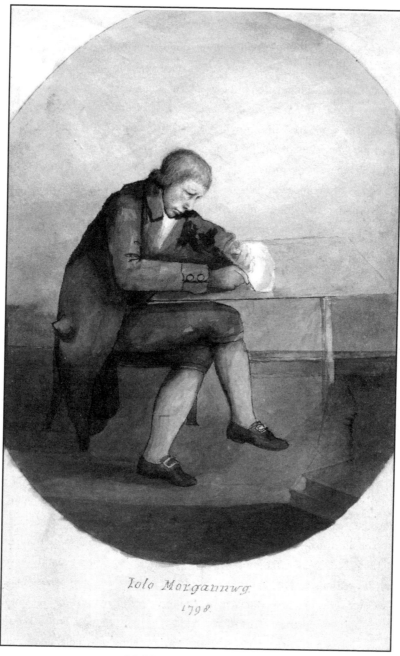

Iolo Morganwyg at the age of 50.

The Catch, by Chatterton's father, was received from Edward Williams, the Welch Bard; a man who, for his genius and learning and worth, is here mentioned with respect and regard.

This 'mention' is out of all proportion with the importance of the contribution (which, not even part of the poet's own *oeuvre*, demonstrates once again how much the Chatterton myth entailed the talismanic accumulation of biographical scraps). As Meyerstein notes, the catch appeared in the *European Magazine* in March 1792. It is introduced there as 'A Catch for Three Voices. The words and music by Mr. Chatterton (Father to Thomas Chatterton the Poet) one of the Choristers of Bristol Cathedral, and not Sexton of St. Mary Redcliffe, as commonly said'; there is no further context and no contributor is mentioned. There are at least three copies of the piece in the Iolo manuscripts, though why he should have written out this little drinking song for members of the Pine-Apple Club is hard to fathom. Nor is it obvious why, or indeed when, he may have sent it to Southey.[40] But it is certainly easier to imagine Iolo copying it out as a curiosity, and a few years later sending it off to Southey and Cottle, than to think he was the initial contributor, or indeed the only begetter. After all, if Iolo had wanted to fake Chattertoniana, he was as well-placed as anyone, and better qualified than most.

The larger question remains unanswered: did Thomas Chatterton inspire Iolo the forger, as he clearly inspired the young William Ireland? Iolo's biographer G. J. Williams played very briefly with the idea in a footnote in 1956, and rejected it.[41] It is true that the hundreds of volumes of manuscripts that piled up in the cottage in Flemingstone reveal no direct evidence for close reading or admiration of the poetry, and there is nothing (the lost letter to Daniel Walters excepted) to show that Iolo ever discussed Chatterton's creations in any but dismissive and general terms – a symptom of what, damningly, he called 'the present age of forgery'. And yet, all the time that he was himself faking medieval poems and inventing druidic triads, two major authenticity debates were rumbling on, one of them on his doorstep in a city he knew extremely well. Iolo covered his own traces with exceptional skill (his own son, who piously edited reams of bardic material for the influential *Iolo Manuscripts* published in 1848, had no idea that most of it was fiction), and he may simply have avoided Chatterton for reasons of self-preservation. But until something more substantial than the Pineapple Catch turns up, the parallels between the two of them must remain simply as parallels (though no less instructive for that). What is certain, though, is that the Chatterton myth affected Iolo's public version of himself as a struggling provincial poet, and, at a particularly troubled period in his life, was fully internalised.

One final example of the threads that weave the two men together can be found in a piece from Iolo's manuscripts titled: 'Cursory observations on Brandon Hill, Cliffton Hill etc. near

Bristol, Dec 19th 1791'. This is a vivid and fascinating page and half on the presumed 'eruption of Brandon Hill', and the 'Earthquake [...] which caused that prodigious chasm [...] seperating Cliffton hill from Leigh Down' in which Iolo combines geological and antiquarian speculation with a brief survey of early Welsh sources that might throw light on the date of the supposed earthquake. But it is the abrupt outburst at the very end of the piece that claims attention here:

> *Stupid Bristol* that never noticed the wonderful curiosities of nature that abound so much in every corner about it, almost if not entirely beyond what is to be met with in any part of Britain, and which crowdingly obtrude themselves so much on the half-opened eye, that one is astonished to think how the Demon of Idiotic Dullness could, with Barrett, pass by them daily without the least attention.[42]

Chatterton, who also stood on Brandon Hill and was depressed by a dull Bristol 'unconscious of the wealth she bears' (CW, 343), would have enjoyed that swipe at his hapless mentor, William Barrett, whose *History and Antiquities of the City of Bristol* (1789), packed with Chattertonian impostures, is here the object of Iolo's scorn. It is perhaps unlikely that two such 'violent and impetuous' types would have appreciated each other's company, but in Iolo's vivid description of Bristol's early British past, as well as in his reimagined Glamorgan, Chatterton would surely have recognized a quality of historical vision, a way of looking, that sets places and landscapes aglow.

The Death of Chatterton

7 DR NICK GROOM

How did Thomas Chatterton die? The standard answer is that he (famously, notoriously) committed suicide out of despair at his poverty and being refused credit at the baker's, out of bitterness at his failure to get published, and because he was mad; and he did so by taking arsenic. Robert Southey, for example, spent a lifetime attempting to collect evidence to show that Chatterton's character was 'solved by madness', and that it was this that drove him to kill himself at the age of seventeen.[1] The irresistible Henry Wallis painting of the young poet dead athwart his bed, with paper shredded and cast about the room and the fatal bottle of poison lately dropped from his lifeless hand, is the iconic image of neglected genius and Romantic suicide. This scene, painted by Wallis in the very room in which Chatterton died, is the embodiment of a Pre-Raphaelite myth.[2] And so in the popular imagination, Chatterton is certainly far more famous for committing suicide than for anything he actually wrote.

But over the past sixty years increasing speculation supported by new research has begun to challenge the suicide case. Chatterton's great apologist, the biographer E.H.W. Meyerstein, may have assumed suicide throughout his *Life of Chatterton* (1930), but within a few years a theory of accidental death by medicinal arsenic had been proposed by Neil Bell in a novel called *Cover His Face* (1943). Bell laments in his 'Postscript'

> because of indifference, because of fear, because of wild words spoken and written as poets will speak and write (Shelley was for ever talking of taking his life), and because there was no one to care, the stigma of suicide was cast upon this marvellous boy who had boasted to his sister that poets don't commit suicide: they were too tough. He might have added that geniuses do not take their own lives; they are too much alive; the life runs too strongly in their veins for them to surrender it to circumstance, or fate, however hard and bitter.[3]

Less than a decade later in 1952, Donald Taylor (whose monumental edition of *The Complete Works* appeared in 1971) published an analysis of Chatterton's financial transactions recorded in his memorandum book to argue that Chatterton was not impoverished at the time of his death. He also produced forensic evidence to establish that a stain in the book, found on Chatterton's person at the time of his death, contained traces of opium.[4] In 1970, on the two-hundredth anniversary of his death, Richard Holmes first seriously argued that it was an accidental overdose that killed Chatterton.[5] Since then the evidence has grown, despite being rejected (or perhaps just overlooked) by subsequent biographers and many critics.[6] The persistence of the suicide myth is remarkable; it also brings out the worst in crit-

ics – Tom Paulin, for example, has rashly dismissed Holmes's pioneering essay as 'point-less'.[7] Surely the point is that if Chatterton's suicide is a myth, the ceaseless promotion of this myth makes the Romantic conception of the poet as a self-destructive genius a poten-tially fictitious construct, which nevertheless enforces an ideology of self-conscious extrem-ity that has since helped to mould literary history.

The aim of this essay, then, is simply to examine the circumstances surrounding the death of Chatterton and to determine whether there are grounds for a reassessment. Despite a gradual trend of opinion among certain academics that has increasingly rejected the sui-cide scenario in favour of accidental death, it is worth noting that the evidence for Chatterton's cause of death has not been comprehensively presented, and that therefore the accidental death theory runs the risk of becoming the new orthodoxy without ever being fully expounded. This then is a preliminary attempt to gather the evidence and present the hearsay case for his non-suicidal death as a coherent argument. I shall be principally shad-owing two scholars, as at this stage I am presenting a reinterpretation rather than new facts: E.H.W. Meyerstein, whose biography remains after over 70 years the standard *Life*, and Donald Taylor's magisterial edition. Neither Meyerstein nor Taylor give much credence to mention of suicide in Chatterton's works or in anecdotes of his life. While these require some attention, they remain a footnote to the following account.[8]

For all the undoubted strengths of E.H.W. Meyerstein's magnificent biography, he was writing at a time when no one doubted that Chatterton had committed suicide. Yet all of Meyerstein's arguments for this state of mortal affairs now seem at best tenuous, at worst pandering to a lingering myth. Of his life in London, Meyerstein inevitably sees Chatterton as doomed from the outset: 'The jaunty, swaggering tone of his London correspondence, possibly the earliest missives he had sent to his folk, covers, in my idea, an almost complete disillusionment, an ingrained pessimism, coupled with a desire to keep Bristol at bay.'[9] But this was the same Chatterton who was 'the only person writing poetry in the April [1770] number' of the *Freeholder's Magazine*, and Meyerstein does admit that 'it is hard to find in the Chatterton of 1770 any traces of a mind unhinged'.[10] He notes Chatterton's habit of stay-ing up all night writing, and his meagre vegetarian diet, but also applauds the disinterested detachment of his journalism and the chameleon-like versatility of his political hackwork: 'A character is now unnecessary,' as Chatterton famously remarked to his sister, 'an author carries his character in his pen.'[11] This is a daringly cynical and superbly pragmatic writing manifesto for a young blood now 'raving in the Lunacy of Ink'.[12]

He also did well out of his career in London as a journalist. Michael Suarez has demon-strated that Chatterton had already published 31 titles in seven different journals (five of

which were published in London) before he even arrived in the capital, late in April 1770.[13] This is a remarkable record of publication, and was to continue – increasing to a total of 56 pieces over the next four months – by which time he had also been commissioned to edit and revise William Maitland's *History and Survey of London*, first published in 1739.

Chatterton was therefore making money – apparently £4 15s 9d during May 1770, and more to the point he was already owed as much as £10 17s 6d.[14] His lodgings were cheap: he was staying with a relative in Shoreditch and sharing his room and could not have been paying much more than a couple of shillings rent – after all, a family could live on a pound a week. Roy Porter warns against trying to give modern equivalents of eighteenth-century prices, but for a rough guide suggests multiplying eighteenth-century figures by a factor of 60-80.[15] So, Chatterton's earnings for that one month were highly respectable and would already have given him some security. He ate little and if he followed his simple diet as he had in Bristol and also abstained from alcohol, he would have had enough to live moderately well for months. A further sum of £2 12s 6d is listed in his pocket-book, which may indicate further earnings. Although Chatterton declared himself 'ruined' at the death of the Lord Mayor Beckford, he later claimed to have made £3 13s 6d on that gentleman's death – again a considerable sum.[16] And when Chatterton moved to Brooke Street in mid-June to a single-occupancy garret at 6s a week (apparently rising to 8s 6d) it was when he received 5gns for *The Revenge*.[17] In this context, the presents he bought for his family – comprising crockery for his mother, a fan for his sister, tobacco for his grandmother, and a few other trinkets – were easily affordable and palpable evidence of his success.

These figures should admittedly be treated with scepticism, but nevertheless do show a steady income. Moreover, after Chatterton's death Michael Lort interviewed the Hamilton father and son publishing dynasty, and they revealed that they had sent him money for his work in the *Middlesex Journal*.[18] The notice of *Love and Madness* in the Hamiltons' *Critical Review* for 1782 emphatically declares that 'he *did not die for want*'.[19] Archibald Hamilton senior, wealthy proprietor of the *Critical*, later confided that he had sent a guinea to Chatterton, with a promise of more funds forthcoming. Despite glowing reports on Hamilton senior's character and largesse, Meyerstein unaccountably doubts that this advance was ever received.[20]

Chatterton's accounts were being kept in good order, he was writing publishable material, so how did he come to die on the night of August 24? The coroner's verdict was that Chatterton 'swallowed arsenick in water, on the 24th of August, 1770, and died, in consequence thereof, the next day'.[21] The inquest probably took place at the Three Tuns public house in Brooke Street (or possibly at the Cordwainers Arms). The jury declared him a *non*

compos mentis suicide. He was buried in Shoe-Lane burying ground, interred on August 28.

As Michael MacDonald and Terence Murphy argue in *Sleepless Souls*, to be convicted of felonious suicide, which was penalized by the forfeiture of all goods and ritual desecration of the corpse, one had to be sane (*felo de se*): 'Men and women who slew themselves when they were mad or otherwise mentally incompetent were not convicted of their crime' (being *non compos mentis*).[22] This latter verdict was very seldom handed down in the sixteenth and seventeenth centuries, but thereafter increasingly predominated, as attitudes to the significance of suicide changed and it became intimately associated with medical and psychological disturbance: 'over 97 per cent of the suicides recorded in the last three decades of the eighteenth century were declared to have been lunatics.'[23] Some of his effects, such as his pocketbook containing his accounts, were sent back to his family – presumably with any remaining money.

But that was not the end of the affair, and there were a number of investigations: primarily by the antiquary Michael Lort and shortly afterwards by the author Herbert Croft, a writer whose obsession with Chatterton led him to purloin manuscripts from the dead poet's own mother and sister and then publish them in a sensational novel, *Love and Madness* (1780). Croft tracked down the coroner and interviewed him in 1780, but unfortunately after a decade he could not trace the witnesses (Frederick Angell, Mary Foster and William Hamsley) and just got the 'arsenick in water' verdict. Of more use, however, was the account of Mrs Wolfe, the Brooke Street barber's wife. She told Croft that Mrs Angell had told her that the boy had not eaten for two or three days and even haughtily refused dinner when she offered it.[24] This sort of tale-telling is far removed from the scene of death and is perhaps just worthless gossip, although it is possibly borne out by Mr Cross the apothecary's anecdote that he purchased a barrel of oysters that Chatterton devoured '*most voraciously*'.[25] Perhaps he was starving, but it is alarming that Mrs Wolfe later changed her story and declared that Chatterton had killed himself because the baker had refused him a loaf on credit. The enhancement of Mrs Wolfe's story, in which Chatterton's situation moves rapidly from declining an informal supper invitation to begging for a crust, was accepted by both Horace Walpole and Thomas Warton – indeed Warton attributes the information that the boy 'died for want of bread' to Cross the apothecary. Bearing in mind Cross's franker account to Lort (quoted below) it would appear that by the time Walpole and Warton came knocking, the loaf story had achieved an iconic status as a Brooke Street myth.[26]

To return briefly to the garrulous Mrs Wolfe's original story. Chatterton's refusal of a meal might simply indicate that his relationship with his landlady was complicated. She was the madame of the house – quite literally so: Chatterton occupied the garret in a bawdy house. He had boasted (perhaps in horseplay) to George Catcott in an innuendo-laden letter

that he had already taken certain liberties with her ('one Night... I made bold to advance my hand under her covered way') and that she had also raised his rent to the unlikely and astronomical sum of 8s 6d 'for finding I had Connections with one of her Assistants'.[27] All this may simply be *braggadocio*, but it does suggest that there was some inevitable sexual tension in the house, and that Chatterton might well have felt compromised by being invited to dine. And in any case, as his eating habits were both frugal and eccentric they were possibly a subject of ridicule among Mrs Angell and her 'Assistants'.

Common consent, however, followed Mrs Wolfe: Chatterton had killed himself through mad pride. Dissenters were silenced. Thomas Tyrwhitt in the 1777 edition of the Rowley poems was admirably cautious: 'He was soon reduced to real indigence; from which he was relieved by death (in what manner is not certainly known), on the 24th of August, or thereabout.'[28] This suggestive remark, among the earliest printed, speaks volumes by leaving the question open. Within the year, however, the editor of Chatterton's *Miscellanies in Prose and Verse* was confidently asserting that

> Every effort appears to have been insufficient to ward off the approach of poverty.... He continued drudging for the booksellers for a few months, when at last, oppressed with poverty and disease, in a fit of despair, he put an end to his existence in the month of August, 1770, with a dose of poison.[29]

Likewise, Chatterton's Bristol patron William Barrett wrote in his *History of Bristol* (1789, published almost twenty years after the event):

> The same pride, the same principles impelled him to become his own executioner. He took a large dose of opium, some of which was picked out from between his teeth after death, and he was found the next morning a most horrid spectacle, with limbs and features distorted as after convulsions, a frightful and ghastly corpse.[30]

This passage complicates matters. Barrett does not mention the arsenic – perhaps he assumed that by now this was common knowledge. Moreover, even in a lethal dose opium would not cause convulsions, which Barrett – a surgeon – would know.[31] It is worth pointing out that up to the eighteenth century, arsenic was the poisoner's drug of choice, whereas after the eighteenth century it was opium, and so some confusion over the agent of destruction in the case of Chatterton's death is to be expected.[32] But Barrett had very much his own theory: he said to Lort that after he had refused to write Chatterton a reference to enable him to go to sea as a ship's doctor, 'in great distress, he [Chatterton] first employed himself a whole day in tearing all his manuscripts to pieces, and then poisoned himself'.[33] The notion of going away to sea is not as preposterous as it sounds – the suggestion is made in Chatterton's last letter to Catcott: 'I intend going abroad as a Surgeon, Mr. Barratt [*sic*] has it in his Power to

assist me greatly by giving me a Physical Character; I hope he will.'[34]

Barrett refused and the next thing he heard was that Chatterton had committed suicide. Despite Chatterton's apparent eagerness to travel, it is surely too much to imagine that he would kill himself for not acquiring a letter of recommendation, and as a friend of Cross the apothecary he presumably could have had introductions to medical men in London itself.

What is particularly unlikely about Barrett's account is his ludicrous claim that Chatterton then spent 'a whole day' ripping up his poems. This is at best a crazy exaggeration of the amount that Chatterton had written and shredded, and readily indicates Barrett's opinion of poetry as compared with medicine – but the comment does remind one that the floor of Chatterton's garret was indeed covered with scraps of paper when it was broken into the morning after he died. It is tempting to speculate what might have been lost: if Chatterton had indeed shredded everything in a frenzy of despair before killing himself, such an action would lend credence to the theory that he deliberately poisoned himself.

It is worth pointing out immediately that two versified suicide notes have since turned up, suggesting that Chatterton did not destroy everything: 'Naked and friendless' first appeared on the twenty-fifth anniversary of his death (24 August 1795), and 'Farewell, Bristolia's dingy piles of brick' was published by John Dix in 1837 in his biography of the poet. But of course there cannot be two sets of 'Last Verses', and indeed every serious commentator has comprehensively rejected both texts (despite this, they continue to be republished – ironically more often than his own poetry does).[35] But their existence, even as forgeries, also points to a small contradiction in the suicide case. Suicide notes, wills, final verses are all indisputable evidence for a deliberate suicide – indeed they are a necessary part of the narrative of suicide, which is why they have been forged more than once – and Chatterton also had a track record of producing suicide notes, however satirical. But such textual witnesses do not lie comfortably with the claim that the poet tore all his manuscripts to pieces.

Furthermore, some papers certainly did survive: Chatterton's copy of Alexander Catcott's *Treatise on the Deluge* (1756), into which he had copied five poems (including 'Heccar and Gaira') was removed from the fatal garret by John Oldham, and one would have reasonably supposed Oldham to have copied any 'Last Verses' that were extant.[36] It is worth noting that, perhaps in imitation of the St Mary Redcliffe muniment room in which he had claimed to have discovered the medieval Rowley papers, Chatterton habitually worked with shredded paper over the floor: he had left his Shoreditch lodgings with the room covered with such rejected 'poettings'.[37] Later, Tyrwhitt was 'credibly informed' that there were no Rowley parchments on the floor, and in any case Meyerstein could not believe that Chatterton would have destroyed anything that might have offered him fame – if only

posthumous: 'What he did destroy he, no doubt, thought bad'.[38] A memorandum of identi-fiable lost works compiled by Lort records very little: 'The Flight' (a 240-line poem to Lord Bute), and 'The Dowager' (a fragment of a satirical tragedy on Bute and Cumberland).[39] If Chatterton did commit suicide, then this did not follow a systematic destruction of his liter-ary corpus, which would have supported the theory that he was in despair – or mad, and nei-ther did he write any verifiable suicide note or last verses. Perhaps the only indication that he was suffering in poverty was the pauper's burial he received.

Nevertheless, Meyerstein was to agree with the suicide verdict:

> I am satisfied that, apart from the denial of the loaf, his constitutional melancholy, exasper-ated by lack of sleep, delays in payment, and the agony, at this juncture, with the burletta unperformed, of keeping up the farce of brilliant success which had run through all his let-ters home, drove him to this, not the least among the regular objects of his contemplation.[40]

The denial of the loaf we have dealt with. Chatterton does seem to have suffered from a 'constitutional melancholy', which is well attested by contemporaries:

> He sometimes seemed wild, abstracted, incoherent; at others he had a settled gloominess in his countenance, the sure presage of his fatal resolution. In short, this was the very tempera-ment and constitution from which we should, in similar circumstances, expect the same event.[41]

Still, even melancholia does not inevitably lead to self-destruction. The 'lack of sleep' refers to his habits in Shoreditch of sleeping little and of writing by the light of the moon. This may be exaggerated, and in any case it is not clear how it would necessarily lead to suicide. The 'delays in payment' claimed here are speculative delays, as Meyerstein is endeavouring to explain how Chatterton could be earning enough to move to more expensive lodgings, and yet at the same time be too poor to buy himself bread. The burletta mentioned is *The Revenge*, for which he had already received a further five guineas, although it had probably not yet been performed. And finally, among such 'regular objects of his contemplation' was, Meyerstein argues, the poison arsenic. He reprints three pieces of circumstantial literary evi-dence to suggest that Chatterton was thinking and writing about arsenic in the last three weeks of his life; two pieces are in fact comic pieces on venereal disease, but 'The False Step' certainly does contain the killing of a character by an apothecary who accidentally pro-vided arsenic instead of magnesia. This is not, however, a suicide, and the other two pieces have been rejected from the canon by Taylor.

But he did die, by all accounts save possibly Barrett's, by arsenic. What was he doing with the arsenic, though – poisoning rats? He certainly purchased something arsenical, as Mr Cross the apothecary later confirmed to Lort:

Mr. Cross says he had the Foul Disease which he wd cure himself and had calomel and vitriol of Cross for that purpose. Who cautioned him against the too free use of these, particularly the latter. He loved talking about religion and to argue against Christianity, saying that he meant to turn Mahometan. This circumstance Cross turned after his death to some account, for being found dead in his bed and to all appearance poisoned, when the Jury sat on the body Cross urged this among other things to prove he was out of his senses.[42]

This is a significant testimony and Bell, interestingly enough, makes much of the relationship between Chatterton and Cross, based partly on the former's interest in medicine. Chatterton's high spirits certainly shine through in Cross's memoir: he was argumentative, controversial, outrageous – threatening (tongue-in-cheek) to 'turn Mahometan' – but Cross rewrites history and uses this to suggest that the young poet was certifiably insane, as opposed simply to being an intellectual rebel who enjoyed provoking debate. But at least this confirms why his corpse was buried rather than mistreated: he was considered by the Coroner's Court to have been mad, as 'urged' by Cross. What Cross was doing selling arsenic to a madman is not explained.

It would also be helpful to know what 'other things' Cross urged. It is possible that Lort is alluding somewhat obliquely to the morbid rumours about pistols and graves, but this is more likely to be a coy reference to Chatterton's extravagant (mad) sex life. If his own stories are to be believed, Chatterton was a priapic rake; if the stories of others are to be believed, he was certainly lustful.[43] But his boasts of sexual conquest must be in part true, as he had contracted the 'Foul Disease' and was consequently dosing himself with potentially dangerous drugs. He had a sexually-transmitted disease of some sort. Meyerstein claims, without clear reason, that this was gonorrhea. However, eighteenth-century treatments for sexually-transmitted diseases suggest that different infections were not at the time properly distinguished – instead, they were all considered to be the early symptoms of syphilis.[44] Yet the early stages of syphilis are not painful, and it is only years later that catastrophic physical and mental breakdown comes. Chatterton's problem is much more likely to have been some other venereal infection, not currently identifiable. Calomel and vitriol was a purgative, and vitriol could also be applied externally. Meyerstein quotes a contemporary medical writer, Robert James, and suggests that calomel is *mercurius dulcis* (mercurous chloride or 'horn-quicksilver'): 'it is most commonly mixed with other purging medicines and some chuse to give it in this manner every other day, in order to cure the pox without spitting'. Vitriol, on the other hand, was probably 'red arsenic' – a preparation of arsenic and sulphur: it 'is used as an emetic, vermifuge, styptic, detergent, and antiphlogistic, but is seldom given inwardly without preparation'.[45] James, in his medical treatise also mentions the 'Arsenical Magnet': a caustic application for breaking venereal buboes. Chatterton had indeed earlier

mentioned in a letter to his sister that he had contracted a 'distemper' and required 'nostrums'.[46] Interestingly, William Blake, who was a twelve-year-old lad about town in London when Chatterton died, wrote something similar in *An Island in the Moon*, 'he eat wery little, wickly – that is, he slept very little, which he brought into a consumsion: & what was that he took? Fissic or somethink – & so died!'[47]

Chatterton was living over a brothel and having some sort of relationship with at least one of the girls there.[48] He wrote bawdy satire and had cultivated a rakish reputation among the girls of Bristol. His mother and especially sister Mary were horrified by these rumours, but they persisted well beyond his death. Ebenezer Sibly, a Bristolian who cast Chatterton's horoscope at the end of the century, blamed his suicide on 'poverty, and the chicanery of prostituted women', *predicting* (27 years after the event) 'certain ruin by means of wicked and debauched women' and that 'death would come by his own hand, under the pressure of despair, heightened by meagre want, through the perfidy of some abandoned female'.[49]

Meyerstein stresses that 'there is abundant motive for the poet's fate *without* this' – 'this' being a venereal disease – but it does create a reason for Chatterton to be taking some sort of arsenic treatment, which by all accounts was a painful procedure.[50] As I have suggested elsewhere, in a much less detailed form, most commentators explain that Chatterton was taking opium to anaesthetize the pain of committing suicide with arsenic.[51] There is disagreement, however. The coroner said 'arsenick in water', whereas Barrett claimed that grains of opium were found in his teeth. This would suggest that Chatterton was not taking the common pain-killer laudanum (opium grains dissolved in alcohol), but opium in its raw state: a coarse powder made into sticks or flat cakes, which could be endured only by an experienced user. Sufficient doubt has, however, already been cast on Barrett's reliability, and as noted above the forensic analysis of the stain in the pocketbook has determined the agent to be a solution of an opium alkaloid. 'Water', in the coroner's account, need not be taken literally as water and could be any 'aqueous decoction, infusion, or tincture' – perhaps such as laudanum.[52] The stain in the pocketbook clearly needs to be analysed again, and the possible effects of any identifiable drugs assessed.

In summary, we have two different scenarios for the death of Chatterton: either Chatterton was mad (or desperate, or starving, and so forth) and poisoned himself with arsenic laced with opium, *or* he was treating himself with arsenic for the pox, and either deadening its pain with opium or simultaneously taking opium recreationally. This may have created a lethal cocktail, or perhaps he just misjudged the dosage. In the context of twenty-first century drug culture, the latter possibility certainly has considerable resonance today.

My contribution to the theory of accidental death is in the gradual exaggeration of the

reports of Chatterton's madness argued by Robert Southey and other Romantic poets.[53] Bearing in mind Mary Chatterton's strict moral probity and her absolute rejection of any stories about her brother's sexual escapades documented elsewhere, it may be that to call Thomas Chatterton *mad* was far less mortifying to the mother and sister than to call him *poxed*. Madness would account for everything: from the Rowley forgeries to his flight to London to his impetuous death – even his vegetarianism and eccentric taste in clothes; it would also divert attention from his sexual improprieties, and even there perhaps go some way to explaining them.

Yet the fact remains that Chatterton died; the question is, how? While the case for suicide was briefly 'proved' by, for instance, the discovery of suicide verses (since exposed as spurious), as well as being driven by the juggernaut of Romantic mythography, the case for accidental death has only ever had the facts to go on. These facts perhaps tell a very different story of the death of Thomas Chatterton.

Notes

Foreword

1. *OED*, 'bright', A. *adj.*, e.

2. *The Complete Works of Thomas Chatterton*, ed. Donald S. Taylor and Benjamin B. Hoover, 2 vols, paginated seriatim (Oxford, 1971), 528. Subsequent references are incorporated in the text.

3. Jonathan Barry, 'The History and Antiquities of the City of Bristol: Chatterton in Bristol', *Angelaki*, 1.2 (1994), p. 75.

4. See Robert W. Jones, '"We Proclaim Our Darling Son" : The Politics of Chatterton's Memory during the War for America', *Review of English Studies*, 53 (2002), pp. 373-95.

5. Peter Isaac, 'The English Provincial Book Trade: A Northern Mosaic', *Publications of the Bibliographical Society of America*, 95 (2001), p. 440; Dipesh Chakrabarty, *Provincializing Europe: Postcolonial Thought and Historical Difference* (Princeton, 2000).

6. Kenneth Morgan, *Bristol and the Atlantic Trade in the Eighteenth Century* (Cambridge, 1993), p. 133.

7. Jean Stein, 'William Faulkner [1956]', in *Writers at Work: The Paris Review Interviews*, intro. Malcolm Cowley (London, 1958), p. 127; Nick Groom, *The Forger's Shadow: How Forgery Changed the Course of Literature* (London, 2002), pp. 3-7.

8. Janet Malcolm, *Reading Chekhov: A Critical Journey* (New York, 2001), p. 4.

9. *The Atlas of Literature*, ed. Malcolm Bradbury, (London, 1996), pp. 46-55.

Introduction

1. E.H.W. Meyerstein, *A Life of Thomas Chatterton* (London, 1930), p. 380.

2. Meyerstein, *A Life of Thomas Chatterton*, p. 433.

3. Thomas Warton, *An Enquiry into the Authenticity of the Poems attributed to Thomas Rowley* (London, 1782), p. 107n.

4. Meyerstein, *A Life of Thomas Chatterton*, p. 335.

5. David Massom, *Chatterton A Biography* (London, 1899), p. 31.

6. H. Hunt, *Memoirs of Henry Hunt Esquire, Written by Himself*, 3 vols (1822), III, p. 41.

7. W. Hunt, *Historic Towns Bristol*, ed. E. A. Freeman, (London, 1887), p. 175.

8. *The Complete Works of Thomas Chatterton*, ed. Donald S. Taylor and Benjamin B. Hoover, 2 vols (Oxford, 1971), p. 1080.

9. Meyerstein, *A Life of Thomas Chatterton*, p. 15.

10. Massom, *Chatterton A Biography*, p. 25.

Chapter 1: Chatterton, More and Bristol's Cultural Life

1. E.H.W. Meyerstein, *The Life of Thomas Chatterton* (London, 1930); D.S. Taylor, *Thomas Chatterton's Art* (Princeton, 1978); N. Groom (ed), 'Narratives of Forgery', *Angelaki* 1:2 (Winter 1993/4); N. Groom (ed.), *Thomas Chatterton and Romantic Culture* (Basingstoke, 1999). The main exception is Georges Lamoine, *La vie litteraire de Bath et de Bristol 1750-1800*, 2 vols (Lille, 1978).

2. A. Stott, *Hannah More: The First Victorian* (Oxford, 2003). See also M. A. Hopkins, *Hannah More and her Circle* (New York and Toronto, 1947); M. G. Jones, *Hannah More* (Cambridge, 1952); H. Thompson, *The Life of Hannah More* (London, 1838); W. Roberts, *Memoirs of the Life and Correspondence of Hannah More*, 4 vols (London, 1834).

3. D.S. Taylor (ed), *The Complete Works of Thomas Chatterton* (hereafter CW), 2 vols but continuously paginated (Oxford, 1971) p. 383.

4. A poem with this title appeared in *Felix Farley's Bristol Journal* Aug. 1 1761. Other poems probably by More can be found in ibid. Jan. 18, 1766, Aug. 15, 1767, Aug. 5, 1769. Poems on her and her work include ibid. May 31, 1766, May 15, 22 and 29, 1773.

5. See DNB and W. Dean, *Handel's Dramatic Oratorios* (London, 1959), pp. 414-33.

6. For Stonehouse see T. Stedman (ed), *Letters from the Reverend Job Orton and Sir James Stonehouse* 2 vols (Shrewsbury, 1800).

7. L.J. Kaplan, *The Family Romance of the Impostor-Poet* (Berkeley and Los Angeles, 1987). For a similar approach to More see E. Kowaleski-Wallace, *Their Fathers' Daughters* (New York and Oxford, 1991).

8. N. C[rutwell], *Bristol Drollery* (London, 1674), p. 37; R. Savage, *London and Bristol Delineated* (London, 1743); CW, pp. 453-4, 465-6, 528.

9. W. Combe, *The Philosopher in Bristol* 2 parts (Bristol, 1775).

10. E. Shiercliffe, *Bristol and Hotwell Guide* 4th edn (Bristol, 1794), p. 106.

11. A.S. Catcott, *Antiquity and Honour of Commerce* (Bristol, 1744), 15. Cf. J. Tucker, *Four Tracts and Two Sermons* (Gloucester, 1774), pp. 28-31.

12. D. Defoe, *Tour through the Whole Island of Great Britain*, 2 vols (London, 1742), II, p. 268; CW, pp. 561 and 572.

13. *Gentleman's Magazine* 12 (1743), pp. 496-7.

14. Bristol Central Library, Bristol Collection 26064 fo. 178; *[Bristol] Oracle and Country Advertiser,* Aug. 31, 1745.

15. J. Thistlethwaite, *The Consultation* (Bristol, 1774 and 1775); R. Jenkins, *The Retaliation* (Bristol, 1775); N. Walker, *Cursory Remarks* (Bristol, 1775); Bristol Central Library Bristol Collection 20095 Jan. 7, 1775; *Felix Farley's Bristol Journal* Jan. 7, 14, and Feb. 11, 1775; *Bonner and Middleton's Bristol Journal* March 25, 1775; *Bristol Gazette* Jan. 19, 1775.

16. E.g. *Elegiac and other Poems in Honour of A.R. Hawksworth* (Bristol, 1769); *Elegy on Death of Rev. Thomas Janes* (Bristol, 1775); I. M. Roper, *Monumental Effigies of Gloucester and Bristol* (Gloucester, 1931).

17. E.g. J. Hewitt, *Miscellanies in Prose and Verse with Letters of Love and Gallantry* (Bristol, 1727).

18. CW, pp. 158-64, 257, 423, 427, 431, 507-8, 559, 571, 601, 683, 686; *Town and Country Magazine* 2 (1770), pp. 105, 216-17, 552, 664, 711, 714.

19. F. Britton, *English Delftware in the Bristol Collection* (London, 1982), pp. 110-11.

20. J.F. Bryant, *Verses* (London, 1787), pp. 25, 27-30, 22-32.

21. Meyerstein, *Life*, p. 8; CW, pp. 353-4, 562, 631-9, 993.

22. *Poems on Several Subjects* (Bristol, 1751), pp. 13, 24.

23. Bodleian Library MSS Gough Somerset 2, fos 153-8 on 'Nokes'; *Felix Farley's Bristol Journal* from Oct. 12, 1765 and *Bristol Journal* from Nov. 2, 1765 on Collins.

24. *The Celebrated Beauties* (Bristol, 1720) and Bodleian mss Gough Somerset 2, fos 150-2; *Les badinages de Monsieur Wynter* (London, 1744); *Felix Farley's Bristol Journal* June 18, 1768, Dec. 16, 1769, July 25, 1772 (on 'mushroom poets' at Hotwells); *Bristol Journal* July 20, 1771; *Town and Country Magazine* 3 (1771), pp. 70-2, 209, 316, 353, 697 and 4 (1772), 150-2, 314-15 and 6 (1774), 214.

25. Lamoine, *Vie litteraire*, pp. 334-41.

26. W. Goldwin, *Poetical Description of Bristol* (London, 1712), preface, dedication, pp. 2, 10; Bodleian mss Gough Somerset 2 fo. 162. See Bristol Central Library Bristol Collection 6485 for Goldwin's other poetry including a 'Description of Clifton' published in *Bristol Weekly Intelligencer* June 2, 1750.

27. J. Dolman, *Contemplations among Vincent's Rocks* (Bristol, 1755); W. Tasker, *Poetical Encomium on Trade* (London, 1779, first published in *Felix Farley's Bristol Journal* Aug. 23, 1777); W. Heard, *Sentimental Journey to Bath and Bristol* (London, 1779); *Felix Farley's Bristol Journal* Oct. 8, 1774 (advertisement for *Abbot's Leigh: A*

Poem by Richard Jenkins); E. Davies, *Blaise Castle* (Bristol, 1783).

28. *Felix Farley's Bristol Journal* March 8, 1766 contains a complaint about young upstarts seeking an authoritative voice through versifying.

29. *Art and Mystery of Printing* (Bristol, 1761); *Gloucester Journal* March 28, 1732; Bodleian mss Gough Somerset 2, fos 166-70.

30. The manuscripts are in the Bristol Central Library Bristol Collection 956, 1564-5, 4521 fo. 281, 9794, 26064 fos 180-2. He also satirised the Methodists, almost certainly composing *The Progress of Methodism* (Bristol, 1743) as well as attacks on them in the newspaper, the *Bristol, Bath and Somerset Journal,* he co-edited at that time.

31. *The Bristol Contest* (Bristol, 1755); Bristol Central Library Bristol Collection 10950, 10961, 10968-9, 10973-4; *Felix Farley's Bristol Journal* Jan. 19, July 13 and Dec. 21, 1754, April 3, 1756; *Bristol Watch Bill* (Bristol, 1755); Bodleian G.A. Glos B4a fo. 67; *Bristol Chronicle* March 28, 1761.

32. Bristol Archives Office, Bristol Infirmary Memoirs vol. 1 fo. 162; CW, pp. 352-3; *Bristol Journal* Feb. 20, March 19, 1768; *Bonner and Middleton's Bristol Journal* Oct. 21, 1775.

33. *Churchill, an Elegy* by 'a Gentleman of Bristol' (Bristol, 1765); *Felix Farley's Bristol Journal* Dec. 1, 1764, July 11, 1767; *Bristol Journal* May 25, 1765, Thistlethwaite, *Consultation*, 37, 46; idem, *The Tories in the Dumps* (Bristol, 1775); idem, *Prediction of Liberty* (1776); E. Gardner, *Liberty: a Poem* (Bristol, 1776).

34. *Bonner and Middleton's Bristol Journal* Nov. 12, 1774 (advertising *The Voice of the People: a Poem to Cruger and Burke*) and Feb. 25, 1775 (advertising *A Gratulatory Poem to the Electors of Bristol*); Lamoine, *Vie litteraire* II: p. 782 nn. 111-1; Thompson, *Life of More*, pp. 25-6; CW, pp. 2, 394, 452, 512, 525-6, 546; *Town and Country Magazine* 3 (1771), pp. 60-2, 353, 697, 1075.

35. For Purver see Bristol Central Library Bristol Collection, 16047 and his *A Poem to the Praise of God* (Bristol, 1748). For Harwood, *A Liberal Translation of the New Testament* (London, 1767); *Felix Farley's Bristol Journal* Jan. 3 and Feb. 28, 1767 and April 15, 1769; CW, p. 768.

36. S. Penny, *Letters on Fall and Restoration of Mankind* (Bristol, 1765); idem, *An Incentive to the Love of God* (Bristol, 1769).

37. J. Needham, *Hymns Devotional and Moral* (Bristol, 1768); T. Janes, *Beauties of the Poets* (London, 1773?; 4th edn, 1792); R. Southey, *Life and Correspondence* ed. C.C. Southey, 6 vols (London, 1849), I, pp. 44-6. Southey's next master, Joseph Flower, was also a religious poet (J. Flower, *The Prodigal Son* (Bath, 1771) and see pp. 102-8 on the poetry of the period 'when anything in rhyme passed current'.

38. R. Young, *Mrs Chapman's Portrait* (Bath, 1926); C. Wesley, *Journal* ed. T. Jackson (London, 1849) p. 46.

39. E. Sharpe, 'Bristol Baptist College and the Church's Hymnody', *Baptist Quarterly* N.S. 28 (1979-80) pp. 7-16; R. Williamson, *Collection of Hymns* (Bristol, 1756).

40. M. Dudley, *Life* (London, 1825), pp. 6-8.

41. Penny, *Incentive*, preface; *Felix Farley's Bristol Journal* and *Bristol Journal* Nov. 11, 1769.

42. *Bristol Journal* July 30, Aug. 6 and 13, 1774; *Felix Farley's Bristol Journal* July 23, 1774.

43. *Felix Farley's Bristol Journal* Oct. 12 to Dec. 21, 1765 and April 26, 1766; *Bristol Journal* Oct. 19 and Dec. 21, 1765.

44. See n. 46 above; *Felix Farley's Bristol Journal* Jan. 7 and 14 and Feb. 11, 1775; *Bristol Gazette* Jan. 19, 1775; H. Burgum, *Narrative of Facts* (Bristol, 1775).

45. *Bristol Journal* May 29, 1773 (Gwatkin) and Sept. 24, 1774 (Peach); Young, *Mrs Chapman's Portrait*.

46. *Felix Farley's Bristol Journal* March 5, 1768 and reply *Bristol Journal* July 2, 1768; More, *Search*; idem, *Essays on Various Subjects* (London, 1777), pp. 15-19, 178.

47. Meyerstein, *Life,* pp. 136, 147-50; *Felix Farley's Bristol Journal* April 2 and May 7, 1774; *Bristol Journal* April 2 and 9, 1774; *Bristol Gazette* April 7 and 14, 1774.

48. Bristol Central Library, Bristol Collection 20095 Oct. 18, 1773.

49. A.W. Oxford, *William Goldwin* (Bristol, 1911); A. S. Catcott, *Exercises Performed at Visitation of Grammar School* (Bristol, 1737); Collins, *Miscellanies,* pp. 137-142; Bristol Archives Office, Corporation Vouchers box 1739; *Bristol Journal* April 17, 1773 and April 9, 1774; Hopkins, *Hannah More*, pp. 248-9. Edward Gardner recalled versifying with Gwatkin at the school in *Miscellanies in Prose and Verse*, 2 vols (Bristol, 1798), II, p. 143.

50. *Bristol Journal* May 28, 1768; *Bristol Journal* Nov. 4 and 27, 1773; *Town and Country Magazine* 3 (1771), p. 353.

51. R. Southey, *Lives and Works of the Uneducated Poets* (London, 1831); A. Yearsley, *Poems on Several Occasions* (London, 1785), preface by More (p. 10 for Chatterton comparison); Bryant, *Verses*, pp. 6, 31-35; Lamoine, *Vie litteraire* I, pp.152-3, 334-41. On this see B. Keegan, 'Nostalgic Chatterton' in Groom (ed), *Thomas Chatterton*, pp. 210-27.

Chapter 2: A Rococo Poet for a Rococo City

1. For the French Rococo style see Katie Scott, *The Rococo Interior: Decoration and Social Spaces in Early Eighteenth-Century Paris* (New Haven & London, 1995); for England see Timothy Mowl & Brian Earnshaw, *An Insular Rococo: Architecture, Politics and Society in Ireland and England, 1710-1770* (1999).

2. *The Complete Works of Thomas Chatterton*, 2 vols (Oxford, 1971), I, p. 186: *Aella*, lines 280-4. Henceforth CW.

3. See Timothy Mowl, *To Build the Second City: Architects and Craftsmen of Georgian Bristol* (Bristol, 1991); also Andor Gomme, Michael Jenner & Bryan Little, *Bristol: an architectural history* (Bristol, 1979); and Gordon Priest, *The Paty Family: Makers of Eighteenth-Century Bristol* (Bristol, 2003).

4. Halfpenny's schemes are illustrated in Walter Ison, *The Georgian Buildings of Bristol* (Bath, 1978), plates 14b & 15.

5. For a detailed analysis of the building of the Exchange see Timothy Mowl & Brian Earnshaw, *John Wood: Architect of Obsession* (Bath, 1988), Chapter 10; also John Wood, *A Description of the Exchange of Bristol* (Bath, 1745).

6. Mowl & Earnshaw, *John Wood*, p. 155.

7. John Wood, *Address'd to Sir Abraham Elton Bt. Mayor and the Corporation* (broadsheet), 'Bristol, Exchange – Wood', ms. Volume in Royal Academy Library, Burlington House (8516/51A).

8. For Bristol's Gothick and Rococo experiments see Mowl, *Second City*, Chapter 3.

9. Written pseudonymously by J.W. Shirehampton (Ison gives John Wallis) and quoted in Ison, *Georgian Buildings*, p. 190.

10. For an analysis of Wood's King's Circus see Mowl & Earnshaw, *John Wood*, Chapter 12.

11. Quoted in E.H.W. Meyerstein, *A Life of Thomas Chatterton* (London, 1930), p. 75.

12. For their gardens see David Lambert, 'The Prospect of Trade: The Merchant Gardeners of Bristol in the Second Half of the Eighteenth Century', *Bourgeois and Aristocratic Cultural Encounters in Garden Art, 1550-1850* (Dumbarton Oaks, Washington, DC, 2002), pp. 123-45.

13. The interior is illustrated in Ison, *Georgian Buildings*, plate 63a.

14. For the Fonthill landscape see Timothy Mowl, *William Beckford*, 1998, Chapter 2; also Timothy Mowl, 'Inside Beckford's Landscape of the Mind' *Country Life*, February 7 2002.

15. W.S. Lewis (ed.), *The Yale Edition of Horace Walpole's Correspondence*, 48 vols (New Haven & London, 1937-83), X, p. 232: Walpole to Montagu, October 22 1766.

16. George Sherburn (ed.), *The Correspondence of Alexander Pope*, 5 vols (Oxford, 1956), IV, p. 205: Pope to Martha Blount, November 24 1739.

17. For Wright see Eileen Harris, 'The Wizard of Durham: The Architecture of Thomas Wright', *Country Life*,

August 26, September 2 & 9 1971.

18. Cote House is illustrated in Mowl, *Second City*, p. 84.

19. A contemporary painting showing the cannon platform is preserved at Blaise Castle House Museum.

20. A 1788 drawing by S.H. Grimm of the gazebo with its classical colonnade is illustrated in Peggy Stembridge, *Goldney: A House and a Family* (Bristol, 1979), pp. 14-15.

21. For Berkeley and Stoke Park see Timothy Mowl, 'The Castle of Boncoeur and the Wizard of Durham', *Georgian Group Journal*, (1992), pp. 38-49.

Chapter 3: Romantic Redcliffe: Image and Imagination

1. Henry Wallis (1830-1916), London, Tate Britain. Leslie Parris (ed), *The Pre-Raphaelites* (London, 1984), pp. 142-144.

2. Richard Jeffreys Lewis (working 1843-1870), present whereabouts unknown.

3. Henrietta Mary Ada Ward (1832-1924), Bristol Museum and Art Gallery. Arnold Wilson, *Catalogue of Oil Paintings, Bristol City Art Gallery* (Bristol, 1970), p. 119.

4. Michael Quinton Smith, *St Mary Redcliffe. An Architectural History* (Bristol, 1995), p. 150.

5. Edward Hawke Locker (1777-1849), Bristol Museum and Art Gallery.

6. Thomas Leeson Rowbotham (1783-1853), Bristol Museum and Art Gallery. Francis Greenacre, *The Bristol School of Artists* (Bristol, 1973), pp. 261-268.

7. Joseph Mallord William Turner (1775-1851), Bristol Museum and Art Gallery. Andrew Wilton, *The Life and Work of J.M.W. Turner* (London, 1979), p. 301.

8. For Turner's previous visits to Bristol, see Andrew Wilton, *The Life and Work of J.M.W. Turner* (London, 1979), pp. 25-27, 301-302.

9. London, Tate Britain. Martin Butlin and Evelyn Joll, *The Paintings of J.M.W. Turner* (New Haven and London, 1977), catalogue 100.

10. Eric Shanes, *Turner's Human Landscapes* (London, 1990), surveys Turner's uses of association in landscapes and views.

11. Thomas Girtin (1775-1802), Bristol Museum and Art Gallery: Thomas Girtin and David Loshak, *The Art of Thomas Girtin* (London, 1954), p. 162.

12. For Rembrandt's *The Mill* and its influence on English painters, see Michael Pidgley, 'The Mill by Rembrandt' in Timothy Wilcox (ed), *The Romantic Windmill*, (Hove Museum and Art Gallery, 1993), pp. 16-27. The Orleans collection was exhibited in Pall Mall in London, 1793-94.

13. For the Sketching Society, see Jean Hamilton, *The Sketching Society 1799-1851* (London: Victoria and Albert Museum, 1971); and Susan Morris, *Thomas Girtin 1775-1802* (New Haven: Yale Centre for British Art, 1986), pp. 18-20.

14. Archibald Alison, *Essays on the Nature and Principles of Taste* (Edinburgh and London, 1790). In several passages Alison discusses the power of association with historical or literary figures to elevate the imaginative response to a particular place so that in a picture its representation will serve 'not only to speak to the eye, but to affect the imagination and the heart' (II, 128).

15. Cotman's portrait drawings of members of the Norton family, and his visit to Bristol, are fully discussed in Sydney D. Kitson, *The Life of John Sell Cotman* (London, 1937), pp. 18-19.

16. The Nortons lived in Wine Street where, as well as bookselling and publishing, they traded in pictures and prints; Robert Southey's family also had their business in Wine Street, as did the publisher Joseph Cottle.

17. As well as the British Museum watercolour, the most dramatic of the Redcliffe views, there are two others in private collections, one of which is signed and dated 1801: Miklos Rajnai, *John Sell Cotman 1782-1842* (London

(Arts Council), 1982), p. 45.

18. Sidney D. Kitson, *The Life of John Sell Cotman* (London 1937), 32 (Plate 7).

19. London, Victoria and Albert Museum; engraved by I. Rosse, 1802, published in John Britton, *The Beauties of England and Wales* XIII, Part 2, (London, 1813), p. 670. See C.M. Kauffmann, *John Varley 1778-1842* (London 1984), p. 94.

20. John Britton, 'An Historical and Architectural Essay Relating to Redcliffe Church Bristol...Including an Account of the Monuments, and Anecdotes of Eminent Persons Interred within its Walls'. Also an *Essay on the Life and Character of Thomas Chatterton*, (London, 1813).

21. For Varley's 1802 Bristol visit, see Kauffmann, *John Varley 1778-1842*, p. 94.

Chapter 4: Dr Viper's Monkey: Philip Thicknesse and the 'Chatterton Monument'

1. Richard Godfrey ed., *James Gillray: The Art of Caricature* (London, 2001), pp. 84-5. The print (an etching with aquatint, British Museum BMC 7721) is entitled 'Lieut Goverr Gall-Stone, inspired by Alecto; – or The Birth of Minerva'.

2. Edmond Malone, Thomas Warton, Thomas Tyrwhitt, and George Steevens were the key scholars who 'saw through' Chatterton's Rowley.

3. Thicknesse's elaborate garden occupied the steep site of what is now Number 9, Lansdown Place West. See E.H.W. Meyerstein, *A Life of Thomas Chatterton* (London, 1930), p. 475.

4. David Fairer, 'Chatterton's Poetic Afterlife, 1770-1794: a Context for Coleridge's *Monody*', in *Thomas Chatterton and Romantic Culture*, ed. Nick Groom (Basingstoke, 1999), pp. 228-52, 231.

5. This is Vicesimus Knox, whose essay 'On the Poems attributed to Rowley' was also published in the third edition of his *Essays, Moral and Literary*, 2 vols (1782), II, pp. 247-51. The text of Thicknesse's 'inscription' is indeed cobbled together from passages in Knox's eloquent celebration of Chatterton's 'genius'.

6. *The Lady's Magazine*, February 1784, p. 62.

7. John H. Ingram, *The True Chatterton: A New Study from Original Documents* (London, 1910), p. 336.

8. *A Sketch of St Catherine's Hermitage* (Bath, 1787). This was published anonymously and is very rare: there is a copy in the Brotherton Library in Leeds.

9. Philip Thicknesse, *Memoirs and Anecdotes of Philip Thicknesse*, 2 vols (1788), II, pp. 299–313.

10. Edmond Malone, *Cursory Observations on the Poems attributed to Thomas Rowley A Priest of the 15th Century* (London, 1782), p. 11.

11. Knox, *Essays, Moral and Literary*, II, p. 248.

12. Linda Kelly, *The Marvellous Boy: the Life and Myth of Thomas Chatterton* (London, 1971), p. 48.

13. See Philip Gosse, *Dr Viper: the Querulous Life of Philip Thicknesse* (London, 1952) for generally reliable biographical information. See also my entry on 'Philip Thicknesse' in the *Dictionary of National Biography* (Oxford, 2004).

14. Philip Thicknesse, *Observations on the Customs and Manners of the French Nation* (1766), p. 91.

15. *CR*, 22 (1766), p. 430.

16. Philip Thicknesse, *The Valetudinarian's Bath Guide; or the Means of obtaining Long Life and Health* (1780), pp.18, 45.

17. Thicknesse, *Memoirs*, II, pp. 153-5, 308-10.

18. 'Dedication' to the rare third volume of the *Memoirs* (1790); cited in Gosse, *Dr Viper*, p. 276.

19. J. Adair, *Curious Facts and Anecdotes not contained in the Memoirs of Philip Thicknesse* (1790), p. 62.

20. *CR*, 70 (1790), p. 461.

21. Gosse, *Dr Viper*, p. 214.

22. *GM*, 62 (December 1792), p. 1154.

23. *GM*, 59 (July 1789), p. 642.

24. *GM*, 61 (November 1791), pp. 1018-19.

25. Knox's 1782 essay very publicly berated Walpole for his neglect – 'Horatio; it was not like thyself; for thou art gentle in thy nature' – and observed (as does Chatterton's poem) that Walpole, as the anonymous author of *The Castle of Otranto*, had himself been guilty of forgery: 'Didst not thou put a false name to thy own romance?' See Vicesimus Knox, *Essays, Moral and Literary*, 2 vols (1782), II, p. 249.

26. In *A Sketch of the Life and Paintings of Thomas Gainsborough, Esq* (1788), Thicknesse boasts how 'I was the first man who perceived … what an accurate eye he possessed, … and who dragged him from the obscurity of a Country Town, at a time that all his neighbours were as ignorant of his great talents, as he was himself' (pp. 3-4).

27. Philip Thicknesse, *Pere Pascal, a Monk of Montserrat Vindicated: in a Charge brought against him by a Noble Earl of Great-Britain* (1783), pp. 5-6.

28. *The Complete Works of Thomas Chatterton*, ed. Donald S. Taylor and Benjamin B. Hoover, 2 vols (Oxford, 1971), I, p. 341. Lines 15 and 8 of 'Walpole! I thought not I should ever see' cited.

29. See Godfrey, *James Gillray*, pp. 84-5.

30. Adair, *Curious Facts and Anecdotes not contained in the Memoirs of Philip Thicknesse*, p. 65.

31. *MR*, 81 (1789), p. 374, reviewing *Memoirs and Anecdotes*.

32. 'Emendations and Additions', in Warton, *History of English Poetry*, 3 vols (1774, 1778, 1781), II, pp. 3-4, and II, pp. 141-58; cited in Paul Baines, *The House of Forgery in Eighteenth-Century Britain* (1999), p. 166.

33. Knox, *Essays, Moral and Literary*, II, p. 248.

34. T. Tyrwhitt ed., (*Poems, Supposed to have been written at Bristol by T. Rowley, and others*) 2nd edn. (London, 1777), p. 14.

35. Fairer, 'Chatterton's Poetic Afterlife', p. 231.

36. H. Croft, *Love and Madness* (London, 1780), pp. 199-201.

37. Mary Robinson, *The Poetical Works of the Late Mrs Mary Robinson*, 3 vols (1806), p. 249.

38. Ingram, *The True Chatterton*, p. 285. See Ingram, pp. 308-12 for a full account of the controversy.

39. Fairer, 'Chatterton's Poetic Afterlife', pp. 238-40 outlines several poetic responses from the 1770s and 1780s which are imaginatively located at the scene of Chatterton's suicide in a seedy London garret.

40. See Gosse, *Dr Viper*, pp. 218-19, citing 'A Sketch of St Catherine's Hermitage', in which Thicknesse observes in an outraged tone that 'In some fine days during the summer, a succession of Ladies and Gentlemen have hindered the gardener from doing three hours work in the whole day'.

41. Thicknesse, *Memoirs*, II, pp. 318-19.

42. Knox, *Essays, Moral and Literary*, II, p. 251.

43. See A.D. Harvey, 'The Cult of Chatterton amongst English Poets *c*.1770-*c*.1820' in *Zeitschrift für Anglistik und Amerikanistik*, 39 (1991), pp. 124-33: but Harvey erroneously states that the poem is reprinted in Yearsley's *Poems on Several Occasions* (which had appeared in 1785).

44. Ann Yearsley, 'Elegy on Mr Chatterton', in *Poems on Various Subjects* (1787), pp. 145-9.

45. Yearsley's biographer suggests that Hannah More's scheme to 'rescue' and support Yearsley may have earned support because it was seen as 'doing something to assuage the civic guilt felt for the neglected Chatterton': see Mary Waldron, *Lactilla, Milkwoman of Clifton: the Life and Writings of Ann Yearsley, 1753-1806* (Athens, GA., 1996), p. 26.

46. John Goodridge, 'Rowley's Ghost: a Checklist of Creative Works Inspired by Thomas Chatterton's Life and Writings', in *Thomas Chatterton and Romantic Culture*, pp. 262-92, 287.

Chapter 5: Visionary and Counterfeit

1. Alexander Gilchrist, *Life of William Blake* (London, 1945), p.5.

2. *The Poetry and Prose of William Blake*, ed. David V. Erdman, (New York, 1970), p. 549. Henceforth Erdman.

3. We must differentiate between 'Jerusalem' the poem that introduces *Milton* and the epic *Jerusalem*. I am referring to the poem-song in this instance.

4. George Gregory, *The Life of Thomas* Chatterton, *with Criticisms on his Genius and Writings, and a Concise View of the Controversy Concerning Rowley's Poems* (London, 1789), p. 19.

5. Erdman, p. 628.

6. Erdman, pp. 670, 563.

7. Erdman, p. 671.

8. Erdman, p. 223.

9. Erdman, p. 655.

10. Erdman, p. 656.

11. *The Poetical Works of William Wordsworth*, ed. E. de Selincourt and H. Darbishire, 5 vols (Oxford, 1949). Henceforth WPW.

12. Erdman, p. 656.

13. Erdman, p. 653.

14. Erdman, p. 569.

15. Erdman, p. 94.

16. Erdman, p. 654.

17. Erdman, p. 545.

18. Arthur Symons, *William Blake* (London, 1907), p. 258.

19. *Coleridge Poetical Works*, ed. J.C.C. Mays, 2 vols (Princeton, 2001). Henceforth CPW.

20. David Fairer, 'Chatterton's Poetic Afterlife, 1770-1794: A Context for Coleridge's *Monody*', in *Thomas Chatterton and Romantic Culture*, ed. N. Groom, (Basingstoke, 1999), pp. 228-251 (p. 229).

21. *The Complete Works of Thomas Chatterton*, ed. Donald S. Taylor and Benjamin B. Hoover, 2 vols (Oxford, 1971). Henceforth CW.

22. Erdman, p. 38.

23. Erdman, p. 35.

24. Erdman, p. 35.

25. Erdman, p. 632.

26. Erdman, p. 544.

27. Erdman, p. 95.

28. Erdman, p. 660.

29. Erdman, p. 154.

30. Morton Paley, *The Continuing City William Blake's Jerusalem* (Oxford, 1983), pp. 165, 52, 242.

31. Erdman, p. 97.

32. Erdman, p. 450.

33. Erdman, p. 446.

34. Erdman, p. 444.

35. E.H.W. Meyerstein, *A Life of Thomas Chatterton* (New York, 1930), p. 283.

36. Erdman, p. 638.

37. John Milton, *The History of Britain, That part especially call'd England*, 1st ed., (1670), p. 3.

38. G. L. Keynes, ed., *The Complete Writings of William Blake* (Oxford, 1966), p. 578.

39. Erdman, p. 620.

40. Erdman, p. 230.

41. Erdman, p. 523.

42. Erdman, p. 248.

43. Erdman, p. 230.

44. Erdman, p. 678.

45. Erdman, p. 555.

46. John Dix, *The Life of Thomas Chatterton* (London: Hamilton, Adams and Co., 1837), 128.

47. Erdman, p. 229.

48. Erdman, p. 1.

49. Erdman, pp. 58-59.

50. Erdman, pp. 62-65.

51. Erdman, p. 25.

52. Erdman, p. 481.

53. Erdman, p. 566.

54. Erdman, p. 267.

55. Erdman, p. 240.

56. *Johnson Miscellanies*, ed. George Birkbeck Hill D.C.L., (New York, 1897), II, p. 15.

57. Oswald Crawfurd, 'William Blake: Artist, Poet, and Mystic', in *New Quarterly Magazine*, II (1874), p. 475.

58. David Erdman, *Prophet Against Empire* (New York, 1977), p. 31.

59. Erdman, p. 570.

60. Peter Ackroyd, *Blake* (London, 1995), p. 52-53.

61. J.T. Smith, *Nollekins and His Times*, 2 vols (London, 1828), I, p. 152.

62. Erdman, p. 198.

63. A.H. Palmer, *The Life and Letters of Samuel Palmer* (London, 1892), p. 245.

64. *Letters of Samuel Palmer*, ed. Raymond Lister (Oxford, 1974), p. 508.

65. Jacob Bryant, *Observations upon the Poems of Thomas Rowley* (London, 1781), p. 350.

Chapter 6: 'Within a Door or Two': Iolo Morganwg, Chatterton and Bristol

1. *The Complete Works of Thomas Chatterton: A Bicentenary Edition*, ed. Donald S. Taylor, 2 vols (Oxford, 1971), I, p. 44.

2. The fullest discussions of Iolo and Chatterton to date are Gwyneth Lewis, 'Eighteenth-Century Literary Forgeries with special reference to the work of Iolo Morganwg' (unpublished D.Phil. dissertation, Oxford, 1991) and Geraint Phillips, 'Math o wallgofrwydd: Iolo Morganwg, opiwm a Thomas Chatterton', *National Library of Wales Journal*, 29 (1996), pp. 391-410. This chapter is indebted to both of these works.

3. G.J. Williams, *Iolo Morganwg: y Gyfrol Gyntaf* (Caerdydd, 1956), p. 320. My translation. Prys Morgan's *Iolo Morganwg* (Cardiff, 1975) is a useful short biography in English; see also Geraint H. Jenkins, *Facts, Fantasy and Fiction: The Historical Vision of Iolo Morganwg* (Aberystwyth: Centre for Advanced Welsh and Celtic Studies, 1997).

4. Claude Rawson, 'Unparodying and Forgery: The Augustan Chatterton', in Nick Groom (ed.), *Thomas Chatterton and Romantic Culture* (Basingstoke, 1999), pp. 25-26.

5. The Iolo Morganwg archive is housed in the National Library of Wales, Aberystwyth (hereafter NLW); it is currently the focus of a long-term research project at the University of Wales Centre for Advanced Welsh and Celtic Studies, Aberystwyth. I am grateful to all my colleagues on the project, and especially to David Ceri Jones and

Ffion Jones, who are editing Iolo's correspondence, for making their work to date available.

6. See Caroline Franklin, 'The Welsh American Dream: Iolo Morganwg, Robert Southey and the Madoc legend', in Gerard Carruthers and Alan Rawes (eds), *English Romanticism and the Celtic World* (Cambridge, 2003) pp. 69-84. For Bristol and south Wales see Philip Jenkins, *The Making of a Ruling Class* (Cambridge: Cambridge University Press, 1983).

7. NLW MS 21319A, p. 12.

8. NLW MS 21387E, p. 10.

9. NLW MS 21416E, item 60; for Gothic mouldings and arches see NLW MS 21417E. Thanks to Prys Morgan for drawing the 'summerhouse' to my attention.

10. NLW MS 21283E, Letter 512 (June 27, 1782).

11. *Ibid.*, Letter 513 (Oct. 1, 1782).

12. See David Fairer, 'Chatterton's Poetic Afterlife, 1770-1794: A Context for Coleridge's *Monody*', in Groom (ed), *Thomas Chatterton and Romantic Culture*, pp. 228-252, at p. 236 and p. 251, n. 28.

13. Pat Rogers, 'Chatterton and the Club', in Groom (ed.), *Thomas Chatterton and Romantic Culture*, pp. 121-150, at p. 128.

14. See especially Groom's *The Forger's Shadow* (London, 2002).

15. NLW MS 13138A, pp. 88-89.

16. NLW MS 13104B, p. 123.

17. *Ibid.*, p. 124.

18. Edward Williams, *Poems, Lyric and Pastoral* (London, 1794), p. 16. As G.J. Williams notes, the account of his childhood is demonstrably romanticized (*Iolo Morganwg*, pp. 108-09).

19. John Davis, *Life of Chatterton* (London, 1806), p. 9.

20. *Poems, Lyric and Pastoral*, p. 15. Tim Burke has identified the *Vocal Miscellany* as a collection published in 1733: see Burke (ed.), *Eighteenth-Century Labouring-Class Poets: Volume III*.

21. On Burns as a likely model see Daniel Huws, *Caneuon llafar gwlad ac Iolo a'i fath*, Darlith Goffa Amy Parry-Williams (Aberystwyth, 1993). Some radical responses to the volume are noted by Damian Walford Davies, *Presences that Disturb: Models of Romantic Identity in the Literature and Culture of the 1790s* (Cardiff, 2002), pp. 143-45.

22. Bridget Keegan, 'Nostalgic Chatterton: Fictions of Poetic Identity and the Forging of the Self-Taught Tradition', in Groom (ed.), *Thomas Chatterton and Romantic Culture*, pp. 210-27; see also John Goodridge, 'Identity, Authenticity, Class: John Clare and the Mask of Chatterton', *Angelaki*, 1.2 (1993/4), pp. 131-48. The questions raised by both critics about the relationship between an 'authentic' poetic voice and the nature of poetic forgery are of immense potential value for the study of Iolo's work.

23. See e.g. NLW MS 21286E, Letter 1024 which begins 'I took the liberty of addressing a letter to you last week with proposals for publishing two small vols of poems, and I presumed to solicit the favour of your name sir without any money, I waited at your door in downing street this morning and was informed that I could not expect any answer'. It ends '[there are] persons to be met with in the very lowest stations, who know more of human Nature than all the kings in the World, who will not allow that the blood which proudly boils in the dirty veins of Monarchs can possibly be as pure as that which streams thro the heart of the honest ploughMan the harmless Cobler, [or] and the friendly and patriotic Chimney-sweeper in whom we find exibited more of the true dignity of human nature than than ever appeared in any King Emperoror ore any rascal whatever of that class'.

24. NLW MS 21285E, Letter 862 (March 1798).

25. NLW MS 21400C, item 24a. The dispute is discussed in my *'Combustible Matter': Iolo Morganwg and the Bristol Volcano* (Aberystwyth, 2003), pp. 14-19.

26. A *caveat*: work needs to be done on the reliability of the list as published. Several of the more impressive names may owe more to wish-fulfilment than fact.

27. NLW MS 21285E, Letter 810 (July 20, 1792).

28. *Ibid.*, Letter 811 (Aug. 9, 1792).

29. *Ibid.*, Letter 812 (Oct. 27, 1792).

30. John Goodridge refers to 'horrific' statistics for suicide (and alcoholism and insanity) amongst the self-taught poets of the eighteenth and nineteenth centuries in 'Identity, Authenticity, Class', p. 133 and p. 147 n. 9. There is an exceptionally stilted passage in Iolo's papers (NLW MS 21433E, item 5) which laboriously sets out the reasons against suicide: I agree with Geraint Phillips ('Math o wallgofrwydd', p. 402) that it could well date from the summer of 1792.

31. *Collected Letters of Samuel Taylor Coleridge*, ed. E.L Griggs, 6 vols (Oxford, 1956-71), I, p. 275.

32. See Gwyn A. Williams, *Madoc: The Making of a Myth* (London, 1978).

33. See especially NLW MS 21285E, Letters 853 and 854 (June 6 and 14, 1795).

34. To Henry Taylor, Jan. 24, 1827. *Life and Correspondence of Robert Southey*, ed. C.C. Southey, 6 vols (London, 1849-50) V, p. 285. For Coleridge, Iolo and Godwin see Davies, *Presences that Disturb*, pp. 167-76.

35. Waring's *Recollections and Anecdotes of Edward Williams* (London, 1850) effectively set the tone for the Victorian image of Iolo as the eccentric but trustworthy repository of a nation's inherited wisdom.

36. Cited in E.H.W. Meyerstein, *A Life of Thomas Chatterton* (London, 1930), p. 12.

37. On the 'lyrical' version of Chatterton see David Fairer, 'Chatterton's Poetic Afterlife', in Groom (ed.), *Thomas Chatterton and Romantic Culture*.

38. NLW MS 21282E, Letter 363 (Feb. 20, 1805); NLW MS 21285E, Letter 898 (Oct. 12, 1813), and Caroline Franklin, 'The Welsh American Dream', p. 84.

39. NLW MS 21280E, Letter 101 (Feb. 23, 1803).

40. NLW MS 13089E, pp. 253-54. The other two copies are uncatalogued: I am grateful to Geraint Phillips for drawing them to my attention, and to Bethan Jenkins for details of the version in the *European Magazine*. Southey's version appears in Vol III, p. 495 of *The Works of Thomas Chatterton* (London, 1803).

41. Williams, *Iolo Morganwg*, p. 342 n.

42. NLW MS 13089E, pp. 174 -76. The piece is published entire in my '*Combustible Matter*', pp. 2-4.

Chapter 7: The Death of Chatterton

1. Letter to Revd J. Boucher (Sept 7 1802), Bristol Reference Library, B28476r.

2. The painting has also generated its own mythology: see Peter Ackroyd, *Chatterton, A Novel* (London, 1987), *passim*.

3. Neil Bell, *Cover His Face: A Novel of the Life and Times of Thomas Chatterton, the Marvellous Boy of Bristol* (London, 1943), pp. 316-17.

4. Donald S. Taylor, 'Chatterton's Suicide', *Philological Quarterly* 39 (1952), pp. 63-9.

5. Richard Holmes, 'Thomas Chatterton: The Case Re-opened', *Cornhill Magazine* 178 (1970), pp. 203-51 (especially 244).

6. For example, Louise J. Kaplan, *The Family Romance of the Impostor-Poet Thomas Chatterton* (Berkeley, 1989).

7. Tom Paulin, review of Richard Holmes, *Sidetracks: Explorations of a Romantic Biographer* (London, 2000), *The Guardian*, July 8 2000.

8. The most telling documents here are the letters to Michael Clayfield and William Barrett, and the 'Will' (E.H.W. Meyerstein, *A Life of Thomas Chatterton* (London, 1930), pp. 334-45 (henceforth Meyerstein); CW, pp. 494, 501-5). These were composed while Chatterton was still apprenticed to John Lambert and won him his freedom, where-

upon he left for London. There seems little doubt that the 'Will' in particular is a literary satire, which as Taylor notes has been seriously misread as a result of Chatterton's death some four months later (CW, p. 1059). Suicide notes were common in the eighteenth century, and had rapidly become a literary *genre* – which Chatterton's undoubtedly is (see Michael MacDonald and Terence R. Murphy, *Sleepless Souls: Suicide in Early Modern England* (Oxford: 1990), pp. 326-7). Stories of Chatterton threatening to kill himself have also been misread. For example, James Thistlethwaite's account that records Chatterton's options should his London literary career fail him – 'my last and final resource is a pistol'– is not necessarily a threat to commit suicide but may instead be an allusion to John Gay's *The Beggar's Opera* – 'A pistol is your last resort' (II.2) – and therefore a threat to become a murderous highwayman (*Poems, Supposed to have been Written at Bristol in the Fifteenth Century, by Thomas Rowley, Priest, &c.*, ed. Jeremiah Milles, (London, 1782), p. 459).

9. Meyerstein, p. 349.

10. Meyerstein, pp. 362, 414.

11. Letter to Sarah Chatterton, *et al* (May 6 1770), CW, pp. 560-1.

12. *The Whore of Babylon*, l.537 (CW, p. 467); also *Kew Gardens*, l.1093 (CW, p. 542).

13. Michael F. Suarez, SJ, '"This Necessary Knowledge": Thomas Chatterton and the Ways of the London Book Trade', *Thomas Chatterton and Romantic Culture*, ed. Nick Groom, (London, 1999), pp. 98-118.

14. Meyerstein, p. 375. The pocketbook is in Bristol Reference Library.

15. Roy Porter, *English Society in the Eighteenth Century* (Harmondsworth, 1990), p. 15. Porter notes that a careful artisan family could live on a pound a week, and that the petty bourgeoisie would usually have annual incomes of £50-£100. 'A new two-up and two-down brick cottage would cost about £150.'

16. Meyerstein, pp. 381-2.

17. Meyerstein, p. 391; five guineas is 105 shillings.

18. Quoted by Meyerstein, p. 439.

19. June, 1782; quoted by Meyerstein, pp. 439-40.

20. Meyerstein, p. 440.

21. Herbert Croft, *Love and Madness. A Story Too True* (London, 1780), pp. 196-7.

22. MacDonald and Murphy, pp. 15-16.

23. MacDonald and Murphy, p. 133.

24. Croft, *Love and Madness. A Story Too True*, pp. 194-5 (quoted by Meyerstein, p. 433).

25. Thomas Warton, *An Enquiry into the Authenticity of the Poems attributed to Thomas Rowley* (London, 1782), p. 107n.

26. Meyerstein, p. 433; Horace Walpole, *A Letter to the Editor of the Miscellanies of Thomas Chatterton* (Twickenham, 1779), p. 25; Warton, p. 107n.

27. Letter to George Catcott (August 12 1770), CW, p. 669. Meyerstein suggests that a rent of 2s to 3s 6d was normal, although garrets might be cheaper (p. 391).

28. *Poems, Supposed to have been Written at Bristol, by Thomas Rowley, and Others, in the Fifteenth Century*, ed. Thomas Tyrwhitt, (London, 1777), p. 10.

29. Thomas Chatterton, *Miscellanies in Verse and Prose*, ed. John Broughton, (London, 1778), p. 439; the editor was possibly John Broughton.

30. William Barrett, *The History and Antiquities of the City of Bristol; compiled from Original Records and Authentic Manuscripts, in Public Offices or Private Hands* (Bristol, 1789), p. 647.

31. Meyerstein, p. 436.

32. MacDonald and Murphy, p. 227.

33. Quoted by Meyerstein, p. 445n.

34. CW, p. 670; see Meyerstein, p. 429.

35. For the most recent account of 'Last Verses', see 'The Case Against Chatterton's 'Lines to Walpole' and 'Last Verses', *Notes and Queries* 248 (2003), pp. 278-80.

36. The volume is now Bodl., MS. Eng. poet. e. 6.

37. Chatterton's bedfellow remembered that 'almost every morning the floor was covered with pieces of paper not so big as sixpences, into which he had torn what he had been writing before he came to bed' (quoted by Meyerstein, p. 380).

38. *1777*, 10; Meyerstein, p. 446.

39. Quoted by Meyerstein, p. 420; Walpole, p. 49; Milles, p. 522.

40. Meyerstein, pp. 437-8.

41. *Critical Review* (1782), quoted by Meyerstein, p. 440.

42. Quoted by Meyerstein, p. 441.

43. For example, Chatterton's reply to a letter from Esther Saunders (April 3 1770), CW, p. 496; letter to Mary Chatterton (May 30 1770), CW, p. 589; and 'The Letter Paraphras'd', CW, pp. 686-7. A teenage girl in his Shoreditch lodging remembered, 'he was a sad rake, and terribly fond of women, and would sometimes be saucy to her' (quoted by Meyerstein, pp. 379-80).

44. Bell argues that the infection was syphilis (p. 320). It is worth reconsidering the flamboyant letter to William Smith and the 'Mystery of composing Smegma'. Meyerstein (pp. 430-1) and Taylor (p. 1138) read this as a reference to soap-making, and there were indeed soap-boilers adjacent to St Mary Redcliffe in Bristol. It could also, however, be a reference to a venereal discharge. The *OED*'s secondary meaning of 'smegma' is of a sebaceous secretion found under the prepuce. Although *OED* gives no evidence that it was used so in the eighteenth century, it makes more sense of Chatterton's comments: rather than suggesting that William Smith gives up poetry to go soap-boiling, he exhorts him to go a-whoring (CW, p. 687).

45. Meyerstein, p. 441n.

46. Letter to Mary Chatterton (June 19 1770), CW, p. 599. The cold had apparently gone by 29 June.

47. William Blake, *An Island in the Moon, Blake's Poetry and Designs*, ed. Mary Lynn Johnson and John E. Grant, (New York, 1979), p. 381.

48. Letter to George Catcott (August 121770), CW, p. 670 (see above, n.33).

49. The horoscope, from *A New and Complete Illustration of the Occult Sciences* (1797), is reprinted by Meyerstein, p. 531-3.

50. Meyerstein, p. 442.

51. *The Forger's Shadow: How Forgery Changed the Course of Literature* (London, 2002), p. 155.

52. *OED*.

53. 'Chatterton *I* think – mad': Lord Byron to Leigh Hunt (Nov 4-6 1815?), *'Wedlock's the Devil': Byron's Letters and Journals*, vol. 4, ed. Leslie A. Marchand, (London,1975), p. 332.

The Authors

Ken Knowles Ruthven is Honorary Professor, Department of English, Melbourne University. His publications include *Critical Assumptions* (Cambridge, 1979), 'Critics and Cryptomorphs: Observations on the Concept of Hidden Form', *Southern Review*, 15 (1982), 92-110; *Ezra Pound as Literary Critic* (London, 1990).

Jonathan Barry is Senior Lecturer in History and Head of the School of Historical, Political and Sociological Studies at the University of Exeter. He has published extensively on the social and cultural history of early modern England, especially on provincial towns, the middling sort and south-western England, with particular reference to Bristol. He is currently preparing a book on religion and society in Bristol c.1640-1775 and another on witchcraft and demonology in south-western England in the same period.

Michael Liversidge teaches art history at the University of Bristol, specialising in British painting and landscaping of the eighteenth and nineteenth centuries. He has been a Resident Fellow at the Yale Center for British Art, and has organised and published catalogues for major exhibitions, including 'Canaletto and England' (1994, with Jane Farrington) and 'Imagining Rome. British Artists and Rome in the Nineteenth Century' (1997, with Catharine Edwards and Elizabeth Prettejohn). He is a Fellow of the Society of Antiquaries.

Timothy Mowl is Reader in Architectural and Garden History at Bristol University where he runs an MA in Garden History. His publications include *Historic Gardens of Wiltshire*, 2004, *Historic Gardens of Dorset*, 2003, *Historic Gardens of Gloucestershire*, 2002; *Horace Walpole: The Great Outsider*, 1996; *Gentlemen and Players: Gardeners of the English Landscape 1620-1820*, 2000; *Stylistic Cold Wars of the Twentieth Century: Betjeman versus Pevsner*, 2000; *An Insular Rococo: Architecture, Politics and Society in Ireland and England 1710-1770*, 1999; *William Beckford: Composing for Mozart*, 1998; *To Build the Second City: Architects and Craftsmen of Georgian Bristol*, 1990.

Katherine Turner is Williams Fellow & Tutor in English at Exeter College, Oxford. She has published on eighteenth-century poetry and travel writing and, with Francis O'Gorman of the Department of English, University of Leeds, has recently edited a volume of essays on *The Victorians and the Eighteenth Century: Reassessing the Tradition*.

Alistair Heys has taught at Swansea University and Liverpool University. He has published in the field of Romanticism and Anglo-Welsh literature. His essays include 'Kings of Pride and Terror: R.S. Thomas and the Welsh Sublime'(2000); 'Frost's Cruel Chemistry: R.S. Thomas's abstruse debt to Coleridge' (2001); 'Innuendo and Mobility: Byron's

Shakespearean masquerade' (2002); 'Dialectic and Armistice: Dylan's Reception of Keats' (2004), and 'The Priested Shore: *Wales*, R.S. and Dylan' (2005). Apart from editing this present volume, he has written *R.S. Thomas and Romanticism*, for publication in 2005.

Mary-Ann Constantine has taught and researched in the field of Welsh and Breton literature and folklore for the past ten years; her publications include *Breton Ballads* (Aberystwyth, 1996) and, with Gerald Porter, *Fragments and Meaning in Traditional Song* (Oxford, 2003). She is currently leader of the research project 'Iolo Morganwg and the Romantic Tradition in Wales' based at the University of Wales Centre for Advanced Welsh and Celtic Studies in Aberystwyth, where she is working on a comparative study of literary forgery in the Romantic period.

Nick Groom is Reader in English and Director of the Centre for Romantic Studies at Bristol University, and Secretary of the Thomas Chatterton Society. Among his books are *Thomas Chatterton and Romantic Culture* (ed.1999); *The Forger's Shadow: How Forgery Changed the Course of Literature* (2002), and an edition of Chatterton's *Selected Poetry* (2003). *The Union Jack: A Biography* will be published in 2005.

Acknowledgments

As editor, I must express thanks to the British Library, Bristol Central Library, Bristol University Library, Exeter University Library, Melbourne University Library, The National Library of Wales and Swansea University Library. Moving from semantics to optics, I also wish to thank the British Museum, Bristol City Museums and Art Gallery, the National Library of Wales, the National Gallery of Washington, Tate Britain and the Victoria and Albert Museum. Gordon Kelsey's photography is also worthy of meritorious mention, as is that of John Fields. I shall also have to thank The Oxford University Press for their permission to quote from D.S. Taylor's edition of *The Complete Works of Thomas Chatterton*. Finally, I should like to express gratitude for the much-tested patience of John Sansom and literary capabilities of K.K. Ruthven, Jonathan Barry, Timothy Mowl, Michael Liversidge, Katherine Turner, Mary-Ann Constantine and Nick Groom.

Index

Illustrations are indicated in **bold**